MANAGING
PROFESSIONAL AND
FAMILY LIFE

MANAGING PROFESSIONAL AND FAMILY LIFE

A COMPARATIVE STUDY OF BRITISH AND FRENCH WOMEN

Linda Hantrais

Dartmouth
Publishing Company

Published by
Dartmouth Publishing Company Limited
Gower House
Croft Road
Aldershot
Hants GU11 3HR
England

Dartmouth Publishing Company
Old Post Road
Brookfield
Vermont 05036
USA

British Library Cataloguing in Publication Data
Hantrais, Linda
 Managing professional and family life : a
 comparative study of British and French women.
 1. Women. Employment. Sociological perspectives
 I. Title
 305.43

ISBN 1 85521 167 X

Printed in Great Britain by
Billing & Sons Ltd, Worcester

Contents

List of Tables

List of Figures

Preface

Since the late 1970s the ratio of women to men in higher education in Britain has been shifting in favour of women, although by the end of the 1980s they had still not reached parity with men, unlike their counterparts in countries such as France or the United States. Women in Britain are now entering many of the traditionally male subject areas in growing numbers, but again to a lesser extent than in some societies in the Western world.

Because they represent only a small minority of women in employment, over the past 20 years well qualified women have not figured prominently in the research conducted into the feminization of the labour force. Notable exceptions are the case studies of the careers of British women in particular professions, such as accountancy, law, medicine and engineering, or 'semi-professions' such as teaching. Nor have women been a major focus in analysis of the match between graduate skills and the needs of the labour market. Although international comparisons have been made of higher education, no comparative work has been conducted specifically on well educated women.

The underlying — and often explicit — assumption made in British studies of professional life is that well qualified women will interrupt their employment when they decide to raise a family or that they choose their occupation because it is compatible with their personal plans. This premise is reflected in the important body of literature devoted to managing the career break, a phenomenon which can be described as peculiarly British.

By focusing attention on the career break and on the return to work, authors in Britain have tended to neglect analysis of some of the coping strategies which would enable women to pursue more continuous careers while also raising a family. Reference to the position of women in other similar Western societies and to their family and employment careers can provide interesting comparative materials illustrating the ways in which the investment made in the education of women might be more fully exploited without adverse effects for family formation.

A number of comparisons based on national data have been made of women's patterns of employment across socioeconomic groups between Britain and France, Sweden and the United States. Despite the fact that all

four figure amongst the countries in the Western industrialized world with the highest female economic activity rates, employment patterns differ in two important respects: many more women in Britain and Sweden are working part time; British women have less continuous employment records than their French, Swedish or American counterparts. National data in each country also suggest that, in comparison with other socioeconomic groups, well educated women are less likely to interrupt their employment when they have a family and that they less often work part time when they have young children.

In this book the contemporary British and French contexts have been selected for further investigation. They afford an interesting comparative case study for two of the European Community member states to illustrate the process whereby women who have undergone higher education seek to maximize returns on the time and effort invested while also often raising a family. In addition to describing the family and employment patterns of women in this category, explanations are sought for the differences observed in terms of the wider social, political and economic environments. To this end, the available national data are supplemented by comparative analysis of the social systems and of relevant policies in the two countries. The results from a new qualitative empirical study, based on a matched sample of well qualified British and French women, are introduced in order to compare and contrast the ways in which women manage their professional and family lives.

The research for this book was carried out with support from the ESRC/CNRS Franco-British programme, the French Embassy in London and the Department of Modern Languages at Aston University, Birmingham. Colleagues in several higher education and research institutions in Britain and France provided valuable assistance with data collection and analysis for which we should like to express our gratitude. In particular, we should like to acknowledge the help received from the Institut National d'Études Démographiques, the Institut National de la Statistique et des Études Économiques, the ESRC Data Archive and the OPCS. Margaret Ferguson and Louise Gibson assisted with our survey data analysis and Judith Glover carried out secondary analysis of national data for us. The women who participated in the empirical study are also to be thanked for the time they devoted to answering our questions and for the interest they showed in the study.

Introduction

Over the past two decades the British have not shown so much concern about the falling birthrate and consequent ageing of the population as some of their European neighbours. Nor does the British public seem to have the same awareness of demographic issues as, for example, the French or the Belgians, whose preoccupation with increasing or maintaining the size of their population has continued unabated since the 1920s for political, economic and social reasons.

One population trend in the late 1980s did, however, rouse some public interest in Britain. In 1982 the number of 18 year olds in the United Kingdom peaked at almost one million. By 1986 the level had fallen to nearly 900,000, and by the mid-1990s it is expected to drop below 650,000. What has come to be interpreted as an irreversible decline in this age group was, by the end of the 1980s, provoking a reaction, at least in sectors of the population directly concerned with the recruitment of young people. In particular, the purveyors of higher education and employers of 18 year olds in the labour market were expressing anxiety about their inability to find appropriate candidates to fill the available places.

Not all the reactions to this demographic trend were negative. Some observers interpreted the national situation as an opportunity for population groups which had previously been under-represented in some areas of employment and in higher education to redress the balance. One such group with recognized potential for further development is that of women, who make up more than half the population but who, by the mid-1980s, still accounted for under 42 per cent of all students in higher education (Government Statistical Service, 1988: Table E). Female students continued, moreover, to be almost invisible in subject areas, such as the pure sciences and engineering, where higher education has consistently had difficulty in attracting well qualified undergraduates.

The fear amongst employers in Britain that they will not be able to recruit and retain a well qualified and experienced workforce prompted a number of organizations, particularly some of the high street banks and a few local education authorities, to look for ways of encouraging women to return to the labour force after devoting several years to raising young children. In 1987 the Confederation of British Industry offered its support to

such schemes, with the recommendation to its members that they should make it possible for women to have career breaks not only in the interests of equal opportunities but also in response to the needs of businesses faced with a dwindling pool of skilled labour. The situation was reminiscent of that in the mid-1960s when it was suggested that skill shortages at the professional level could be an opportunity for women to supplement the inadequate supply of men and that women — especially married women — afforded an untapped reserve (Arregger, 1966:xv). In the late 1980s, it would have been more appropriate to refer to 'women with children', but in other respects the general tenor of the argument had not changed markedly.

Rather than being government led, in Britain the initiative for promoting schemes designed to keep well trained women in the labour force has come from employers. Indeed, it can be demonstrated that government policy in Britain has deliberately set out to be non-interventionist as far as the economic activity of women is concerned. Another characteristic of the British scene in the late 1980s was that, even amongst employers, the emphasis was firmly on women returners rather than on continuity of employment, the underlying and implicit assumption being that women should and do want to make a break in their employment career as and when they decide to have a family.

International studies of women and employment

If, on occasions, the British look to other countries to find out how they are coping with similar problems, eyes are often turned towards the United States (for example Dex and Shaw, 1986; Mallier and Rosser, 1987; Meehan, 1985) or to Sweden (Ruggie, 1984) for comparative materials. As the prospect of the mutual recognition of educational qualifications, free movement of workers between European Community member states and the harmonization of social policy within the EC becomes a reality, it seems imperative to compare what is happening in the education, employment and family policy fields in Britain with developments in neighbouring EC countries. In the case of well qualified workers, and especially women, it is also interesting to speculate about the likely direction of the flow of graduates in the future according to their perceptions of the attractiveness of living and working in another country and the efforts employers may be prepared to make to recruit from abroad in order to fill vacancies in middle and top management positions.

Under the auspices of the OECD, multinational studies have been made of sexual inequalities in education (OECD, 1986) and of various aspects of women's economic activity (for example OECD, 1980, 1985; Paukert, 1984). Similarly, the EC has commissioned studies of women's professional, family and social roles in its member states (for example Peemans-Poullet, 1984). The themes of the feminization of the labour force (Jenson et al, 1988) and women's rights within Europe (Buckley and Anderson, 1988) have

been examined in series of parallel studies by contributors from different EC countries.

Despite the abundance of seemingly comparative international studies, the problems of comparing women's family lives and patterns of employment cross-nationally are not to be underestimated. Differences in the ways in which issues are conceptualized and difficulties resulting from the non-comparability of data make this a hazardous undertaking, even if only two countries are being considered (Hantrais, 1989). The problems are compounded in multinational studies. The result may be that comparisons remain at a superficial quantitative and descriptive level, simply because the amount of information is overwhelming, because data are lacking for a particular year or variable or because they have been derived according to different criteria.

If cross-national comparisons are to be meaningful, it is essential to locate the available statistics in relation to their wider context. This can be done using what has come to be known as the societal approach. In the area of industrial sociology Marc Maurice and his collaborators at the Laboratoire d'Économie et de Sociologie du Travail in Aix-en-Provence (1979, analysed by Rose, 1985) pioneered this approach in their study of organizations and applied it, for example, in comparisons of the relationship between skills, qualifications, training and employment in France and the Federal Republic of Germany. Their purpose was not to develop a method specifically for international comparisons, but the approach does provide a useful framework for comparing institutions across nations, since it stresses the specificity of social forms and institutional structures in different societies. The corollary is that the explanation for differences in patterns and structures must be sought in the wider sociocultural context. The method therefore implies detailed knowledge and understanding of the many institutions and structures of the societies being compared and lends itself best to the comparison of a limited number of variables in only a few contexts so that depth is not sacrificed to breadth.

Franco-British comparisons of well educated women

France offers an interesting contrastive example with Britain for such in-depth international comparisons of the career paths of well educated women. Scrutiny of quantitative data and of single nation studies in France shows that women already outnumbered men in higher education in the early 1980s (Oeuvrard, 1984:480). They also appear to be present in larger proportions than in Britain in some of the traditionally male dominated disciplines (Government Statistical Service, 1988: Table 36[34]; *Note d'information*, 87-23). Data from Franco-British comparisons of employment patterns suggest that French women subsequently follow more continuous full time employment careers than their British counterparts (Dale and Glover, 1987).

The success of women in higher education in France has been interpreted as a major factor in raising their level of expectations for professional life (Battagliola and Jaspard, 1987:53). From the available evidence women in middle and higher management positions would seem to have an important impact on working conditions in general and on attitudes towards work (Ray, 1981). At the same time well educated women apparently feel that they must rise to the challenge by excelling not only in their employment but also in their family roles by demonstrating their ability to manage the two areas of their lives without sacrificing either one to the other (Castelain-Meunier and Fagnani, 1988).

Another topic for comparison which is of considerable interest for the British observer is the way that women in France are supported and encouraged by the state in their efforts to combine family and professional life. To some extent, this intervention can be construed as recognition of their contribution to the community both as mothers and as workers. In Britain, by contrast, state 'interference' is minimal and tends to be reserved for individuals who demonstrate their inability to cope if left to their own devices.

Purpose of the study

The interest of comparisons between societies which have reached a similar stage of socioeconomic development, but where the dominant pattern of employment for women differs in many respects, is that they raise questions about the inevitably of a particular model and about possible explanations for it. They also provide an opportunity to assess the feasibility of alternatives to the accepted orthodoxy.

The intention in the study reported in this book was to conduct a detailed comparative analysis of the professional and family lives of well educated women in Britain and France. Although new empirical work was carried out on a matched sample of women graduates (one hundred in each of the two countries), they are not the sole nor even the main focus of the study. Rather their accounts are used to exemplify the arguments raised in the course of analysing the place of women in the two systems of higher education, their entry into the labour force and patterns of employment, the ways in which public policy affects the progression of family and employment careers, the impact of the family upon employment patterns and of employment on family life and the strategies deployed in order to manage the two strands.

In seeking to elucidate these themes within a comparative perspective, the study goes beyond a juxtaposition of the available data. When examining the place of women in higher education, for example, meaningful comparisons can be made only if the cultural implications of different aspects of the system are analysed. The same approach is applied to women's entry into the labour market, their occupational progression and the way they organize and manage family building and childcare.

The argument

The focus in the first chapter is on the higher education systems in the two countries as a preparation for an employment career and on the relative position of women within each system. Subsequent chapters analyse the means whereby women in Britain and France exploit their education and training and combine employment with family life.

The main argument of the book, running through all the chapters, is that women who pursue their education beyond compulsory schooling will expect to ensure a return on their investment, as will the state and employers who also make an important contribution to their training. On the basis of the available evidence, in comparative terms, the expectation might be that women in France make greater use of their human capital investment by being more committed to full time employment and by pursuing a more continuous and upwardly mobile employment career than their British counterparts, thereby coming closer to the male model of employment.

A second argument developed in the book, particularly in the second and third chapters, is that the rising level of education amongst women might be expected to produce a change in their position in the labour market. If more equal opportunities are made available for women to participate in higher education and more women take advantage of them, as illustrated in Chapter 1, the anticipated outcome could be a reduction in occupational segregation and a weakening of the barriers associated with a dual labour market. Because of their educational achievements and their more continuous employment histories, French women could expect to experience fewer constraints in choosing and pursuing their career.

The third and fourth chapters examine women's patterns of employment and family formation with reference to the range of policies, including women's rights legislation, employment law and family policy, which may affect the relationship between employment and family life and between the supply and demand sides of women's labour. The legislative framework is compared in the two countries, with a view to identifying the factors which are likely to influence the decision of women to enter certain types of employment, to continue in work or to make a career break and, subsequently, to return on a full or part time basis.

Emphasis in Chapter 3 is on the factors shaping the demand for women's labour. Attention is also paid to the impact of women's rights legislation on pay, occupational segregation and concentration and equality of opportunity. Thirdly, it is argued that, as they move closer to male patterns of employment, women might be expected to have an effect on the workplace which may be forced to adapt in order to accommodate a type of worker displaying different needs and aspirations. This may already be happening in the public sector. It has been suggested that in the future, as more women reach the higher ranks in all advanced industrialized societies, the civil service will be obliged to manage the career progression

of personnel with greater regard for individual needs (Timsit and Letowski, 1986). The implication is that the female model of employment should not simply be a copy of that for men but should be adapted to take account of factors associated with family life. From what has already been said about women's patterns of employment in Britain and France, it would seem that employers in France may already have moved further in this direction under the added incentive of the positive action programmes which have been introduced.

Fourthly, greater continuity of employment amongst women, which brings them closer to the male model, may be double edged in terms of the attractiveness of female labour for employers: on the one hand continuity ensures returns on investment in training, but on the other it creates a more stable labour force at a time when employers are seeking flexibility. The knowledge that younger women may be more likely than men to leave employment is a factor which can be taken into account by employers in their recruitment policies, but a situation where supply side factors are dominant may be propitious for well educated women, if suitably qualified labour is in short supply, by giving them the opportunity to negotiate terms which are to their advantage. Such a situation may have arisen in Britain in the late 1980s and could lead to more support for well qualified women than might be forthcoming as the result of any legislative change.

The focus in Chapter 4 is on the supply side of women's labour. Different approaches to employment and family policy are examined in the two countries together with the provision made for young children. Attention is devoted to the impact the family can have on the patterns of employment of women who have undergone higher education and on their perceptions of the relationship between professional and family life. The ways in which marriage and the family affect the commitment to employment are analysed in relation to the returns on investment in education. Again France affords an interesting contrastive example with Britain in that, since the interwar period, successive French governments have developed concerted social policies designed to enable women to engage in full time employment while also raising a family. Despite these different perspectives, the birthrates in the two countries are almost identical. It can be argued, fifthly, that state intervention in France has been instrumental in creating conditions enabling women to fulfil their two roles for a chosen family size, whereas in Britain the same result, in terms of family building, has been achieved largely by interruptions to full time employment. Well educated women in France would seem to be aware of how to exploit the available opportunities and publicly funded support networks to their advantage, whereas British women are more likely to have to rely on their own resourcefulness.

Finally, in terms of 'two roles' theory, the greater continuity of employment amongst French women, in combination with the responsibilities of motherhood — unless these are delegated to or shared with spouses — might be expected to produce greater role strain and

overload. This argument presupposes that women continue to have the main responsibility for childrearing. The possibility exists, however, that the sexual division of labour within households may change as women come closer to male patterns of employment if patriarchal roles are consequently undermined. The evidence in support of this theory is examined in Chapter 5 by looking more closely at the way in which women handle the relationship between family life and employment in the two countries and by investigating the coping strategies adopted in order to manage the situation. These range from recourse to various support networks to adaptations in schedules, changes in patterns of activity and the redefinition of the division of labour within households. Attitudinal data are also analysed in order to discover how the women concerned assess their own experience.

The final chapter brings together the different strands of the arguments presented throughout the book and analyses the implications of the findings from the comparative study of women's professional and family lives both for sociological theory and public policy. One of the interests of examining the interaction between the family life and patterns of employment of well educated women is that they can be said to offer role models for women in other sectors of society. The same may be true of cross-national comparisons. The rather different models afforded by well educated women in Britain and France may each have characteristics which could profitably be imitated.

1 Women in Higher Education

Politicians in Britain and France frequently use international comparisons of the proportion of the population in higher education and the share of the gross national product devoted to it in order to demonstrate the importance they attribute to education as a citizenship right and a means of improving their country's economic performance. Statistics which indicate that the proportion of women entering higher education is on the increase or has reached parity with men are taken to imply that women are being given equal opportunities and that discrimination against them has been removed.

Cross-national comparisons of higher education are, however, more difficult to make than these statements might suggest, and straightforward interpretations of the available statistics can be misleading. The broad definition of higher education, provided in the International Standard Classification of Education handbook and often used in international comparisons (for example *Statistical Bulletin*, 4/87), makes national data very difficult to compare. According to the ISCED, higher education is 'more specialised study normally undertaken after successful completion of a good basic education lasting for at least 11 years. Such a definition does not, for example, take account of the distinction which is generally made in Britain between further and higher education.

The results of comparisons based on statistics collected nationally, using this type of definition, are likely to be unreliable when the educational systems being compared are structured very differently, as is the case for Britain and France or Britain and the United States, to take only two examples. The latter comparison is, however, not infrequently made by British politicians in suggesting a model for the future development of higher education (for example Baker, 1989). Further reservations need to be expressed about the use of quantitative measures in isolation from their context. Presented in this way they provide only a very partial view of the situation, for it is not simply the proportion of an age group in higher education which is likely to affect the labour process but rather the nature of the training provided and the way it is perceived and exploited by employers and employees alike.

If meaningful and worthwhile comparisons are to be made of the

relative position of women in higher education in two or more countries, it is therefore essential to have a proper understanding of the educational systems concerned and to be able to locate them within their wider political, economic and sociocultural frameworks.

COMPARING HIGHER EDUCATION IN BRITAIN AND FRANCE

Regardless of the comparability or otherwise of the figures being quoted, in the late 1980s, government ministers in both France and Britain were claiming that a million or more students were in higher education, while also predicting that the proportion of school leavers entering higher education would continue to rise during the 1990s. In relative terms, when the proportion of the 18-24 year old age group in higher education was compared in 1983-84, the UK was said to be trailing behind France, the Federal Republic of Germany, Italy, Japan, the Netherlands and the United States (*Statistical Bulletin*, 4/87: Table 3). More detailed scrutiny of the components of these figures for the UK and France can help to put these comparisons into perspective.

In the UK, as summarised in Table 1.1, towards the end of the 1980s the million figure was barely reached by including full time, part time and sandwich students in the 46 UK universities, the Open University, 25 polytechnics, 14 central institutions in Scotland and 638 colleges of higher education, who were following a variety of degree and diploma courses at undergraduate and postgraduate level. The figures included some 70,000 students from abroad but excluded students enroled on nursing and paramedical courses in Department of Health and Social Security establishments, numbering about 95,000 (Government Statistical Service, 1988: Table 28[26]). If they are counted — and the ISCED definition infers that they should be — then the number of students in higher education in the UK could be said to have passed the million.

For France the million figure was achieved and easily passed by counting all students enroled in the 72 universities (13 in Paris), the 68 *instituts universitaires de technologie*, the 258 *classes préparatoires*, 300 or so *grandes écoles* (including about 70 business schools and 175 institutes of engineering, many of which are attached to the universities) and several other institutions of higher education, who were studying for degrees and diplomas or preparing to take entrance examinations for the *grandes écoles* (the role of the IUT, *classes préparatoires* and *grandes écoles* is further discussed later in this chapter). By 1988-89 the universities alone accounted for close on a million students.

According to the figures in Table 1.1, in 1986-87 about 45 per cent of total enrolments were in the universities in the UK and 75 per cent in France (excluding the IUT). The number of full time students in 1986-87 was put at over 600,000 in the UK and part time at nearly 360,000 (Government

Statistical Service, 1988: Table E). No distinction is made in the French statistics between full and part time study. Since relatively few French university students are in receipt of a maintenance award (about 16 per cent), it is almost standard practice for them to undertake some form of employment while studying, although this does not affect their official status as students and is not differentiated in fee levels.

TABLE 1.1 STUDENTS IN HIGHER EDUCATION IN THE UK AND FRANCE, 1965-87

| | UK | | France | |
	1965-66	1986-87	1965-66	1986-87
Universities	186,000	441,000	413,756	904,912
Technical education/IUT	-	-	25,740	192,022
Polytechnics	4,100	180,103	-	-
College students	238,900	350,897	-	-
Grandes écoles*	-	-	26,609	74,368
Classes préparatoires	-	-	26,660	48,811
Other institutions	-	-	9,875	-
TOTAL	429,000	972,000	502,640	1,220,113

* Including only the écoles d'ingénieurs in 1965-66.

Sources: CNAA, 1966:45, 1988: Table 4; Government Statistical Service, 1988: Table E; Note d'information, 87-24; Ministère de l'Éducation Nationale, de la Jeunesse et des Sports, 1988: Table 10.1.

Time series data confirm that, in both countries in absolute and relative terms, the number of young people continuing their education after taking school leaving examinations has risen rapidly. The total number of students in higher education in the UK more than doubled between 1965-86, despite the fall by 50,000 in the number of 18 year olds in the population. The growth for part time students over the same period was even greater at almost 200 per cent. The increase in the student population in higher education can, to some extent, be attributed to government policy. In the mid-1960s, in response to the Robbins report, the government enacted a number of measures designed to ensure that higher education should be available to all those who are suitably qualified, in terms of their ability and level of attainment, to pursue their studies. Several new universities were created, 11 former colleges of advanced technology were designated as universities, and the polytechnic sector was established, together with a number of colleges, for which the Council for National Academic Awards acts as a validating body for degree level and

postgraduate qualifications. The Open University began recruiting in 1970-71 and by 1986-87 accounted for eight per cent of all students.

In France, similarly, very rapid growth occurred in the 1960s and 1970s. New universities were built, and the IUT were established in the university sector in 1966 with a function not dissimilar to that of the polytechnics. The number of university students, which started from a much higher base than in the UK, more than doubled between 1965-66 and 1986-87, while the number in technological institutions increased threefold. The *école* sector did not expand so rapidly. The overall growth in numbers was partly demand led and partly due to the effects of the post-war population explosion. The Ministère de l'Éducation Nationale has attributed one-quarter of the growth to demographic trends and three-quarters to the greater demand for education, which was encouraged by policies intended to democratize and promote higher education by creating more opportunities for young people to pursue their studies beyond secondary schooling (*Note d'information*, 87-24).

Despite the rapid increase in both countries in the numbers entering higher education, the gap between them has been maintained in terms of the proportion of the relevant generation in higher education: in relation to the number of 18-24 year olds in the population, a larger proportion of the age group in France (16 per cent) than in the UK (nine per cent) was recorded as being in some form of higher education in the late 1980s (Government Statistical Service, 1988: Table 22[20]; *Note d'information*, 89-05). At the end of the 1960s the proportion of the relevant age group receiving higher education was under seven per cent in the UK and over 12 per cent in France (Department of Education and Science, 1970a: Table 32; *Note d'information*, 87-24).

Predicted growth for higher education in the 1990s was expected to be demand led in the UK, in response to the needs of the economy, and to attract a more diversified clientèle, including more members of previously under-represented groups, for example women (Baker, 1989). In French universities, the target for the year 2000 was set at two million, without reference to the need to recruit more women. If each country meets its objectives, it seems reasonable to predict that the disparity between them will continue and may increase further.

Access to higher education in France and Britain

The number of students in higher education at any point in time is determined by several factors: ease of access to the system, length of courses, completion rates and possibilities for changing courses or taking further qualifications after an initial award. In combination, these factors might explain the larger numbers in higher education in France, but direct comparison for each of the areas tends to be problematical for several reasons.

Access to higher education for different age groups cannot simply be

compared by examining the educational status of young people aged 19-20. When 28 per cent of 19-20 year olds in the UK are said to be in post-secondary education, of which 14 per cent are in full and part time higher education (Government Statistical Service, 1988: Table 22[20], excluding nursing and paramedical courses), and 39 per cent of the equivalent age group in France are said to be in some form of secondary or post-secondary education, of which 23 per cent are in higher education (*Note d'information*, 89-05), these percentages need to be interpreted with some caution due to a number of differences in the two educational systems.

Firstly, discrepancies arise between the two countries in the proportion of 17-18 year olds in the population who continue their education at school after the end of compulsory schooling at the age of 16. In the UK in the late 1980s 20 per cent of 17 year olds and less than three per cent of 18 year olds were still at school (Government Statistical Service, 1988: Table 22[20]). In France 70 per cent of 17 year olds and 44 per cent of 18 year olds remained in schooling (*Note d'information*, 89-05). Not unexpectedly, a smaller proportion of the British age group (17 per cent, according to Government Statistical Service, 1988: Table 35[33]) than their French counterparts (33 per cent in 1987, *Note d'information*, 88-53) goes on to obtain the necessary qualification from school (at least one General Certificate of Education Advanced level in England and Wales and the *baccalauréat* in France) to enable them to apply for a place to study for a degree or another post-secondary award in a higher education institution.

Secondly and as a concomitant to the first point, school leavers do not obtain their qualifications at the same age in different countries. In the UK most pupils will have passed their school leaving examinations by the age of 18. In France 22 per cent continue at school at the age of 19 in classes preparing them for the *baccalauréat* (*Note d'information*, 89-05), generally because they have had to repeat a year. By the time they reach the final year of schooling, it has been estimated that only about 40 per cent of pupils are 'on schedule' (OECD, 1986:121). Consequently, French students are available for and enter higher education on average at a later age than their British counterparts, as is also the case in other West European societies, such as the Federal Republic of Germany, although not necessarily for the same reasons.

Thirdly, higher education covers a very wide range of types and levels of education. Not all those who continue after the school leaving examinations will be studying for a degree. Three levels of higher education are distinguished in the statistics: 5, 6 and 7. Courses grouped under 5 are subdegree level, including occupational qualifications such as those in nursing. Level 6 covers first degree courses or their equivalents and level 7 postgraduate programmes. In the UK over 30 per cent of higher education enrolments in 1986-87 were at level 5 (Government Statistical Service, 1988: Table 28[26]). In France, where first enrolments in universities are for the two year foundation course, *diplôme d'études*

universitaires générales, which is not necessarily followed by a degree, and various other alternatives are available, as discussed below, approximately 40 per cent of students who enter the first year of higher education subsequently go on to read for a degree (Charlot, 1988b:16).

Fourthly, another factor to consider in estimating the proportion of a generation likely to enter higher education is that access to higher education can operate according to an 'open' or 'closed' system. The expectation is that a larger proportion of qualifiers will enter higher education if the system is open. In the UK entry to higher education can be described as selective and therefore 'closed', whereas in France it may be 'open', as in the universities, or 'closed', as in the *grandes écoles*. A few university courses in France, namely medicine and pharmacy, exercise a *numerus clausus*, and some institutions try to filter applications, for example Paris-IX (Dauphine), which has established a reputation for its courses in economics and takes only students who achieve a distinction in the *baccalauréat*. Similarly, Paris II (Assas) for law, Aix-Marseilles-III for law and economics and Paris-IV (Sorbonne) for history and arts subjects practise selective entry. In theory though, no formal selection procedure operates at entry, unlike the UK system where the school leaving examination is only the first stage in the process of gaining a place in higher education.

In France, where the school leaving examination automatically ensures access to university education, the objective set in 1989 by the then Ministre de l'Éducation Nationale, Lionel Jospin, was that, by the end of the century, 80 per cent of an age group should reach the level of the *baccalauréat*, compared with 33 per cent in 1987 (representing 278,244 passes, *Note d'information*, 88-53) and 12 per cent in 1966 (Oeuvrard, 1984:477). Virtually all of those who pass the *baccalauréat général* (as opposed to 70 per cent of those awarded the school leaving certificate in technical subjects, the *baccalauréat de technicien* or *brevet de technicien*) enter some form of higher education.

At this juncture, it is sufficient to note the disparities in the age at which secondary education is completed and the seemingly different proportions of the relevant populations passing school leaving examinations. Rather than trying to find equivalents for the many non-degree level diplomas in the two systems of higher education, more meaningful comparisons can be made by examining the range of opportunities afforded by higher education in the two countries and the nature of the qualifications which can be obtained, especially at or above degree level.

One reason for trying to compare the number of students who achieve a degree level qualification is to gain a better appreciation of the likely impact of the agreement reached by the EC member states in 1988 that a school leaving examination followed by three years of higher education should automatically be recognized as being of equivalent status. This decision was

taken after many years of protracted discussion which reflected the difficulty of trying to match course content and teaching methods from one country to another throughout the Community.

Although of greater interest for the purposes of this study, comparisons of degree level qualifications are not much easier to make than those of the overall numbers in higher education, particularly if equated with a school leaving examination plus three years further study, since large proportions of students in the two countries are following first degree courses lasting for more than three years: study for a degree in Scotland routinely takes four years, and the same applies to other British students on sandwich courses in many of the technological subjects and languages. A French degree (*licence*) can theoretically be obtained in three years of post-secondary study (a two year general foundation course plus one further year), but it is far from unusual for undergraduates to spend much longer before achieving a pass in the relevant examinations. In terms of content and the level of specialization, the *maîtrise*, which is taken after a further year of study, may more closely resemble the British first degree. In any one year almost as many students in France are awarded the *maîtrise* as the *licence*, whereas only relatively small numbers of British graduates take a masters degree.

The standard length of some courses is considerably longer than the three and four year models and longer in France than in Britain. Medicine requires five years of study in Britain followed by a pre-registration year and as many as eight years in France, or more if a year has to be repeated, which is the case for two-thirds of those entering the second year. Dentistry requires five years of study in Britain, and in France four years further study after the first two in common with medicine. Proposals were being considered in 1989 to extend the length of training for dentistry to bring it into line with medicine. Pharmacy requires a three year degree course in Britain followed by a pre-registration year. In France, where only one repeat is allowed, four years of further study are needed after the foundation course. In Britain veterinary studies normally take five years, whereas in France four further years are required in higher education following very competitive entry to one of the three *écoles vétérinaires* after studying in a *classe préparatoire*, resulting in a total of six or seven years.

In the late 1980s the Ministère de l'Éducation Nationale estimated the average length of higher education in France to be 5.4 years (*Note d'information*, 87-24). Even this seemingly high figure represents a reduction over the past 25 years due to the introduction of shorter diploma courses which have attracted large numbers of students. If these shorter courses are excluded, average length rises to 6.4 years. In its international comparisons, however, the UK Department of Education and Science describes the typical duration of a university course in France as being four years, and only Scottish courses are said to be typically of four years in the UK (*Statistical Bulletin*, 4/87: Table 2).

Another problem in making comparisons at this level is the availability

of relevant data. In the UK statistics on enrolments for first degrees (collected by the Universities Central Council on Admissions and the CNAA) are readily available and reliable, but in France they are more difficult to collect for a number of reasons. As already mentioned, since the first two years of study lead to a general certificate which is a prerequisite for enrolment for a degree, students do not register directly for a degree when they enter university. French students may enrol for more than one course at the same time (approximately one in three of the students in the *écoles préparatoires* also enrol on a university course). A follow-up study of 1983 school leavers with the *baccalauréat* showed that 75 per cent of first year students in higher education were first enrolments, five per cent had enroled on a university course as a standby while pursuing other studies, nine per cent had enroled at university after having followed a non-university course, eight per cent had changed courses and two per cent were deferred entry (Charlot, 1988b:13-4). Also no limit is imposed on the duration of study for a first degree in the absence, for many courses, of any restriction on the number of times a years' work can be repeated. Nor are students obliged to sit examinations at the end of the academic year. The question also arises whether the two years spent in a *classe préparatoire* in preparation for entry to one of the *grandes écoles* should be included in the reckoning, since they can give exemption from the first two years of study at university.

Notwithstanding these reservations, official statistics for 1986-87 showed that the universities in the UK admitted about 117,000 full and part time students, including the Open University (Government Statistical Service, 1988: Table 27[25]), and the polytechnics about 62,000 students (CNAA, 1988: Table 2) to read for a degree level award, representing almost 20 per cent of the relevant age group (approximated to 18 year olds). First enrolments on university courses in France numbered 210,584 (*Note d'information*, 87-40), constituting about 25 per cent of the relevant age group (approximated to 19 year olds), while the *classes préparatoires* accounted for another five per cent of the same group (*Note d'information*, 87-24). These figures suggest that the discrepancy between the two countries for the number of students in the system is of a similar order at the point of entry into higher education and, as indicated previously, for students in the system at the age of 19-20, although subsequently it may be expected to become more marked due to the length of studies in France.

Progress through higher education

The first year or so of university education in France tends to be perceived as a transitional phase when young people test their abilities and search for new disciplines and subjects which might interest them, with the intention of changing direction, if need be, once they have found what they want (Charlot, 1988b:13). In Britain, many options will already have been

foreclosed by the time a student enters higher education, and the great majority of undergraduates will follow through the course for which they have been selected without contemplating a change of orientation. Since access to higher education is the logical and expected sequel to secondary education in France but a more considered decision and subject to a process of selection in the UK, it is important to observe the way in which progress through the system differs in the two countries and affects the meaning and value of qualifications obtained from different types of institution.

The drop-out rate from degree courses is relatively low in Britain, estimated by the Department of Education and Science at about 10 per cent. In 1987 over 127,000 students were awarded a first degree (*Statistical Bulletin*, 4/89: Table 8). Between 13-14 per cent of an age group (approximated to 21 year olds) can be said to obtain a degree. Of these about 75,000 are awarded in the universities (including the Open University) and 52,000 for CNAA approved degree courses in the polytechnics and colleges (including university validated degrees). As the number of undergraduates has more than doubled since the mid-1960s, while the relevant age group has been growing more slowly and is now declining, the proportion of graduates in the population has expanded.

In France, by contrast, the very substantial increase in the number of students in universities since the early 1970s does not seem to have been accompanied by a similar proportional increase in the number being awarded the *licence* or *maîtrise*. In that recruitment in French universities is demand led, students are free to pick and choose between courses. They therefore have to accept the consequences if lecture halls are full to capacity, or beyond, and tutorial support is, in British terms, completely inadequate. One of the outcomes of these conditions is that the failure rate is high. Since students generally have to fund their own studies, especially if they are repeating a year, many change courses, drop out when they encounter failure or cease to study full time. The proportion of entrants who obtain a qualification at the level of the DEUG is estimated at 45 per cent (Charlot, 1988b:18). Although the failure rate is between 50-60 per cent in most disciplines in the first year at university (57 per cent in economics, 55 per cent in medicine, 46 per cent in the sciences), relatively few students actually abandon higher education completely. Most change to other types of courses and qualifications, and eventually all but about 20 per cent of those who enter higher education obtain an award, albeit not necessarily that for which they had originally enroled (Charlot, 1988b:24).

Another factor contributing to the relatively low drop-out rate and the shorter duration of undergraduate studies in higher education in the UK is the more favourable staff-student ratio. Although staff-student ratios in British universities had risen from an average of 8.4:1 in 1972-73 to 14.2:1 by the mid-1980s (University Grants Committee, 1984:88), they are much lower than in France, where the average in the state sector of higher education is nearer to 25:1 in the universities. In the IUT the level is below

21:1 (*Notes d'information*, 87-31) and may be lower still in many of the *grandes écoles*.

Ratios vary considerably from one discipline to another: in the UK the level ranges from 16.8:1 for law, 14:1 for business and management and 12.6:1 for other social studies to below 10:1 for most engineering subjects and 5.2:1 for veterinary studies, 5:1 for dentistry and 4.6:1 for medicine (Committee of Vice-Chancellors and Principals and University Funding Council, 1989: Tables 2.1-2.32). In France the discrepancy is even more marked: from 29:1 in law and political science, 25:1 in the arts and humanities and 20:1 in pharmacy, it drops to 13:1 in medicine and 11:1 in dentistry (*Notes d'information*, 87-35; 87-40). One of the intentions in operating a *numerus clausus* in medicine and pharmacy in France is to keep the staff-student ratio as low as possible.

The relatively small proportion of students obtaining a 'first' degree in France can also be attributed, in part, to the existence of other types of qualification at both subdegree and postgraduate level. Until the mid-1960s the French degree had a status not unlike that of the degree in Britain: it was the first qualification obtained by a student three or four years after the *baccalauréat* and generally the only one available. The trend since the 1960s has been to create a multilayered system of qualifications giving students much greater flexibility and the opportunity to leave the system at different points with an award. At subdegree level the DEUG and *diplôme universitaire de technologie* accounted for almost 93,000 qualifications in 1986; three-quarters as many students received the *maîtrise* (39,275) as the *licence* (51,827) and 3,478 an award in engineering; 26,858 obtained a postgraduate level qualification, including doctorates in medicine, pharmacy and dentistry (*Note d'information*, 87-23). In Britain higher degrees are awarded to a similar number of students: 28,000 in 1987 (*Statistical Bulletin*, 4/89: Table 8). When qualifications at subdegree level (46,000 professional qualifications, higher national diplomas and certificates awarded in 1987) and other postgraduate diplomas and certificates and first degree level professional qualifications (about 60,000) are added, the British figure for the total number of awards in any one year is above that for France in absolute terms. In relation to the higher education population, a considerably larger proportion of the British student body therefore obtains a qualification in any one year.

As summarized in Table 1.2, comparisons between the two countries suggest that a larger proportion of an age group in France is likely to pass the appropriate level of school leaving examination and undertake some form of higher education. The absence of selection at entry to universities in France is one explanation for the much greater number of students in the system compared with the UK. This does not, however, mean that more young people in an age group achieve a particular level of qualification. Since they can repeat or change courses almost at will in most disciplines, university education also takes longer to complete in France,

thereby further increasing the number of students in the system at a given point in time. For students enroled on courses leading directly or indirectly to a degree, a much higher drop-out rate is recorded in the university sector in France than in the universities and polytechnics in the UK, with the result that, in relation to their age group, the proportion of students who obtain a first degree or equivalent is greater in the UK. If first year enrolments and the number of degrees awarded annually are contrasted, two out of three UK undergraduates, but less than one in four French students entering higher education might expect to qualify with a degree or *licence* respectively.

TABLE 1.2 PROGRESSION THROUGH HIGHER EDUCATION IN THE UK AND FRANCE, 1986-87

	UK	France
% of age group passing school leaving examinations	17	33
% of population aged 18/19 entering higher education	14	22
% of population aged 18-24 in higher education	9	16
Drop-out rates from degree level courses in %	10	40
% of an age group awarded a degree, licence or maîtrise	13	10
Total qualifiers as % of higher education population	29	23

Sources: Charlot, 1988b:16; Government Statistical Service, 1988: Tables 22[20], 35[33], 36[34]; *Notes d'information*, 87-23, 88-17, 88-53, 89-05; *Statistical Bulletin*, 4/89: Table 8; and data supplied by the Department of Education and Science.

When other qualifications are added, in absolute terms more British students can be said to be gaining awards of post-secondary standard and, in relation to the population in higher education, a larger proportion of the student body is found to be qualifying in the UK. Although British students have a better chance of success, the system has the disadvantage of being much more rigid and does not offer the same range of alternatives for those who might prefer to transfer to a shorter course or avail themselves of the other opportunities to exit from higher education without completing a degree.

Alternative higher education programmes

For the purposes of comparison British students reading for a first degree (three and four years) can be identified relatively easily, and they provide a meaningful grouping both within the educational context and for analysis

of their labour market potential. In the French case, by contrast, the alternatives to the standard university programmes need to be considered at greater length since they are relevant to an understanding of both the educational system and subsequent employment opportunities. The features which have been shown to characterize the French system imply that students probably require much greater personal motivation, resourcefulness and external support (generally from their families), as well as the capacity to work independently, if they are to persevere and be successful in completing a course, leading to a defined career objective. By contrast, the British student, once in the system, will be faced with relatively few choices or alternatives, and his/her progress through higher education will be closely monitored, encouraging successful completion. Moreover, a first degree qualification from a university or polytechnic will usually be accepted as a suitable prerequisite for 'graduate' employment.

In the UK, in terms of recognition and status, no other award is considered as a direct equivalent to a degree, although students on other courses may be classified as 'undergraduates' for statistical purposes (Government Statistical Service, 1988:xvii). Individual institutions design their own syllabuses, set their own examinations and award their own degrees, which are nationally validated through a system of external examiners. CNAA courses are carefully scrutinized by panels of experts and also validated by external examiners. Despite the recognition given to them at national level, within the university and polytechnic sectors an informal hierarchy has developed which attributes greater status to degrees from certain institutions in particular subjects, and these are factors which can subsequently affect access to employment.

The degree in France, as already suggested, accounts for a relatively small proportion of the qualifications obtained in higher education, and a university course is not necessarily the first choice for the most able students. Universities award nationally recognized and validated degrees and other qualifications, which are presumed to have the same market value irrespective of the institution concerned, with the exception of the small number of courses mentioned above which have gained a reputation for their high standards and therefore operate a selective entry system. Although access to universities is essentially non-selective and the university system accounts for the great majority of students in higher education, it is not the only form of higher education available for *bacheliers*, the holders of the school leaving examination. Nor is it the most prestigious pathway through higher education. Two selective systems operate in parallel and in — some would say unfair — competition with the universities: the *grandes écoles* and the IUT.

For entrance to the majority of the *grandes écoles*, which are mostly independent from the universities, a competitive examination is set, generally requiring one or two years further preliminary study in specially designated *classes préparatoires*, primarily aimed at those who achieve the

best results in the *baccalauréat*. Even within the *classes préparatoires* there is a hierarchy of prestige: the most highly reputed institutions are the *lycées* Louis-le-Grand, Carnot, Pasteur, Saint Geneviève, Hoche, and Masséna. More than 15 per cent of *bacheliers* and two-thirds of those who are awarded the *baccalauréat* C (the most highly prized in the 1980s) attend the *classes préparatoires*, which can be classified according to the type of *grandes écoles* they are preparing students for: *préparation mathémathiques supérieures ou spéciales* for the *écoles d'ingénieurs* and *écoles normales supérieures; préparation lettres supérieures* for the *écoles normales supérieures; préparation vétérinaires* for the *écoles vétérinaires;* and *préparation agronomie* for the *écoles d'agronomie*. About 83 per cent of students in the *classes préparatoires* are studying science subjects and 15 per cent the arts and humanities (*Note d'information*, 88-42), which gives some indication of the importance of the non-university sector in the sciences. An alternative route is to take a DEUG or a *licence* and then seek entry into the second year of a *grande école*, which implies that the level achieved at the end of the programme is above that for the university *licence*. For the *instituts d'études politiques*, which have an intermediate status between universities and *grandes écoles*, direct access into a preparatory year can be after taking the *baccalauréat* or following the award of a DEUG or a *licence*. A few of the *grandes écoles* recruit directly after the *baccalauréat* and integrate the equivalent of the two preliminary years into their programmes which therefore last five instead of three years.

Recruits who are creamed off for the *grandes écoles* encounter conditions which are very different from those in the overfilled universities: students are relatively few in number and the drop-out rate is low; they are taught by practitioners in the relevant field, and small group work and case studies are standard teaching methods, especially in the *écoles de commerce*; training is professionally oriented; places in a number of the *grandes écoles* are fully funded and, in some cases, students are paid a salary, as for example, in the École des Impôts, the École Nationale de la Magistrature and the École Nationale d'Administration; relevant and high status employment is guaranteed on completion of courses for those who have not already secured jobs and for whom this form of education serves as a traineeship. Whereas almost a million students enrol in universities in France, fewer than 100,000 attend the *grandes écoles*. A single university may have as many as 30,000 enrolments, while the *grandes écoles* will frequently hold their maximum at 1,000. Because programmes are very tightly structured and vocationally focused and goals are clearly defined, once students have overcome the initial hurdle, they are more likely to complete their course than in the universities. Their main concern, in some of the top *grandes écoles*, such as the ENA, will be the classification in the final examinations which will determine the career options open to them but, in most cases, the exit point is less important than the fact of gaining initial access and qualifying by passing the final examinations.

The IUT also operate a system of restricted entry and, within the

traditional university sector, they provide conditions which are more conducive to study, success in obtaining a qualification and in finding employment, albeit at a different level from the *grandes écoles*. The IUT, like the polytechnics in Britain, are a fairly recent innovation, dating from 1966, with the object of providing a more practical and vocational form of higher education than the traditional universities. They were designed to answer the needs of the economy in a way not dissimilar to the polytechnics, where science and engineering students still account for the largest single subject grouping and more than a third of all students following degree programmes. Throughout the 1970s an IUT qualification tended to be considered as second rate to that awarded by a traditional university but, by the mid-1980s, these institutions had established a reputation for producing results which were appreciated by employers. Their products had become sought after by industry, and the conditions they provided for study were superior by far to those in the universities.

Entrance to an IUT is based on school leaving examination results, references and sometimes an interview or test, with one place for every five applicants. The number of students on any course is very small compared with the universities. About 63,000 students are accepted each year for the two year courses. Many candidates have already been awarded the DEUG or are attending a *classe préparatoire* and are applying as a stand-by in case they do not obtain a place at one of the *grandes écoles*. The failure rate in the IUT is lower than for the first year of the DEUG, with less than one in three. Those who complete the course and are awarded the DUT know they should have little difficulty in finding suitable employment. The most sought-after programmes today are increasingly in electronics, management and information technology rather than mechanical and civil engineering, which the IUT were originally set up to provide. By 1987-88 43 per cent of enrolments were in the non-industrial sector (*Note d'information*, 88-25).

The fact that the IUT are tending to attract more students in information technology, rather than the core engineering subjects, could result in their products becoming less distinctive on the labour market. This concern may have prompted proposals which were being considered in 1988-89 to extend the period of study by introducing more work experience. The longer course is intended to result in a higher level of qualification, which would further strengthen the position of the IUT as competitors with the standard non-technological university programmes.

The 'unfair' competition provided by the *grandes écoles*, in combination with economic and social pressures, has also provoked a response from the universities: alternatives have been created to the traditional degrees, which served, until the 1970s, as the first stage in preparing students for the teaching profession, the middle grades of the civil service or research. Since 1984 new options have been introduced into the DEUG, and courses have become multidisciplinary and more

vocationally oriented. The *diplôme d'études universitaires scientifiques et techniques*, the science alternative within the DEUG, is intended to lead directly into professional openings. New masters degrees, such as the *maîtrise de sciences et techniques*, or *magisters*, have been introduced in some universities. The *magisters*, which were set up in 1985, are interdisciplinary programmes, lasting for a further three years, recruiting students selectively after they have completed the DEUG. A small number of technological university centres have been created to offer undergraduates specialized professional training in what is again a selective system. Compiègne, in particular, has gained a strong reputation for its courses. Another alternative is to follow more than one programme of study at the same time in order to enhance theoretical and conceptual knowledge by practical training and skills, for example by complementing a languages degree with a qualification in management or marketing.

Whereas the universities in France have been described as a siding or car park, the *grandes écoles* are considered to be the cradle of the nation's elite, and the IUT could be assimilated to the nursery slopes where technical proficiency can be acquired before embarking on the steeper runs. Even though they do not offer designated degree courses, in comparing the British and the French higher education systems, it would be misleading to omit these more selective and prestigious alternatives to the standard university path in France, particularly since the conditions they offer more closely resemble those in some institutions within the British higher education system than in the French universities. In that these alternative types of higher education attract different categories of student and lead to distinct career openings, they are not without relevance to the discussion of the position of women in higher education in the two countries.

The cost of higher education

Difficulties in carrying out cross-national comparisons of the number of students in higher education and the proportions of a given generation successfully completing different post-secondary level courses are compounded when an attempt is made to compare the cost to the nation and the individual of pursuing higher education to this level. Figures which present the contribution from government can give a misleading impression, since public spending on education may be supplemented from other sources, such as company sponsorship, chambers of commerce and households. In the past polytechnics and colleges in Britain received most of their funding from local government, and local authorities were the main providers of student support grants, whereas in France local government is not involved in the funding or management of higher education. The fact that the non-university sector of higher education in France is heavily subsidized by commerce and industry as well as by ministries, other than the Ministère de l'Éducation Nationale, which may

pay salaries to 'students' in the *grandes écoles*, must also be taken into account in any calculation of the cost of educating an individual.

The budgetary heads concerned vary from one country to another. Since the universities in the UK are the main purveyors of research, the cost of employing academics is very different from that in France, where the Centre National de la Recherche Scientifique pays about 17,000 research workers and 9,000 technical and administrative staff in 1,300 designated units (Le CNRS a 50 ans, 1989:3).

Although the exercise is fraught with difficulties, estimates of the relative cost of higher education both to the nation and the individual are not without relevance for an understanding of the perceptions that both parties have of the investment made in education and the need to ensure that it brings appropriate returns. The topic is of particular interest for this reason when examining the relationship between higher education and the labour market for women.

Despite the much larger number of students in higher education, France is generally placed near to the bottom of the scale amongst industrial nations for the amount the state invests in higher education in relation to GNP, whereas the UK with the Netherlands and the United States are said to devote a larger share of their GNP to higher education. When an international comparison was made in the mid-1980s by the Department of Education and Science for *per capita* expenditure and for the cost of enabling a student to obtain a qualification, the UK seemed to be spending more on higher education, as illustrated in Table 1.3.

TABLE 1.3 CURRENT PUBLIC EXPENDITURE ON HIGHER
 EDUCATION IN THE UK AND FRANCE, 1983

	UK		France	
	a	b	a	b
As % of GNP	1.1	0.8	0.7	0.6
Per capita at 1983 prices in £	57.00	44.00	42.00	38.00
Per qualifier at 1983 prices in £000	14.0	10.7	8.4	7.7
Student support at 1983 prices in £	940.00*		170.00	

a — all expenditure
b — excluding student support and welfare
* Excluding fees

Source: Extract from *Statistical Bulletin*, 4/87: Table 8.

The gap between Britain and France widened when student support and

welfare were considered. In this respect central government in the UK appeared to be spending almost three times as much as its closest rival, the Netherlands, amongst the countries listed above.

In the UK universities are funded primarily by grants from central government, who are advised by the University Funding Council (University Grants Committee previous to 1989). They make their own appointments and manage their own budgets independently of the UFC. In the late 1980s central government was providing 92 per cent of funds and local government eight per cent (Government Statistical Service, 1988: Table 7[6]). In France the state not only directly pays the salaries of academics in the universities but also appoints them. As in the UK, it makes grants towards current expenditure on equipment, supplies and estates, calculated according to the size of buildings, the number of students and the disciplines taught, and allowing little or no flexibility within a given budgetary head. In 1988 92 per cent of expenditure for a university student came from central government, one per cent from local government, under three per cent from firms and four per cent from households (Note d'information, 89-35). The proportion contributed by central government is lower for IUT and engineering students since companies make a larger contribution (seven per cent for IUT students and 10 per cent for university engineering courses). Local authorities do not subsidize fees nor do they supply maintenance awards. The cost borne by households is considered by the Ministère de l'Éducation Nationale to be made up primarily from enrolment fees with no reference to maintenance, which is covered for many students in Britain, at least in part, by local authorities.

Fee levels and costs vary from one country to another, from one type of institution to another and from subject to subject. In 1986-87 in the UK full time undergraduate tuition fees in universities, paid for all home students by their local education authority, were set at £536 a year. Under the system of funding introduced for the 1990-91 intake home student fee levels were due to rise to £1,675. In the polytechnics, which were administered and funded essentially by local authorities prior to 1989, tuition fees were set at a much lower rate: a notional £65. French universities also operate on a notional fee level which was no more than 450 francs in 1986-87. Even the standard university fees in the UK are a long way from representing the full cost of higher education. The 'full cost' fees, which are paid by overseas students in British universities, come nearer to giving an indication of the expense involved.

Within a single educational system the disparity in the cost of educating a student in different subjects may affect the choice of programmes made available. Full cost fee are much higher for medicine or the sciences than for the arts, humanities and social sciences, ranging from £8,450 for medicine and £5,066 for engineering and science to £3,480 for management, law, economics, arts and humanities subjects. The new guide prices for

university students issued in 1990 by the UFC as upper limits on the level of public funding for different subject groups in British universities identified clinical dentistry as the most costly (£9,400) and politics, law and other social science subjects as the least expensive (£2,200). Differential full time fees being introduced for home students from 1991-92 were designed to distinguish three band levels: classroom based (£1,675), laboratory/ workshop based (£2,500) and clinical (£4,500) courses.

In France the average annual cost of a university education for engineering students, the most expensive type of course, was estimated to be 49,310 francs in 1984, compared with 12,600 francs for law and economics, which were the least expensive (Mendès-France, 1987b:238; *Note d'information*, 87-31). In comparative terms the cost of educating a students in the different disciplines on an annual basis would seem to be highest for universities in the UK for medicine and lowest for law and economics in universities in France. Whereas engineering is also amongst the more expensive subjects in the UK, medicine is amongst the lower cost subjects in France (17,800 francs).

The cost varies in France from one institution to another: a course in a *grande école* is more than twice as expensive as the average for a university place (Mendès-France, 1987a:41). The annual cost in an IUT is also higher than the average for universities. Fees in the different *grandes écoles* vary according to the main source of funding. They range from as much as 162,000 francs for two years at the École Polytechnique and 28,000 francs a year in one of the *grandes écoles de commerce et de gestion* to as little as 500 francs annually for three years at the École Supérieure d'Optique (Le guide des études supérieures, 1989:299-319). At the École Nationale de la Magistrature and École Nationale des Ponts et Chaussées no tuition fees are charged. Many of the *grandes écoles* are heavily subsidized by ministries, such as those for the army, telecommunications, industry and agriculture. Of the *écoles d'ingénieurs* 129 are state funded, 40 are private and operate higher fee levels but remain nonetheless under the control of the Ministère de l'Éducation Nationale. The *écoles de commerce* collaborate closely with industry and commerce, depending on their sponsorship or funding for students and relying on their support through the *taxe d'apprentissage* (a pay roll tax of 0.5 per cent), which firms can choose to donate to the *écoles*. The *taxe d'apprentissage* could therefore be considered as an indirect state subsidy and part of public expenditure. Tuition fees, which most students pay for themselves, either with parental support or by contracting loans, account for about a third of the full cost. Since the *grandes écoles* rely on a different system of funding, buying in the majority of their teaching staff from industry and commerce, they do not incur the overheads which the universities have to bear from paying full time lecturers, but their spending on the physical environment may be high as this is a factor taken into account in attracting students and in securing sponsorship.

Since university qualifications are recognized and validated by the state

in France as being of equal value whatever the institution where they are obtained, in theory, students can — and usually do — attend the nearest university to their home. This is less likely to be the case for students in the *grandes écoles*, many of which are located in the Paris area. As only about 16 per cent of French students receive grants, they rely heavily on the support of their families and on being able to continue to live at home. In 1984-85 maintenance costs incurred by households for a student were estimated at 21,800 francs per annum (Mendès-France, 1987b:238-41). In the UK, by contrast, more than 90 per cent of university students live away from home as do almost 90 per cent of students in polytechnics and colleges. Just over 53 per cent of university students receive a maintenance award from their local education authority (Government Statistical Service, 1988: Table 4), calculated on the basis of parental income and at a recommended level of £1,900 for a full grant in 1986. When the parental contribution to maintenance is taken into account, the incidence of expenditure falls differently in the two countries: central government probably contributes nearer to two-thirds of the total in the UK, with local education authorities sharing the remainder in a similar proportion with households, whereas in France households are bearing as much as 50 per cent of the total average cost.

Whatever accounting system is used, the French figure for government spending on an individual student in higher education would appear to remain well below the level for the UK. Expenditure is also spread more thinly in France over a larger number of students. In comparing the cost of higher education in the two countries, the length of courses in France should not, however, be forgotten: when the time spent over studies and the need to cover maintenance are taken into account, the average cost of producing a French qualifier is much closer to the British level. Another distorting factor which makes British higher education look more expensive is the inclusion in the university budget of research as part of staff costs, whereas in France research is funded separately.

The burden on households for supporting their offspring through higher education would seem to be much heavier in France. Part of the cost may be offset by the tax relief which parents receive if their children are in higher education and by child allowances which continue to be paid while offspring are in full time education, unmarried and still living at home. The relatively high cost borne by households could, however, be a factor influencing the motivation to continue with higher education and, subsequently, to exploit any qualifications obtained.

Finally, an aspect of the finances of higher education which makes it difficult to evaluate the number of undergraduates in France and also their cost to the nation and to households is that some students are known to enrol in order to be able to take advantage of facilities and special discount rates, without necessarily working for and sitting examinations. Given that fees are much higher in universities in Britain than in France and that

students are more closely supervised, the phenomenon of the 'phantom' student is almost non-existent in the British university system. Exact figures for *bona fide* students in France cannot, therefore, be based on enrolments, and some universities are known to rely on a high proportion of students either not attending lectures or dropping out once their names are on the books and they have paid their fees, in order to be able to manage on inadequate resources. For a number of reasons, the average cost of higher education for French students who actually achieve a qualification may not be very different from that in Britain.

THE PLACE OF WOMEN IN HIGHER EDUCATION

Despite the problems of trying to compare two national systems of higher education, the claim can be made, with some justification, that the proportion of women amongst students entering higher education has been gradually increasing since the early 1970s in both Britain and France, albeit most probably at a different rate and to a differing extent. As intimated in the preceding discussion, direct comparison of the numbers of women in higher education is not, however, sufficient to provide an understanding of their relative position in the two systems. The types of courses and institutions where women are well represented or under-represented need to be examined to see whether they are making an impact on the more prestigious and more costly types of higher education which are generally likely to be those offering the best opportunities for well paid high status employment.

Access to higher education by women

If passing school leaving examinations is only the first hurdle for applicants to higher education, the number of women in the system might be expected to account for a smaller proportion of an age group in the UK, since fewer young people of both sexes are known to reach this level than in France. Although they are improving their relative position, in the UK women are still outshone by men in their achievement at school leaving age, when the number (two or more) of GCE 'A' levels or Scottish Certificate of Education Higher levels required for entry to most higher education course is considered. When the proportion of school leavers obtaining the relevant grades is examined over time, as illustrated by Table 1.4, in the past boys were found to perform consistently better than girls, but recently the gap has almost closed. If a smaller number of passes is compared, girls are in a better position in relation to boys.

The higher proportion of girls, compared with boys, obtaining the *baccalauréat* contrasts sharply with the situation for the two sexes in the UK for 'A' level passes. In France women have also improved their

position in relation to men over time (they outnumbered men by 1968), although the disparity between the sexes was not so great in the 1960s as in the UK. The pass rate for girls taking the *baccalauréat général* is nowadays higher than that for their male counterparts: 71 per cent compared with 69 per cent, and they account for 57 per cent of all successful candidates (*Note d'information*, 88-17). For the *baccalauréat technologique* their pass rate is almost identical to that of male candidates at 65 per cent, with nearly 55 per cent of successful candidates.

TABLE 1.4 SCHOOL LEAVING EXAMINATION PASSES IN THE UK
 AND FRANCE, 1965-87

	1965-66		1986-87	
	Boys	Girls	Boys	Girls
UK (as % of school leavers)				
2 + 'A' levels or 3 + 'H' grades	12.9	9.1	14.9	14.6
1 + 'A' levels or 1 + 'H' grades	3.2	3.1	3.6	4.2
France (as % of age group)				
Baccalauréat	13.0	12.0	28.5	38.5

Sources: Government Statistical Service, 1988: Table 31[29]; *Note d'information*, 88-17; Oeuvrard, 1984:477.

The seemingly lower level of achievement for men in the school leaving examination in France may reflect the nature of the examination process: in the French system pupils are assessed over a wide range of subjects, and success probably depends to a great extent on their maturity, the ability to work hard and absorb, process and present large amounts of information, requiring well developed verbal skills. The British system, by contrast, allows for specialization and concentration of effort, in theory on subjects which are of particular interest and which reflect individual character and personal skills. The French system may therefore favour qualities which are generally seen as more stereotypically feminine and the British system those which are more often considered to be characteristic of men.

Girls would also appear to have lower aspirations in the UK. Although 33 per cent of girls were planning to go into further or higher education compared with 25 per cent of boys, according to the School Leavers' Survey in England for 1986-87, seven per cent of girls and eight per cent of boys intended to go on to study for a degree or enter teacher training. Boys are, in fact, more likely to be taking up places in the universities and polytechnics, while girls are going into other types of further education. As

indicated by Table 1.5, since 1965-66, the proportion of full time and sandwich home undergraduates in universities who are women has increased substantially in the UK. The rate of increase has also been greater than for men. Amongst part time students, the proportion of women is much larger, and this is the form of higher education which has undergone the fastest growth. Although data for the breakdown by sex for polytechnic students in the mid-1960s are not strictly comparable with recent figures, women appear to have made important gains in this sector and had almost reached parity with men by the late 1980s.

TABLE 1.5 WOMEN IN HIGHER EDUCATION IN THE UK AND FRANCE (AS A PERCENTAGE OF ALL STUDENTS/QUALIFIERS), 1968-87

	1968-69	1986-87
UK		
University students	27.6	41.4
Undergraduates (full time)	29.5	42.7
Undergraduates (part time)	43.1	55.6
University graduates (first degree)	29.8	42.1
Polytechnic students*	8.8	48.3
Polytechnic graduates	-	46.0
France		
University students	43.9	52.7
University graduates (licence)	53.7	59.8
University graduates (maîtrise)	46.8	56.3
IUT students	19.4	37.2
IUT qualifiers	-	39.7
Classes préparatoires students	23.6	33.5

* CNAA first degree home students in 1968-69

Sources: CNAA, 1988, Table 17; Department of Education and Science, 1970b: Table 33[33], 1971: Tables 29[28], 32[31]; Government Statistical Service, 1988: Tables 27[25], 36[34]; *Notes d'information*, 88-25, 88-45; Ministère de l'Éducation Nationale, de la Jeunesse et des Sports, 1988: Table 10.7; *Statistical Bulletin*, 4/89: Table 2; *Statistiques des enseignements*, 1968-69a:7, 26, 1968-69b:6, 1969-70:13, 19, 27-8.

Predictions that women may compensate for the fall forecast in the number of 18 year olds available to enter higher education would seem to be borne out by figures for university applications in 1988 which had grown

due to the increase in the number of mature students and female applicants, the latter accounting for 46 per cent of the total, for home candidates (UCCA, 1989: Table 3). Notwithstanding these trends, the Education Secretary, Kenneth Baker, was predicting in 1989 that it would be 25 years before women students would be in a majority for degree awards.

In France the proportion of women entering higher education has been greater than that for men since 1982 (Oeuvrard, 1984:481): over 55 per cent of university entrants were women by the late 1980s, almost the reverse of the situation at the beginning of the 1970s. Whereas in the UK women have made more of an impact on the polytechnics than the universities, in the IUT they account for a smaller proportion of the total student body. The British polytechnics offer, however, a much wider range of subjects including the arts, humanities and social sciences. Despite a marked improvement in their representation, women still make up a smaller proportion of the total number of students in the *classes préparatoires*.

When male and female students in the 19-24 age group are compared in the two countries, in the UK men students account for a larger proportion of their age group at this level than do women: 10 per cent and eight per cent respectively (Government Statistical Service, 1988: Table 22[20]). In France 17 per cent of women and 15 per cent of men in the same age group are found to be in higher education (*Notes d'information*, 89-05). The proportion of women in both countries decreases as the level of higher education rises. In the UK it falls to 29 per cent at postgraduate level (Government Statistical Service, 1988: Table 36[34]). In France, where women are in the majority at the level of the DEUG and *licence*, and up to the age of 24 (*Note d'information*, 89-05), at higher degree level only 39 per cent of students are women (Poulet, 1987:555).

Selection of subjects and patterns of study

Although women have been improving their overall position in school leaving examination passes and access to higher education, clear differences remain in the types of courses followed. The pattern of study in higher education would seem to be determined to a great extent — and probably more so in Britain than in France — by the choices made in secondary school. The divide between the arts and the sciences in higher education can most probably be explained largely in terms of gender bias created during secondary schooling.

At school more girls than boys opt for the arts/humanities, commercial, paramedical and creative options. Figures for 1986-87 for GCE Ordinary levels in Britain showed that, already by that stage of schooling, a larger proportion of girls than boys had scored passes in arts and humanities subjects (English, history, music, drama, visual arts), vocational studies (business and domestic science) and in biology (Government Statistical Service, 1988: Table 33[31]). In mathematics and other science subjects the

percentage of passes for girls was consistently lower than that for boys, especially in physics (31 per cent of all passes) and technical subjects (22 per cent of all passes). At GCE 'A' level and SCE 'H' level, a similar pattern emerged, but the disparities were reinforced, as illustrated in Table 1.6.

TABLE 1.6 GIRLS AS A PROPORTION OF SUCCESSFUL CANDIDATES FOR 'A'/'H' LEVELS IN THE UK AND FOR THE BACCALAURÉAT IN FRANCE BY SUBJECT, 1970-87

	1970-71	1986-87
Britain		
Mathematics/science	24.5	27.0
Mathematics/mixed	-	42.6
Total mathematics	20.8	35.2
English/arts/social studies	51.7	67.1
English/mixed	-	59.0
Total English	64.9	63.9
Science	26.7	29.5
Arts/social studies	48.1	60.2
Mixed science and arts or social studies	-	48.0
France		
A - arts, humanities	70.9	82.1
B - economics and social sciences	54.7	60.7
C - mathematics and physical sciences	30.4	34.3
D - mathematics and natural sciences	52.5	52.4
D' - agronomy and technical sciences	24.5	27.4
E - science and technology	4.9	5.3
F1-7, F9, F10 applied sciences	9.1	9.0
F8 - paramedical sciences	-	98.3
F11, F12 - performing and creative arts	-	63.0
G - commerce and administration	71.6	69.0
H - computing science	29.8	32.6

Note: For all passes in the UK in 1970-71 and two or more passes in 1986-87.

Sources: Department of Education and Science, 1973: Table 35[32]; Government Statistical Service, 1988: Table 34[32]; *Note d'information*, 88-17; *Statistiques des enseignements*, 1973:9, 25-8.

By the late 1980s almost twice the proportion of girls were scoring passes in English, arts and social studies, compared with boys, and more than twice

the proportion of boys, compared with girls, were achieving passes in mathematics/science. Arts and social studies remained the prerogative of girls and the physical sciences that of boys. Although the figures are not strictly comparable for the two dates, the bias already established at the beginning of the 1970s towards English, arts and social studies would seem to have been reinforced, and the gains made in mathematics and science subjects appear to have been relatively limited.

In France, boys still outnumber girls in mathematical, scientific and technological options represented by the *baccalauréat* categories C, D' and E, F1-7, F9, F10 and H. As girls have become the majority of successful candidates at the *baccalauréat*, another form of intellectual segregation has developed whereby subject combinations which emphasize mathematics have become the passport to the most prestigious forms of higher education. In particular, the *baccalauréat* C, which has high coefficients for mathematics and physics, has been recognized as the most sought after. Girls continue to account for a lower proportion of the passes in this area than for subject combinations with a stronger literary emphasis. Over time girls have further strengthened their already dominant position in the arts and humanities, economics and social sciences, but the situation has scarcely changed in the mathematical and scientific options.

From the figures in Table 1.6, the *baccalauréat* would appear to produce a greater polarization of subject choices: for example, A and F8 are almost exclusively female, and E and the applied science categories of F are almost exclusively male. In practice, however, the *baccalauréat* may not be so exclusionary as 'A' levels: since a literary *baccalauréat* also requires the study of mathematics, it does not automatically prevent a candidate from being accepted for a course in medicine. The study of French, mathematics, philosophy and a foreign language is common to the A-E categories of the *baccalauréat*, and these subjects, except philosophy, are present in each of the other categories. All but the categories A, B, G and some of F include sciences or technology. Although women may prefer the less scientific combinations, they are nonetheless more likely to be exposed to the sciences for at least part of their secondary education, whereas the British system makes it easier to avoid whole blocks of subjects, as demonstrated by choices for GCE examinations.

Through the category of the *baccalauréat* which they choose, female students are, nevertheless, already determining their options in higher education. Whereas almost all qualifiers with the *baccalauréat* C will enter higher education whether they are male or female, within the G category, which is predominantly female, only 50 per cent of qualifiers will continue their education after secondary schooling (Charlot, 1988a:3). Of those who pass the *baccalauréat* A about 70 per cent go to university but, whereas most men read law, women enrol for arts and social sciences. From amongst those who pass the *baccalauréat* D, the women who go into higher education tend to opt for social sciences or paramedical studies. Those who

obtain passes in the F and G categories are less likely than A to E to undertake higher education or to pursue one of the more prestigious career paths. The E category, which is almost exclusively male, generally leads to engineering and science courses. From amongst those who take the *baccalauréat* C are recruited most of the entrants to the *classes préparatoires*. Female students who pursue this possibility tend to opt for the more literary branches (*Note d'information*, 87-44).

When the student populations in the two countries are compared, as in Table 1.7, similarities can be found between them in the choices of degree subjects studied. In both countries women in higher education tend to be concentrated in certain types of courses. Whatever measure is used, women are dominant in the arts, languages, social studies and pharmacy, and under-represented in the sciences, particularly the physical sciences and engineering. The time series data show how women have consolidated their position in the arts and humanities and made substantial progress in business studies, economics and law, which were identified earlier in this chapter as the two least expensive university subjects. In the more 'scientific' disciplines their situation has improved more slowly, particularly in some of the more costly engineering subjects, but in the medical sciences they have made significant gains.

Differences emerge between the two countries in the extent to which women are dominant in certain disciplines and have made inroads into traditional male reserves. As at school leaving certificate level, in the arts and humanities, where women are already well represented, their presence is more marked in France than in Britain, and they have reached a stronger position in university economics and law. French women also appear to have achieved a higher level of success in the male strongholds of the sciences and engineering/technology. Whereas the rate of progression has been similar in medicine, British women have gained a larger share of qualifications in dentistry, despite the fact that they started from a lower base in the late 1960s.

Even in the disciplines where women are over-represented in higher education in general, they are less well represented in the more prestigious institutions: they accounted for 39 per cent of all graduates from Oxford and Cambridge in 1986, for 48 per cent in languages and the humanities and 44 per cent in the social sciences (Central Services Unit, 1987: Tables 1c, 1d). In France women have been slowly improving their position in the most prestigious sector of higher education. By 1987 the proportion of women in the science based *classes préparatoires* had reached 27 per cent, compared with 22 per cent at the beginning of the decade; in the literary options the situation was stable with 68 per cent (*Note d'information*, 87-44). The shift was being reflected within the *grandes écoles* by the end of the 1980s. In many cases women started from a zero position. Whereas they were admitted to the École Supérieure de Physique et de Chimie Industrielles de Paris in 1917, and the first woman graduated from the École des Mines de

Saint-Etienne in 1919, some of the *grandes écoles* have only recently opened their doors to women: Ponts et Chaussées in 1959, the École des Mines de Paris in 1969, and the École Polytechnique in 1972. The prestigious Écoles Normales Supérieures d'Ulm (for men) and de Sèvres (for women) did not become coeducational until 1985.

TABLE 1.7 WOMEN AS A PROPORTION OF ALL STUDENTS AND GRADUATES BY SUBJECT IN THE UK AND FRANCE, 1968-87

	1968-69	1986-87
UK		
ALL UNDERGRADUATES		
Languages	56.7	67.9
Administration, business, social studies	33.1	47.3
Economics	13.9	24.1
Law	17.0	42.7
Medicine, dentistry, health studies	26.3	53.1
Science	25.2	36.2
Engineering and technology	1.5	11.8
UNIVERSITY GRADUATES		
Arts/humanities	49.6	50.9
Languages	54.0	70.2
Business	31.5	38.9
Economics	13.9	30.5
Law	16.5	45.2
Pharmacy	47.2	63.5
Medicine	23.6	44.5
Dentistry	18.0	45.0
Science (physical)	25.8	25.0
Engineering and technology	1.6	9.2
POLYTECHNIC GRADUATES		
Languages, literature, area studies	-	75.3
Humanities	-	40.7
Social studies	-	53.1
Commerce and management	-	45.6
Law	-	48.5
Subjects allied to medicine	-	75.1
Biological sciences	-	53.7
Mathematical sciences	-	24.8
Engineering	-	3.7
Technology	-	23.5

	1968-69	1986-87
France		
UNIVERSITY STUDENTS		
Arts and humanities	64.6	69.8
Economics	23.9	46.5
Law	36.8	54.8
Pharmacy	57.8	63.1
Medicine	29.2	45.3
Dentistry	21.4	40.2
Science	32.6	33.5
Engineering and technology (IUT)	19.4	37.6
Industrial sector (IUT)	-	19.8
Service sector (IUT)	-	60.5
UNIVERSITY GRADUATES		
Arts and humanities	67.0	72.5
Economics	19.6	47.2
Law (and political science in 1986)	27.3	58.2
Pharmacy (doctorate in 1987)	61.4	64.5
Medicine (doctorate in 1987)	24.3	40.1
Dentistry (doctorate in 1987)	22.2	37.3
Science (excluding biology)	44.0	39.9
Industrial sector (IUT)	-	22.9
Service sector (IUT)	-	60.7
GRANDES ÉCOLES STUDENTS		
Écoles normales supérieures	-	36.7
École des Hautes Études en Sciences Sociales	-	46.9
Écoles de commerce	-	42.4
Écoles Supérieures de Commerce et		
d'Administration des Entreprises	-	48.7
Law and administration	-	40.1
École Nationale d'Administration	-	21.0
Écoles de la magistrature	-	54.2
Écoles d'ingénieurs	5.3	19.0

Sources: CNAA, 1988: Table 17; Department of Education and Science, 1970b: Table 26[26], 1971: Table 29[28]; *Notes d'information*, 88-25, 88-45; Ministère de l'Éducation Nationale, de la Jeunesse et des Sports, 1988: Table 10.7; *Statistiques des enseignements*, 1968-69c, 5-12; *Tableaux statistiques*, 1987a:15, 1987b:33, 1988:8; *Universities' Statistical Record*, 1987: Table 6.

Although they are far from achieving parity in numbers in the most prestigious *grandes écoles*, women have begun to make their mark in these male strongholds, as illustrated in Table 1.7. Some women have achieved spectacular successes: for example Annie Chopinet was placed first in the final classification at the École Polytechnique in 1972 when women were first admitted. With the exception of the business schools, where they have almost reached parity with their male counterparts, in general women remain in the minority and are more likely to gain access to the non-scientific *grandes écoles*.

Although comparisons between UK university graduates and French students from the *grandes écoles* show that women are poorly represented in the sciences, engineering and technology, they do seem to have made more of an impact in these disciplines than in the universities and polytechnics in the UK. In international studies France has been found to be the European country which has seen the largest increase in the proportion of women in engineering (Marry, 1989:293). Between 1964-85 the number of women qualifying in the *écoles d'ingénieurs* increased sevenfold whereas that for men barely doubled (Marry, 1989:299), even though the proportion of women amongst students in the most prestigious engineering institutions remains very small. While the proportion of women studying in the IUT has doubled since the 1960s, as shown in Table 1.7, they are, nonetheless, more likely to be studying for qualifications in the service sector. In the industrial sector, they account for only about seven per cent of qualifiers in the engineering subjects (*Note d'information*, 88-25). In Britain, the 'Girls into Science and Technology' (GIST) and 'Women Into Science and Engineering' (WISE) campaigns, which were designed to promote the study of relevant subjects in schools and in higher education, have not prevented the country from being at the bottom of the league for women studying engineering in higher education. WISE, which was launched in 1984, specifically sought to motivate women to opt for courses in the sciences by showing how a qualification in these areas can lead to a rewarding career.

Several possible reasons can be put forward to explain why women are not being attracted into the physical sciences and engineering in greater number and why the French seem to be more successful in this respect. One is the negative image associated with engineering, particularly in Britain, which discourages men as well as women from entering the discipline. The difference between the two countries may be explained by the fact that the lesser degree of specialization in the school curriculum in France does not foreclose certain options in the same way as 'A' levels limit later choices, which could have an impact on the number of women in the sciences in general. In that British education has long depended upon a selective and segregated system in the production of its intellectual elites, which has not been completely eroded by coeducation, as reflected in 'A'

level passes, by the time women reach higher education it may already be too late to ensure greater equality of access to all disciplines or institutions.

Implications of different patterns of higher education

Measured in terms of pass rates, women in France would seem to be more successful than their British counterparts when they are in direct competition with men. They are also more likely to complete a course within the minimum time limit. However, the overall length of courses and the need to search out ever more qualifications, more prestigious and more costly options could militate against women, who may be less able to rely on long term parental support.

It has been suggested that women may be gaining an advantage in France in a selective educational system which depends upon a willingness to observe social rules, to pay attention to others and to make economic use of space, in contrast to the male model which relies on competitiveness, aggression, self-assertiveness and a generous use of space (Establet, 1988:88). In that women are found to be more precocious in their studies, they may have the edge in competitive situations. They are also said to have the advantage that they are more likely than their male counterparts to be able to concentrate better on their work, to plan and carry out tasks. The logical outcome of this situation is that the traditional reproduction of gendered mechanisms is likely to be disturbed (Establet, 1988:91). From the evidence produced here, this process of disturbance would seem to have already been taken further in France than in Britain, but its impact is still limited.

The introduction in French universities of shorter more specialized and professionally oriented qualifications does seem to have been to the advantage of women who have established a stronger position in science subjects in the university sector, but the obstacles restricting their access to the more prestigious non-university programmes remain considerable. The apparent reluctance of women to enter some fields may be due more to their perception of a particular discipline than to their ability to pursue a course and obtain the necessary qualifications. Anecdotal evidence suggests that men have tried to hinder access by women in certain institutions in order to prevent them from taking over numerically, as for example in the École Nationale de la Magistrature, where women nonetheless already account for over 50 per cent of students (Maumusson, 1988:64).

In both countries close analysis of the relationship between the type of qualification obtained from secondary school and the pattern of study in higher education suggests that the choice of subjects at school is an important factor in success at a later stage. In France, despite the broader subject spread, the category of *baccalauréat* selected will determine subsequent opportunities (Pigelet, 1989a:4). The creation of technical and administrative streams for the *baccalauréat* in 1969 undoubtedly led to new openings for women, but the hierarchy of prestige has remained and may

even have been reinforced by ensuring that access to the most highly reputed and most advantageous options in career terms is primarily via the route which women are less likely to pursue, the *baccalauréat* C.

When women begin to make inroads into areas which were in the past the prerogative of men, the goal posts seem to be shifted so that it becomes more difficult for them to reach the highest qualifications. The exclusiveness of the *baccalauréat* C is only one example in the French context. Others would be the way in which a traditional university education has lost its value as an occupational training or the development of the most prestigious or expensive *classes préparatoires* as the main or exclusive route into the top *grandes écoles*. The extension of the length of studies in dentistry or the *numerus clausus* in pharmacy are placing women in ever more competitive situations.

In conclusion, a number of differences can be identified between the two countries as far as the place of women in the educational system is concerned. Measured in terms of the number of passes in school leaving examinations, girls are more successful than boys in secondary education in France, whereas the reverse is true in the UK. A larger proportion of young people enter higher education in France than in the UK, although the overall success rate in achieving some form of qualification is not dissimilar in the two countries. More women than men continue their education after leaving school in France, and again the reverse situation applies in the UK. If the argument that more continuous careers are related to more higher education is valid (Battagliola and Jaspard, 1987:53), then these comparisons would suggest that French women should have the advantage in this respect, since they would seem to be present in greater numbers in both absolute and relative terms. Although they have not reached parity with men in all fields, women in France would seem to have made more progress in some of the traditionally male areas within science, engineering and technology, thereby making it possible for them to gain access to a wider range of previously male dominated occupations. As in Britain, however, they continue to be less well represented in some of the more prestigious and often most costly areas of higher education.

2 The Labour Market for Well Qualified Women

Organizational differences in institutional structures in Britain and France are found to affect access to higher education for women, their progress through the system and perceptions of the value of the qualifications obtained. Career openings and development might also be expected to be influenced by the same factors and therefore to display different patterns in the two countries.

Since the 1960s the relationship between particular programmes of study and the needs of the labour market has become an increasingly important criterion in assessing course design and in the validation of qualifications. Following a period of rapid expansion, the 1980s were characterized in Britain by reductions in funding and demands that higher education should be more accountable to the tax payer, as stated in the government White Paper, *Higher Education: Meeting the Challenge* (Secretary of State for Education and Science, 1987). In France financial and political pressures have been exerted in order to ensure that higher education contributes more directly to the economy.

Despite continued criticism (for example Taylor, 1984) and counterargument (Tarsh, 1988), every year British universities are rated according to first destination statistics which are taken as a performance indicator of their 'success' in producing employable graduates. In France employability, measured by employment rates for qualifiers and by income, has become an increasingly important consideration in recruitment to higher education institutions, as demonstrated, for example, by the publicity given to the careers of *alumni* in prospectuses for business schools and in ratings of performance. Students expect to be able to assess the attractiveness of a qualification in terms of the extent to which the training they receive matches the requirements of a particular job.

Although the general trend in both Britain and France is towards greater accountability of education, important differences remain in the extent to which the higher education sector is attributed and assumes the role of preparing young people for professional occupations. This is a complicating factor when comparisons are being made of entry into the labour market, as illustrated by the problems involved in achieving mutual recognition of the equivalence of professional qualifications in

anticipation of the free movement of labour within the EC member states. In 1988 the protracted negotiations resulted in a compromise: an agreement was reached over a minimum level, with the reservation that the appropriate professional qualifications will not necessarily have to be accepted as sufficient justification for establishing a practice in another country. Safeguards were introduced to protect nationals from competition on the part of inadequately qualified foreigners, and the civil service was made exempt from the freedom of movement clause. A further indication of the problems involved in matching qualifications to employment is the fact that in medicine, pharmacy, law or chartered accountancy, to take only a few examples, the three years of study in higher education, following the school leaving certificate, stipulated for the recognition of equivalence do not in any case represent the time needed to acquire a professional qualification or to become operational professionally in any of the countries concerned.

A parallel can be drawn between the international situation regarding mobility and the labour market opportunities for well educated women in relation to men: in theory, men and women have the same access to qualifications and employment but, in practice, barriers would seem to have been erected which serve to protect male dominated occupational statuses. In analysing the areas of higher education in the two countries where women are well represented or in a minority and in following their progress through the educational system, it was clear from the data examined in the previous chapter that they had not achieved parity with men on the types of courses and in disciplines or institutions which would be most likely, subsequently, to lead to openings in many of the more prestigious employment careers. Although, for example, women in France appeared to be making a greater impact in university sciences and engineering than in Britain, they were still markedly under-represented in these disciplines in the *grande école* sector, where employment is almost guaranteed for those who complete a course.

The relationship between higher education and employability is of particular interest with respect to women. If accountability is to be measured in terms of the likelihood of finding suitably paid employment at the appropriate level within six months of completing higher education, any inequalities resulting from gender bias should be a reason for concern amongst governments. Similarly, any differences in career development which can be attributed to gender should also provide an incentive for action, since they can lead to a possible loss on investment. Scrutiny of the results of follow-up surveys of students who have successfully completed higher education courses and comparison of material illustrating the relative position of well qualified women in the labour market provide insights into the way in which women in Britain and France make use of the investment in their higher education. They also add another less frequently discussed dimension to the debate on accountability.

HIGHER EDUCATION AND THE LABOUR MARKET FOR WOMEN

Although academic interest in women's studies over the past two decades has resulted in an abundant literature on all aspects of women's working lives and has led to a number of comparative projects, few cross-national comparisons have been made of the opportunities open to women who have undergone higher education and of the process whereby they enter the labour market. The five nation FORM project comparing higher education in Eastern and Western Europe, *FORMation des étudiants et leur conception de la vie*, carried out under the auspices of the European Coordination Centre for Research and Documentation in Social Sciences (Niessen and Peschar, 1982) did not include Britain and France and was not concerned with gender differences.

The results of the first follow-up study made exclusively of the employment patterns of British graduate women were published almost a quarter of a century ago (Arregger, 1966) and afford a useful benchmark against which to measure more recent developments. Since the 1960s, however, even in single nation studies, women have not figured prominently in most of the research conducted into the match between graduate skills and the needs of the labour market.

In both Britain and France, the entry of graduates into the labour market is recorded and analysed. Every year the Universities' Statistical Record collects first destination statistics in the UK for the numbers of graduates who are in employment six months after completing their degrees. Data are available by gender and subject groupings for different employer categories. The employment of polytechnic and college graduates is also recorded annually by the Department of Education and Science. In addition, the Higher Education and the Labour Market Panel Study (Brennan and McGeevor, 1988) has provided information about the career paths followed by polytechnic and college graduates several years after completing their courses and, in this case, special analysis has been undertaken of women (Chapman, 1986; 1989). Other national and smaller scale studies have charted the progress of graduates from universities, polytechnics and colleges (Boys and Kirkland, 1987), sometimes with the focus on specific subject areas (for example, Radcliffe and Warner, 1986, for philosophy; Thurman and Wildon, 1985, for biology), but data on gender are not given prominence in this research.

In France, where universities do not have a network of careers advisory services such as that which has developed in the UK or in the *école* sector, the Universities' Statistical Record has no equivalent, and employment data on qualifiers from public sector institutions are not systematically collected annually. The Centre d'Études et de Recherches sur les Qualifications has conducted follow-up studies of higher education qualifiers (reported in the review *Formation-emploi*), and the Institut National de la Statistique et des Études Économiques regularly surveys the level of training and qualifications of the whole population (*Enquête sur la*

formation et la qualification professionnelle). Neither of these organizations has focused specifically on women, but gender is included as a variable in the surveys, and relevant data can therefore be extrapolated.

Higher education as a preparation for a career

In the UK it is widely accepted that many courses are not intended as a preparation for a particular profession. The Graduate Model (Brennan and McGeevor, 1988) gives a schematic approximation of the relationship between undergraduate courses and their relevance to the labour market. The model, which derives from an analysis of the employment of British polytechnic graduates, is depicted in an adapted version in Figure 2.1 to take account of postgraduate qualifications and British university courses which are not available in polytechnics (medicine, philosophy and classics, for example). It has been extended to cover French higher education.

FIGURE 2.1 THE PROFESSIONAL VALUE OF HIGHER EDUCATION
COURSES IN THE UK AND FRANCE

Professional value	Courses providing relevant training	
	UK	France
Generalist Possesses general work related skills and knowledge	*First/higher degree* Arts/humanities Geography History Classics Philosophy Communication and social studies Interfaculty studies	*DEUG/licence/* *maîtrise/doctorat* Arts/humanities Social sciences Philosophy History Geography
Generalist Plus Possesses general and specialist work related skills and knowledge	*First/higher degree* Modern languages Economics Politics Mathematics Science Applied chemistry Applied biology Computer science Environmental science Fine art Theology	*DEUG/licence/* *maîtrise/DEA/* *doctorat* Human and natural sciences Computing Economics Politics Applied languages Applied mathematics Administration Theology

Professional value	Courses providing relevant training	
	UK	France
Occupational Generalist Possesses general and specialist work related skills and knowledge and an identifiable area of application	*First/higher degree/ diploma* Business studies Environmental planning Transport Hotel catering Textile and fashion design 3D design Performing arts	*DEUG/licence/ DESS* Psychology Business studies Performing arts Instituts d'études politiques Law
Occupational Specialist Possesses general and specialist work related skills and knowledge and a specific occupational role	*First/higher degree/ professional qualification* Librarianship Accountancy Law Psychology Urban estate management Civil, electrical, production engineering Medicine Dentistry Pharmacy Veterinary science Nursing Graphics design PGCE (teaching)	*DUT/DEA/ DESS/maîtrise/ doctorate/école* sector Applied sciences Écoles de commerce Écoles d'ingénieurs Medicine Dentistry Pharmacy Veterinary science CAPES/agrégation (teaching) Physical activities and sports Other écoles (arts/graphics/ administration)

PGCE—postgraduate certificate in education
DUT—diplôme universitaire de technologie
DEA—diplôme d'études approfondies
DESS—diplôme d'études supérieures spécialisées
CAPES—certificat d'aptitude au professorat de l'enseignement secondaire

Source: Adapted from Brennan and McGeevor, 1988:49.

According to the model, students who fall into the categories for occupational generalists and specialists can be said to have a higher education qualification which should lead on to an identifiable occupation, whereas those in the first two categories are likely to find that their qualification is not recognized as a prerequisite for a specific occupation. Even the occupational generalists and specialists may be only partly exempted by their degree from professional examinations: a degree in accountancy, for example, will only give exemption from the conversion course which has to be taken by 'non-relevant' graduates before proceeding with the standard two years of professional training.

The model reflects the fact that the market for higher education qualifiers is not uniform. In addition, important national differences can be found in the expectations which employers have of the educational system. For some employers in Britain the degree serves as a screening device, guaranteeing that graduates from the system have good academic ability, as well as a high level of attainment in a number of general skills, and that they will be able to adapt and respond to changing needs; for others, more specific disciplinary skills are sought for particular types of employment; and some occupations are closed to graduates who have not studied the relevant subjects. While graduates from the occupational specialist subjects can also seek employment which is open to all disciplines, thereby extending their potential range of opportunities, those who do not have a marketable specialization are limited to the category of jobs where no particular subject is specified.

Data from follow-up studies of British graduates suggest that a number of factors influence the ease with which graduates find employment: gender, age, social class, ethnic background, the subject and the institution at which they studied, motivation and personality. Most attention has been paid to the impact of the subject studied on employability.

If the pattern of studies of women in higher education, as presented in Table 1.7, is compared with what might be interpreted as the employment potential of qualifiers from different disciplines in Figure 2.1, women are found to be over-represented in most of the degree level subjects which provide only general work related skills and knowledge. Almost two-thirds of women in Britain will have studied languages, arts and social sciences, particularly the non-business related subjects, and graduates in these areas are known to have difficulty in finding employment. With a few notable exceptions, such as pharmacy, law, psychology, nursing and librarianship (where numbers are very small), women are less well represented in subjects which have clearly defined occupational objectives. The effect of the increase in the number of women undertaking higher education in Britain has been to boost the output of graduates in the generalist categories: the number of women graduates has, for example, risen much faster than the number of men in biological sciences, social sciences, the arts and languages (Tarsh, 1985:271). Women are, however, also largely

responsible for the fast growth in business studies, which is considered as a 'more employable' subject.

Many of the university courses in France are known to offer very poor employment prospects. This is particularly true of the arts and humanities, which are the subjects where women are over-represented. As in Britain, women constitute the vast majority of students following some of the most occupationally relevant courses at non-degree level, such as paramedical and social work studies as well as those leading to secretarial qualifications which result in relatively low status employment. Except in the more technical scientific and engineering branches, they are also more likely to have taken one of the shorter courses, which may affect their longer term promotional opportunities.

Clear differences can be found in the relevance of particular courses to employment and, in both countries, women tend to opt for the subjects which report some of the lowest levels of occupational specialism. If demand approximates fairly closely to supply, the implication is that the students who have qualified in the more occupationally specialized areas will readily find employment. In that some of the subjects studied predominantly by women are directly relevant to employment (for example nursing, pharmacy, librarianship), they are also more likely to lead to work in what have become predominantly female occupations.

Matching the needs of the labour market

Because relatively few subjects belong to the occupational specialist category, a large proportion of British graduates expect to undergo professional training after completing a degree, either in the educational system or within a company, as the standard route into long term employment. In the past teaching was a career followed by a large proportion of graduates in the arts and humanities and explained why further training in the educational system was a common pattern for new graduates. Fewer than 15 per cent of graduates now undergo further training in an educational institution preparing for a higher degree, teacher training certificate or other postgraduate professional qualifications (Universities' Statistical Record, 1989: Table C). After peaking in 1980-81, the proportion of graduates entering teacher training fell steeply and, by the end of the 1980s, accounted for less than five per cent of known first destinations.

While professional training in the educational system is the path followed by only a minority of graduates, women (about seven per cent) are more likely than men (less than three per cent) to undertake this form of further training within higher education: they made up over 90 per cent of all university graduates going on to study for a postgraduate certificate of education in 1987-88 (Universities' Statistical Record, 1989: Tables 2, 3). Other forms of training (often secretarial) accounted for some five per cent of women graduates and research or further academic study for seven per

cent. A higher proportion of men (11 per cent) went into further academic study and a smaller proportion into other training (three per cent).

Of graduates with known destinations, more than 60 per cent (both men and women) enter employment immediately on completion of their degree, a proportion which has been increasing steadily since the beginning of the 1980s when fewer than 50 per cent of graduates were in this situation (Universities' Statistical Record, 1982:6, 1989:8). If graduates enter employment rather than continuing to be students, this does not mean that they are not required to undertake professional training. Employers in a number of fields, who are looking initially for trained minds rather than technical expertise, now generally provide their own in-service company training.

An increasingly common pattern for British graduates is therefore to undertake this type of training and to study for professional examinations while in employment. Professions such as chartered accountancy or banking recruit graduates from all disciplines and provide training over three years for examinations which are recognized nationally by professional bodies. Many companies offer management traineeships or qualifications in information technology or international marketing, sometimes sponsoring their employees to take an MBA. While all graduates in medicine enter long term employment on graduation, their training continues for several more years as they take their professional qualifications. After reading for a degree in pharmacy, students go on to complete a pre-registration year entitling them to membership of the British Pharmaceutical Association which will have validated the degree.

Where they are competing for company traineeships which are not degree specific, women are less likely to be successful than their male counterparts. They are present in much smaller numbers in the UK amongst those working for professional qualifications from organizations outside the educational system: for example, they made up 35 per cent of the 1986-87 student intake of the Institute of Chartered Accountants in England and Wales (Grosvenor, 1988:45).

The situation for qualifiers in France is rather different in that more importance is attached to credentialism and to qualifications obtained in the education system. Since women in France are found to be entering higher education in greater numbers than men, they might be expected to be better placed than their British counterparts to acquire qualifications which will enable them to find appropriate employment. The situation is complicated, however, by the existence of various routes through higher education to which men and women appear to have differential access.

The employment prospects of French university students have been affected by a number of structural changes introduced in recent years, which are transforming higher education into a more 'continuous' system (Vincens, 1986b:4-6). Until the 1960s the products from French higher education were clearly delineated: the university degree in the arts and humanities led almost directly to a career in teaching; science graduates

went into teaching or research; law was a prerequisite for administration and the legal profession. Access to universities was unrestricted for those who obtained the *baccalauréat*, and the match between the number of qualifiers and available employment was arbitrary, except insofar as competitive examinations were used as a means of controlling entry to the main occupations followed by university graduates, namely in the civil service and teaching, or the high failure rates eliminated 'unsuitable' students from the system. The civil service and teaching examinations served as a test of general and specific theoretical knowledge as well as powers of reasoning and expression. They were the logical development of undergraduate programmes rather than a means of assessing practical skills and proficiency, such as would be needed on the job. The rise in the number of young people in schools as a result of the post-war demographic explosion created a demand for teachers which lasted throughout the 1960s and justified the continuing recruitment of university graduates to the profession.

While teaching is no longer accepted as the main career opening for university students, the 'popularity' of the teaching profession has probably not declined to the same extent as in the UK. The survey of 1984 qualifiers by the CEREQ showed that 24 per cent of all students awarded a *licence* or *maîtrise* in the sciences and 22 per cent in the arts and humanities went on to take a qualification as teachers (Charlot and Pottier, 1988: Table 4). When other types of teaching, in both the public and private sectors, are included, 45 per cent of all university qualifiers at this level in the sciences and 54 per cent in the arts were found to have entered the teaching profession. Women continue to account for the majority (two-thirds) of the students competing for the CAPES and half of the candidates for the *agrégation*, the professional qualifications for teaching (according to the Direction Personnel des Enseignants).

Today employers in the private sector in France expect products from the different forms of higher education to be in a 'finished' state and immediately operational. Under growing political and economic pressures, higher education has adapted to meet the changing needs of the labour market, with the result that the number of degrees awarded has been reduced and a shift has occurred away from the arts towards the sciences, law, economics and business related subjects. Shorter courses with a more readily identifiable career objective have been developed specifically to answer the demand of industry and commerce for middle management. Institutions have used the opportunity to set up new courses in order to attract sparse funds by designing innovative programmes with a clear occupational bias. The universities have thereby tried to change their image and function: for example, the specialized professionally orientated courses created at subdegree and postgraduate level depend on a rigorous selection process and, because the number of places is limited, such alternatives are believed to have greater market value. This view may be justified in that attempts have been made to establish contact with firms in order to help

the relatively small number of students to find employment. In this respect, the universities, or parts of them, have moved closer to the *école* model.

By contrast, access to the *grandes écoles* has always been highly selective and, like the competitive examinations for the civil service, based on general knowledge and analytical powers. Programmes were designed originally as a preparation for specific categories of employment, particularly in managerial positions, for which they filtered out the best candidates. Although ostensibly intended to democratize access to senior management positions, the ENA, which was established in 1945 as the training institution for the top ranks of the civil service, added another rung to the education ladder. Since the 1960s, in response to economic pressures, the *école* sector has tended to become even more competitive and hierarchical, and increasing emphasis has been placed on applied skills. The business school courses focus their teaching on case studies, and programmes in engineering institutes such as Ponts et Chaussées and the École des Mines have been extended to cover management techniques, languages and international affairs.

The outcome of the structural changes in French higher education is that a continuum has been created, whereby students are given the opportunity to find their level and leave the system with whatever qualifications they have been able to amass when they do not feel that they can usefully pursue their education any further. To this extent the system can be said to have become 'continuous' (Vincens, 1986b:4). At the same time, in its efforts to respond to market needs, hierarchical structures have been reinforced, with the result that the relationship between the type of course followed and employability has probably been further strengthened.

When the responses of higher education to market forces are compared, a different pattern can be identified in the two countries. Although the 'non-relevant' degree is also characteristic of the French university system, further professional training is less likely to be obtained on the job. A university first degree will often be followed by two or more years in a *grande école*, or another institution of similar status, for which a degree may be a normal prerequisite, as for example in the *instituts d'études politiques*. The trend in both educational systems is towards ever more training at postgraduate level, leading to more professional qualifications. The difference between the two countries is that in Britain this training is likely to happen outside the formal education system, with qualifications being administered, validated and recognized by professional bodies; in France, by contrast, professional qualifications are administered, controlled and recognized by the state as part of formal education in specialized institutions established for that purpose. The uncertainty facing French university graduates, due to the non-relevance of many university programmes, is exacerbated by the fact that they are also in competition with students from the *grandes écoles* or IUT who are acquiring not only the knowledge and expertise which will make them immediately

operational in the employment context but also the prestige which results from this privileged and more occupationally specialized background.

If a distinction is made between internalist and externalist changes (Kogan, 1988:18), French higher education can be said to have been more responsive to pressures from the external environment, whereas the British system has largely continued to uphold the dominant guiding principle that higher education should not have as its main objective to satisfy the demands of the market and a business culture. If some of the aims of higher education in helping students to acquire and develop the capacity for independent thought, the ability to communicate easily and to process information come close to matching the needs of employers in Britain, this may often be incidental rather than intentional. The effect of these two different approaches for women is ambivalent: new opportunities have been created in both societies, but this does not necessarily mean that well qualified women automatically gain access to high status employment.

Access to employment

Despite criticisms of the way first destination statistics have been exploited in Britain to promote higher education institutions which tend to fare well in the ratings, analysis of the speed with which graduates initially find employment does seem to provide a fairly reliable indicator of their later employment patterns (Boys and Kirkland, 1988). In the published analyses, this is usually correlated with subjects studied and the institution where the qualification was obtained.

Initial access to employment continues to vary substantially according to the subjects taken: in the UK more than 80 per cent of those who graduate from a university in business and financial studies or education, and almost 80 per cent of graduates in engineering and technology immediately enter full time permanent employment, whereas this is the case for under 50 per cent of graduates in biological and physical sciences, languages, humanities, social sciences and the creative arts (Universities' Statistical Record, 1988: Table C). The opportunities for graduates from these subjects are improving as more of the graduate vacancies offered are non-degree specific but not to the extent that the discrepancies have disappeared.

Graduates from polytechnics have more difficulty than those from universities in finding employment if they have read subjects which are not professionally oriented. The polytechnics have a better record than the universities, however, in securing permanent employment for some of the subjects which produce the most employable graduates: civil and production engineering, architecture/planning and computing (Universities' Statistical Record, 1988; AGCAS Polytechnic Statistics Working Group, 1987).

Since a substantial proportion of university students in France are still taking courses which are not intended to serve as a professional training

(corresponding to the generalist and generalist plus categories), it follows that they are likely to be the group experiencing most difficulty in finding employment matching their level of qualification and competence. As new types of programme and qualifications have become available, the university degree has tended to lose its specificity and marketability. Many French students who reach degree standard continue their studies in order to avoid unemployment or instead of taking jobs which they feel would be inappropriate.

Courses in French universities are less likely than those in the *grandes écoles* or the IUT to lead directly into employment, except in teaching where students who pass the competitive examinations are guaranteed immediate appointments. The number of posts available is, however, controlled by the Ministère de l'Éducation Nationale which decides each year how many new teachers will be required in the state sector, adapts the pass rate accordingly for each subject area and makes appointments. The barrier is therefore at the point of qualification rather than at entry to employment. In Britain three hurdles have to be passed: selection for professional training, qualification for and appointment to a teaching post. Consequently, even when qualified a teacher has no guarantee of being offered employment.

Graduates with qualifications in the sciences and engineering are more likely to find work immediately on completion of their course than qualifiers in the arts, humanities and social sciences. In both countries, women are less prominent in these areas. According to the 1984 survey by the CEREQ of qualifiers from higher education in France, students from an *école d'ingénieurs* find employment most quickly but, even within the sciences and technology, differences are apparent: mechanical and electrical engineering, electronics and computing qualifiers enter employment more quickly than those with a qualification in agronomy, biology, biochemistry and other natural sciences (Charlot and Pottier, 1988). The top business schools (Hautes Études Commerciales, the École Supérieure des Sciences Économiques et Commerciales, the Écoles Supérieures de Commerce de Paris and de Lyon, the École Européenne des Affaires de Paris and the Institut Supérieur de Commerce de Paris) also produce good results for first employment, followed by the ESCAE which award state approved certificates. University graduates take longer on average to enter employment, but many (50 per cent of those studying for a postgraduate award) will already be in employment before they complete their course. Holders of subdegree level qualifications generally spend even longer securing lasting employment. Long term unemployment is particularly common for some of the qualifiers in the arts and humanities, even if they have postgraduate qualifications.

When the situation of women is examined using data from the same study, they are almost always found to take longer in securing their first job (CEREQ, 1989:30, 33). Women accounted for 18 per cent of qualifiers from the *écoles d'ingénieurs* but, whereas 82 per cent of the men had found

employment in less than six months, this was the case for 62 per cent of the women. Women were 41 per cent of the qualifiers from the *écoles de commerce* but, whereas 77 per cent of the men were in employment within six months, this applied to 67 per cent of the women. The advantage for men, in terms of the time spent finding employment, was smallest in the top ranking *écoles*: 80 per cent of the men compared with 69 per cent of the women were in employment within six months. In the second rank business schools the difference was greatest: 81 per cent of the men and 64 per cent of the women entered employment easily. In the third ranking schools, the situation was reversed: 72 per cent of women and 68 per cent of men had found employment within six months, but even here men had the advantage, as in the other types of business schools, in that they were more likely to have secured long term employment (CEREQ, 1989:41-3). In the shorter technological streams, such as the DUT, women also experience considerably more difficulty than men in finding employment: amongst qualifiers in marketing options three times as many women as men were unemployed for more than a year (Pigelet, 1989b:5).

If first destination statistics are taken to indicate low demand for a subject in Britain, it has been predicted that graduates from that subject are more likely to undergo further training, less likely to use their degree subject in their work and more likely to be in employment not requiring a graduate level qualification (Tarsh, 1988:100). These predictions are generally fulfilled three years after graduation for women from British polytechnics and colleges who appear to be trapped in a process from which they have little chance of escape (Chapman, 1989).

Despite the emphasis placed on the degree subject studied, the available evidence suggests that it may not be the main variable explaining differences in employment prospects several years after graduation (Brennan and McGeevor, 1988). The results of a study of philosophy graduates, a subject area where men outnumber women (70 per cent men), indicated, for example, that, five years after completing their course, employment patterns were similar to those of graduates from other disciplines (Radcliffe and Warner, 1986).

The age variable would seem to create some important differences between Britain and France and between the sexes when access to employment is being considered. In contrast to France, alternative more professionally orientated qualifications have not been created to the same extent within the higher education sector in Britain. Nor have those which existed expanded proportionately. The result is that, whereas French students are likely to remain in higher education for a much longer period before they qualify as occupational specialists, British graduates of the same age will already be well established in employment and gaining practical paid work experience, while also taking professional qualifications.

In European terms, British graduates have been said to be at a disadvantage in the international labour market because of the non-relevance of their degrees and their age, if they seek employment abroad

immediately on graduation (Raban, 1988). The age 'disadvantage' can easily be illustrated by comparing British with French university graduates. Most British undergraduates enter higher education at the age of 18, having obtained the requisite number of 'A' levels in a small number of subjects which they have probably chosen as their specialism because they performed well in them. The expectation is that they will complete their three or four year degree course on schedule and graduate by the age of 21-22, ready to enter the labour market. Their French counterparts are likely to be older (between 19-20 or even 21) by the time they complete secondary schooling, since it is a common practice to repeat a year in primary or secondary school, often due to problems with a particular subject which nevertheless has to be mastered at the appropriate level. The broader programme in the first two years of university education, or the time spent in a *classe préparatoire*, and the need to repeat one or more years after failing examinations increase the age gap between graduates in the two countries. The age 'disadvantage' can, however, be turned into an asset after a traineeship and a few years of experience. When graduates of the same age are compared, those from the British system can be strong competitors with their French counterparts who will probably only just be completing full time study. The age gap is even more marked between British and German graduates, especially men, because of the greater length of courses and the need to carry out compulsory military or community service.

If age is a factor which can be used to advantage, the effect for women in Britain is likely to be negligible since there is little, if any, difference in the ages at which men and women complete higher education. In France, however, age might serve to enhance the opportunities for women in competition with their male counterparts since they are available for employment at an earlier stage. As shown in the previous chapter, women are less likely to repeat a year of schooling or spend time in an *école préparatoire* trying to gain entry to one of the *grandes écoles*. They are more likely to be following shorter courses and do not need to interrupt their progress to do 11 months of national service. They could, in theory, be using this time to gain work experience while men of the same age are still completing their studies or serving in the armed forces. However, as women tend to restrict their opportunities by obtaining qualifications requiring shorter periods of study in less prestigious institutions, they are likely to be using some of the time saved in seeking their first job.

The institution from which students gain their higher education qualifications has been found to affect access to employment. In the UK first employment opportunities are influenced by an institutional hierarchy. Oxbridge graduates fare better than students from other universities and polytechnics, although subject differences cannot be discounted and are thought to be more discriminating (Boys and Kirkland, 1987:40-1). At the two extremes of the first destination ranking, Oxbridge engineers, who are found to enter employment with greatest ease, are 87 per cent male, whereas polytechnic social science graduates, who have most difficulty, are

58 per cent female. The phenomenon of hierarchical gender concentration also applies in France, where, as shown in Table 1.7, women are under-represented in the *école* sector, and particularly in the top engineering institutions which prepare students for direct entry into high status employment; they are over-represented in vocational training programmes such as those leading to administrative and secretarial work.

On the basis of results from the different studies which have been conducted, it could be postulated that gender, and more particularly gender socialization, is the overriding factor which produces poorer employment prospects for women in that it determines disciplinary orientations, the type of higher education institution where they are likely to have studied and the way they anticipate and prepare for their career.

WOMEN'S OPPORTUNITIES IN THE LABOUR MARKET

From the discussion in the previous chapter a clear picture emerged of the different routes into and through higher education and of the ways in which they may predetermine the career openings available to women at a later date. The implication of the choices made by women in higher education is that they are less likely to have studied subjects which lead immediately to employment and, more especially, to what has been defined as a planned career: 'a continuous period in the labour force, with the same or different employer or seeking work, during which the individual does his or her best to make rational decisions which advance their employment "career"' (Crompton and Sanderson, 1986:28). While the career planning process begins at an early age for men as they are encouraged to take the 'right' decisions during schooling, women are less likely to have made 'rational' choices with a view to advancing a linear employment career.

Expectations from employment will be shaped by perceptions of the opportunities available and the role models which can be imitated. Analysis of polytechnic and college graduates has shown that women graduates' expectations in terms of their employment prospects are different from those of their male counterparts: while men were looking for work requiring leadership skills and offering good promotional prospects, employment security and a high salary, women more often attached importance to helping people, to utilizing their skills as fully as possible and engaging in continually challenging work (Chapman, 1986).

Two of the quantifiable measures introduced in British and French follow-up studies of qualifiers from higher education for assessing relative success in finding graduate employment of suitable level are status and income. These criteria are often referred to in establishing employability ratings for different courses and are therefore worth considering further, particularly with reference to the ability of women to pursue a planned 'career'.

Employment prospects for women

Studies in both countries indicate that women are more likely than men to be overqualified for the work they are doing: data from the HELM study showed that three years after graduation 61 per cent of the men and 51 per cent of the women were in employment requiring a degree level qualification (Chapman, 1989: Table 2.1.2). Expressed in slightly different terms, in the French context, 83 per cent of men who achieve a higher education qualification (or equivalent) are in middle or higher grade managerial and executive positions, compared with 58 per cent of women (Glaude, 1987:164).

When the employment status of British men and women graduates was compared in the HELM study, more men were found to be in higher grade professional employment than women one year after graduation (34 per cent compared with 13 per cent); three years after graduation both sexes had improved their position but men to a greater extent than women (40 per cent and 17 per cent, reported in Chapman, 1989: Table 1.1.2). In relation to the categories used in the Graduate Model, a larger proportion of men in the occupational specialist grouping had obtained higher grade professional work for all degree subjects except pharmacy (Chapman, 1989: Table 1.1.3). The general conclusion was drawn that, even if they had followed exactly the same courses, women were less likely than men to be employed in the highest status positions.

Data from the 1982 follow-up study on training and employment of French higher education qualifiers indicated that, amongst those in employment nine months after completing a university course, 53 per cent of men and 33 per cent of women were in high status jobs (Vincens, 1986a:45). Consistently smaller proportions of women were being recruited into the higher managerial positions (Vincens, 1986b:23). In the sciences 49 per cent of male qualifiers were in higher grade occupations compared with 39 per cent of women. Both sexes improved their position five years after qualifying, but men, with 65 per cent, maintained their advance over women, who reached 51 per cent.

Whereas university qualifiers in the arts, humanities and sciences are likely to be in teaching, those in law, economics and business will enter management and administration, with the result that 50 per cent of men with degree level qualifications and above will be in management and administration compared with 20 per cent of women who reach this standard (Vincens, 1986a:17). More than 68 per cent of men with a *grande école* qualification were in senior management and seven per cent were in the professions, but 39 per cent of women (who accounted for only 12 per cent of former students from the *grandes écoles*) with the same level of qualification were in senior management positions and five per cent in the professions. Much larger proportions of the women in the survey were in middle management or the teaching profession. A similar pattern emerged for those with a qualification at degree or postgraduate level, where women

accounted for 45 per cent of qualifiers (Vincens, 1986a: Table 4). Overall the public sector remains an important recruiter of university graduates, and women are known to be over-represented amongst those seeking employment in this area rather than in the private sector.

Data from the 1984 CEREQ study confirmed the existence of a clear hierarchy amongst the business schools in France in the type of employment found by their students, with qualifiers from the most prestigious institutions more often obtaining senior management positions in the financial sector (CEREQ, 1989:41-3). Similar proportions of men and women students opted for this specialism but women again seemed to take longer in finding initial employment.

Secondary analysis of labour force survey data for 1987 has shown that women who have studied in an *école d'ingénieurs* are much more likely than their male counterparts to enter employment in teaching or research; they are more often self-employed or in the public sector and much less likely to be in management positions in industry or commerce, where most qualifiers from the *écoles d'ingénieurs* are employed (Marry, 1989:324-5).

Following labour market segmentation theory, the subjects studied by women in higher education are likely to ensure that they commit themselves to a narrower range of employment opportunities and to jobs which are more often occupied by women and have therefore come to be categorized as 'female' employment. In addition, women who do enter professional occupations tend to be concentrated in practitioner rather than administrative functions and to make less progress towards the highest ranks of their profession, implying that their contribution is of lower status and matches their more circumscribed aspirations (as testified, for example, by Allen, 1988; Crompton and Sanderson, 1990; Huppert-Laufer, 1982; Kelsall, 1980).

Some types of employment, such as teaching, nursing, secretarial and social work (the semi-professions), have long been considered as characteristically female. In 1985 13 per cent of UK university arts and languages graduates and 26 per cent from the polytechnics were entering clerical, secretarial and manual jobs (Tarsh, 1987:13), mainly in what could be classified as female work. When a particular type of employment comes to be sex typed as being appropriate for women, it tends to lose status and salary levels fall, with the result that men begin to avoid it and to direct their interest elsewhere. The 'more able' graduates (understood to be those who have read for an Oxbridge degree, according to Kogan, 1988:17) are, for example, no longer interested in jobs in teaching, since they do not offer high rewards in terms of status and income.

Other categories of employment have more recently become feminized: until the early 1950s the legal profession in France was an exclusively male preserve, whereas in the early 1990s women are expected to make up more than 50 per cent of the judiciary (Soulez Larivière, 1987:230). A similar trend has been occurring in pharmacy in both countries. In Britain women were a small minority until the 1950s, since when their numbers have been

increasing rapidly: from less than 20 per cent in the early 1960s in Britain, they had reached nearly 40 per cent in 1985 (Crompton and Sanderson, 1990). In France at the beginning of the century only 58 women were recorded as pharmacists; by 1945 they accounted for more than 45 per cent of pharmacy students (a level not reached until the end of the 1960s in Britain); by 1962 48 per cent of pharmacists were women (according to census data), and by the late 1980s they had reached almost 60 per cent of registrations with the professional body, the Ordre des Pharmaciens.

Analysis of women graduates from polytechnics after three years in the labour market has shown that they are less likely than men to be upwardly mobile and that they underachieve in comparison with men (Chapman, 1989). Studies which follow the career progression of graduates from other institutions and over a longer period further demonstrate that women's opportunities tend to decline, while those of their male contemporaries continue to rise (for example, Kelsall, 1980; de Singly, 1987). By undertaking higher education women have begun their career planning, thereby making themselves eligible for high grade employment, but in many cases they have trained for female occupations or have selected options which will not enable them subsequently to reach the top ranks of the professional hierarchy.

Income levels of well educated women

Another quantifiable measure often used to judge the employment prospects of qualifiers from different courses is earning power. Table 2.1 shows the distribution in rank order of incomes for graduates from different subjects one and three years after graduation for the British samples and on entry to employment in France.

The HELM study found that three years after graduation, the average annual income of 1982 polytechnic and college students in full time employment was almost £9,000 (Brennan and McGeevor, 1988:35). Although initially engineering graduates commanded the highest salaries, three years after graduation business and management graduates had moved into first place, followed by built environment and engineering. Within this grouping the course with the highest income was production engineering. Graduates from economics, business studies, computer science, pharmacy, urban estate management and electrical engineering were all earning over £10,000 within three years of graduating. Those from English literature, geography, librarianship, communication studies, law, social studies, applied biology and with nursing qualifications earned below £8,000. Law and librarianship were at the bottom of the scale.

The Brunel survey of 1982 graduates from a sample of universities, polytechnics and colleges showed that the Oxbridge engineer earned the highest salary three years after graduating, followed by Oxbridge chemists and economists (Boys and Kirkland, 1987:73). Business and management studies were well placed, as were university and polytechnic combinations

with computing science. At the bottom of the scale were university and polytechnic law and college social science. In some fields of employment, such as law, starting salaries are low because the graduate is attending law school. Even Oxbridge graduates are well down the list for this subject but, once they have gained professional qualifications, lawyers can command very high incomes, as confirmed by the results of a survey of 1980 graduates six and a half years after completing their degrees (Clarke et al, 1988:506). After a longer period in employment qualifiers in computer science, law, economics, mathematics, electrical and mechanical engineering and business studies were found to command the highest salaries, with between £14-16,000. Qualifiers in education, biology, languages with arts, professional and vocational subjects, psychology and biochemistry were earning the lowest salaries, with less than £11,000. Moreover, in low pay areas, such as teaching, librarianship or nursing, where women are dominant, the prospects of achieving a rapidly accelerating income are particularly poor.

The net effect of differences in the types of job occupied by men and women, as illustrated by the HELM study, is that three years after graduation more women than men are likely to be in the lower income bracket (21 per cent of men and 38 per cent of women earned less than £7,000 a year), and fewer women than men are likely to be in the higher income bracket (35 per cent of men and 20 per cent of women earned more than £10,000 a year). The higher the level of income, the larger the proportion of men: almost three times as many men as women were earning over £13,000 (Chapman, 1989:37-9). Even when they held qualifications in the same subjects, women consistently received lower incomes than their male counterparts.

In France the salaries which qualifiers can expect to command vary according to the institution where they studied: the least well paid will be university graduates in the arts and humanities, the natural and human sciences. Postgraduate qualifications in these disciplines only slightly improve the position. Graduates in law or economics are next on the scale. University qualifiers who obtain postgraduate awards in France reach the same position as those from the third ranking business schools; a qualification from one of the *instituts d'études politiques* is worth slightly less, in terms of salary, than a postgraduate qualification in the sciences. Among engineering qualifiers the natural and human sciences lead to less well paid employment than the physical sciences which attain the same level as the second rank business schools. The top of the scale is reached by qualifiers from the most reputed engineering and business schools.

The figures in Table 2.1 for French institutions apply to first employment undifferentiated by sex, but again it is clear that the qualifiers commanding the highest starting salaries are in areas where men are dominant and where an upwardly mobile profile is a common expectation at this level of qualification.

TABLE 2.1 MEAN INCOME BY SUBJECT FOR QUALIFIERS IN THE UK
AND FRANCE, 1983-87

	1983 - 1 year after graduation	1985 - 3 years after graduation
UK		
POLYTECHNICS AND COLLEGES		
(Annual in £)		
Engineering	6,638	10,005
Built environment	5,947	10,029
Science 1	5,649	8,687
Business/management	5,262	10,054
Interfaculty	5,133	8,354
Science 2	5,125	8,887
Art and design	5,058	8,918
Arts/humanities	5,055	8,115
Social science	5,032	7,853
UNIVERSITIES, POLYTECHNICS, COLLEGES		
(Annual in £)		
Oxbridge engineering	11,040	
Oxbridge chemistry	10,150	
Oxbridge economics	9,606	
University commercial	9,514	
Polytechnic computing/mathematics	9,479	
University engineering	9,400	
Polytechnic commercial	9,001	
University computing/mathematics	8,844	
Oxbridge mathematics	8,630	
Oxbridge history	8,525	
Polytechnic engineering	8,512	
University economics	8,299	
Polytechnic chemistry	8,000	
Oxbridge law	7,997	
Polytechnic social sciences	7,886	
College other arts and humanities	7,800	
University chemistry	7,794	
University history	7,196	
College history	7,003	
College social science	6,810	
Polytechnic law	6,009	
University law	5,405	

	1987 For first employment
France	
HIGHER EDUCATION	
(Monthly starting salary in francs)	
Grandes écoles d'ingénieurs	12,000
Grandes écoles de commerce	12,000
Second rank business schools	10,500
Écoles d'ingénieurs, pure sciences	10,500
DEA/DESS in pure sciences	10,500
Instituts d'études politiques	10,000
Third rank business schools	9,400
DEA/DESS in law/economics	9,400
Écoles d'ingénieurs in human sciences	9,000
University degree in pure sciences	8,800
DEA/DESS arts and humanities	8,000
DEA/DESS natural and human sciences	8,000
University degree in law/economics	8,000
University arts and humanities	7,200
University natural and human sciences	7,200

Science 1: mathematics, science, applied chemistry, applied biology, computer science, environmental science.
Science 2: psychology, hotel and catering administration, pharmacy, nursing

Sources: Adapted from Brennan and McGeevor, 1988:35; Boys and Kirkland, 1987:73; Charlot and Pottier, 1988:3.

Analysis of earnings five years after the completion of higher education confirms that women have chosen the least profitable qualifications and that, even with the same level of educational attainment, they can expect to earn lower salaries than their male counterparts (Baudelot and Glaude, 1989:4).

The figures presented in the table are not comparable cross-nationally, and direct comparisons of men and women graduates in the two countries cannot be made on the basis of the available information. National data for non-manual workers collated by Eurostat indicate that salary differentials between men and women are probably greater in Britain than in France. As a proportion of the average gross monthly earnings in 1988 women in this broad category were earning a little under 55 per cent of the average for men in Britain and 65 per cent in France (Eurostat, 1989b: Table II/3). Weekly earnings in Britain differ on average by 32 per cent and for

graduates by 33 per cent (OPCS, 1986: Table 7.19). In France the gap between women's and men's monthly earnings is on average about 25 per cent, although it is argued that, when like is compared with like and structural differences are compensated for, the gap between men and women is reduced to less than 15 per cent, the remaining disparity being explained by the fact that men are more often eligible for bonus payments and fringe benefits (Glaude, 1987:169). Without these adjustments, in the public sector, the difference between men and women for all categories of workers falls below 20 per cent. For the senior grades it is greater at 22 per cent, and in some of the higher positions and more technical posts it rises above 30 per cent (Meron, 1987:174). The larger difference at higher levels is explained by the fact that few women in these grades command the top salaries (Benveniste and Hernu, 1987:18).

The causal relationship between feminization and low status and pay may not be proven, but the evidence considered here would seem to suggest that men are more likely to be attracted to employment which offers the highest financial rewards. If the Oxbridge engineer is the type of graduate commanding the highest income three years after leaving university, it is not because he is working as an engineer but rather because he has been headhunted by the sector able to afford the highest financial inducements, which is currently the City. Similarly, qualifiers from the ENA, Centrale or HEC will obtain the jobs with the highest status and salaries not because they have studied government, engineering or management, but because the institutions and subject areas concerned are reputed to produce students who conform to a particular intellectual mould and display the personal qualities being sought by recruiters.

Some observers (for example Vincens, 1986a:51) feel it is only a matter of time before women reach parity with men in all areas. This conclusion may be rather optimistic and is not supported by the evidence examined in this chapter. For the moment, follow-up studies of British graduates, in particular, show that, even taking into account factors such as degree class, type of course or institution, women's different expectations tend to match reality in that they are less likely to be recruited into jobs offering the best occupational potential in terms of pay, promotion and status.

Women's progress in managerial and professional occupations

The improvement in women's education in France has been considered of major importance in raising the level of their expectations for professional life (Battagliola and Jaspard, 1987). In Britain, it has also been argued that the substantial increase in the level of education received by women should enable them to gain access to high status positions (Crompton and Sanderson, 1986). Cross-national comparisons may help to put these claims into perspective and provide some indication of the extent to which they can be substantiated.

The comparisons made in previous sections of this chapter referred primarily to the position of women in relation to men at, or near to, the point of entry into the labour market. In order to determine whether the seemingly greater educational opportunities available in France are improving the relative position of well qualified women in the employment hierarchy, an attempt is made in this section to compare women in the higher grade occupations.

Although very few international comparisons have been conducted of women in professional occupations, secondary analysis of large scale data sets, complemented by smaller scale studies of various aspects of employment, have made available a substantial body of comparative data, highlighting some of the more salient differences between the patterns of employment of women in Britain and France (discussed in more detail in the next chapter). Emphasis here is on the overall distribution of women's employment in professional occupations in the two countries.

The problems, described in the previous chapter, which arise in trying to compare the number of students in higher education, are similar to those involved in using national data sets to compare the distribution of employment according to occupational groupings, to the extent that it has been argued that socioeconomic groups should only be compared at an aggregate level (Glover, 1989). The International Standard Classification of Occupations, which is used in the EC version of the labour force surveys, is an attempt to provide a common basis for classifying occupational groups. Comparisons using this system suggest that French women are under-represented in the 'administrative and managerial' grouping, in relation to British women, not because of structural differences between the two countries but rather because of differences in the way in which the classification is applied (Dale and Glover, 1987:39). Comparisons over time are further complicated by changes made in 1982 in the system of classification of occupations in France, but it seems likely that profiles for women in these broad groupings are probably similar in the two countries, and that occupational structure has been developing along the same lines over the past 20 years (Dale and Glover, 1987:38).

These observations are borne out by Table 2.2 which shows trends over time up to the early 1980s for the proportion of women in the higher professional and managerial/administrative categories in relation to all women in employment and to all workers employed in the relevant category. Although the data constitute coherent series for each of the two countries, they are not directly comparable: for Britain they are derived from censuses for 1951-81 (using the classification provided by Routh, 1980: Appendix A); for France they are taken from the INSEE classification of labour force survey data. Whichever of the two measures is used, in both countries women would appear to have improved their position over time and to have been progressing more rapidly in recent years, although in France they started from a very low base in the 1950s. The seemingly more

favourable situation in Britain may be due to overall differences in the systems of classification, as suggested above.

TABLE 2.2 OVERALL PROGRESSION OF WOMEN IN HIGHER GRADE OCCUPATIONS IN THE UK AND FRANCE, 1951-81

	1951 / 1954	1971	1981
As % of all women workers			
UK	3.2	4.0	6.4
France	1.2	3.2	5.1
As % of all workers in category			
UK	23.5	21.7	29.8
France	13.8	19.8	25.9

Sources: CNIDF-INSEE, 1986: Table 43; INSEE, 1979: Table PA 03, 1982: Table PA 03; Mallier and Rosser, 1987: Tables 3.6, 8; Michal, 1973: Table 24.

While women have been improving their position in the higher grade occupations, men have also been progressing: from nine per cent of all male workers in Britain in 1951 the proportion had reached 16 per cent by the early 1970s (Routh, 1980: Table 1.1); labour force survey data for 1987 (excluding professional and related occupations in education, welfare and health) continued to place men well ahead of women, with 29 per cent of men in the higher grades and 12 per cent of women (OPCS, 1989b: Table 5.11). In France seven per cent of men were employed in high grade positions in 1968; the proportion had risen to nearly 11 per cent by 1982; and by 1987 it had reached 12 per cent, which was almost twice the level for women (INSEE, 1982: Table PA 03, 1987a: Table PA 02; Michal, 1973: Table 24). In both countries women are much more strongly represented in intermediate non-manual work. Professional and related occupations in education, welfare and health and clerical and related work account for 45 per cent of economically active women and 12 per cent of men in Britain (OPCS, 1989b: Table 5.11). The intermediate and skilled non-manual categories in France, including clerical workers, account for 30 per cent of economically active men and 62% of all women in employment (INSEE, 1987a: Table PA 03). Despite the progress achieved, in both countries, greater access to education appears to be only very gradually eroding occupational segregation in the highest grades, and women remain much less likely than men to be employed in professional and managerial occupations, when measured at these broad levels of aggregation.

When the employment of men and women in professional and managerial occupations is examined at a lower level of aggregation using labour force survey rather than census data for both countries, as in Tables 2.3, some indication can be obtained of the relative position of women in the two societies over a range of broad occupational groupings, although again the figures are often not directly comparable.

TABLE 2.3 THE EMPLOYMENT OF WOMEN IN HIGHER GRADE POSITIONS IN THE UK AND FRANCE (AS A PERCENTAGE OF ALL WORKERS IN EACH CATEGORY), 1966-87

	1966 / 1968	1987
UK		
Professional, management related	12.5	24.4
Professional (education/welfare/health)	50.3	66.9
Literary, artistic, sporting	29.6	40.3
Professional (science, engineering)	0	10.0
Managerial	9.2	26.6
France		
Professional	18.8	31.7
Public sector management	10.8	23.1
Teaching and research	38.8	46.9
Information, arts	39.0	43.5
Private sector management	12.8	25.3
Higher grade technical staff	3.1	8.3

Sources: Department of Employment and Productivity, 1971: Table 106; INSEE, 1979: Table PA 03, 1987a: Table PT 04; OPCS, 1989b: Table 5.11.

Time series data indicate that in both countries women have improved their rating in all the higher grade occupational categories recorded in the table over the past two decades, and particularly in professional and management related occupations in the private sector. In the literary, artistic, sporting, information and arts areas they were approaching parity with men by the mid-1980s. In engineering and technology, where they started from a very low base, despite rapid progress, women still constituted only a very small minority in higher grade technical positions.

According to the figures presented in the table, women in Britain would appear to have made a greater impact on the professional grouping for education, welfare and health than in France, but this apparent difference may be explained by the system of classification: whereas the French category for teaching and research includes only qualified teachers in secondary schools and teachers and researchers in higher education, the

equivalent British labour force survey data group together in Social Class II all teachers except those in higher education (who are counted with professional occupations in Social Class I) and all nursing staff occupations which are excluded from the French classification at this level. Comparative analysis of economically active women with children who were in the categories of professional, teaching, nursing and intermediate non-manual occupations at the beginning of the 1980s suggested that more French women belong to these categories when they are reduced to a comparable base: 18 per cent of British and 29 per cent of French women (Dex and Walters, 1989:205).

Aggregated national figures conceal very different employment patterns and histories, as well as differences in the meaning and status of the employment concerned. Another approach in assessing the progress made by well educated women in the labour market is to analyse the position of women in particular occupations and the status attributed to these occupations. In the late 1970s and early 1980s a considerable body of literature was developing in Britain on women in top jobs (Fogarty et al, 1981; Silverstone and Ward, 1980; Wheeler-Bennett, 1977). A number of single nation studies have been conducted of the careers of British women graduates, with special reference to professions such as accountancy, banking and pharmacy (Crompton and Sanderson, 1990), law (Podmore and Spencer, 1986) and medicine (Allen, 1988) or 'semi-professions' such as teaching (Kelsall, 1980). These studies provide some interesting insights into the ways in which women are establishing a position in professional occupations, but they too show that women continue to be dominant in the less well paid jobs and are less likely than their male counterparts to follow a linear career in an organization with good prospects for promotion and upwards mobility.

In France, although the topic is popular amongst journalists, less academic attention has been devoted to professional women: the place of women has been investigated in management (Huppert-Laufer, 1982), in the civil service (Davisse, 1983), in one of the public service industries, Electricité de France (Meynaud and Auzias, 1987) and in engineering (Marry, 1989). Like the British studies, this work confirms that the career expectations of women continue to differ markedly from those of men and that the actual paths followed are less likely to lead women towards the most prestigious and best paid jobs with the most promising promotional opportunities.

Where the employment patterns of well qualified women have been examined cross-nationally for a particular occupation, as in the study of women in banking conducted a decade ago in Belgium, France, the Netherlands and the UK (described in Labourie-Racapé et al, 1982; Povall et al, 1982), interest has not been concentrated on women in the higher ranks of the profession, although it is possible to draw out some relevant data. The study of banking showed that more women in France were reaching the higher grades. The proportion of women in middle management in

banking was also found to be greater in France than in the other countries investigated. The position of women over a wider range of professional occupations has not yet been directly compared across several countries.

When comparisons are attempted at one further level of disaggregation, using the information given in Table 2.4 (with time series data where available), other trends can be discerned. Although once more the data are generally not directly comparable, women in France would appear to have made greater gains in a number of the higher grade occupations in relation to their British counterparts. Their progress in recent years is particularly marked in some of the occupations offering opportunities for public sector employment, such as teaching and research in higher education, medicine, the legal profession and the senior grades of the civil service, reflecting their advances in the relevant disciplines in higher education. The considerable increase in the proportion of women in banking in France may not be unrelated to the fact that banks fall within the public sector. Where women in the higher managerial and professional occupations seem to be well represented, as in the teaching profession in both countries or in medicine, pharmacy and banking in France, they tend to remain under-represented in the highest ranks.

More detailed analysis reveals further differences between the two countries and suggests that the way in which some of these professional occupations are structured may affect the opportunities available to women. In the context of the present study, it is of particular interest to compare the position of women in higher education, since this is an area where women students are exposed to role models at a stage in their education at which they are likely to be planning their career. When the position of British women academics was examined in the 1970s, horizontal segregation, which had previously been diminishing as women were appointed to posts in a wider range of subjects, was found to be on the increase again (Rendel, 1984). Vertical segregation had been reduced up to 1930, as more women were promoted to higher posts, but had since increased, and this trend was confirmed in the 1970s. Vertical segregation would seem to have decreased only slightly in the 1980s in Britain, since the posts secured by women have been largely at lecturer level. Horizontal segregation continues to be very marked. In Britain women constitute 30 per cent of university lecturers in languages, 28 per cent in education and 24 per cent in medical studies, which are disciplines dominated by women undergraduates. In the biological, physical and mathematical sciences nine per cent of lecturers are women and five per cent in engineering. Women account for 16 per cent of senior lecturers/ readers in languages, 10 per cent in education, 14 per cent in medical/health studies and three per cent in the physical sciences (Universities' Statistical Record, 1990: Table 29).

In France the profession is less segregated both horizontally and vertically. Women are more strongly represented both in the arts and humanities and in the male dominated subject areas. At lecturer/senior lecturer level women account for 39 per cent of academics in the arts and

humanities, 45 per cent in medical studies, and 23 per cent in the sciences (*Note d'information*, 87-35). While female students in both countries continue to be exposed to predominantly male role models, women appear to have made a stronger impact on the academic profession in France than in Britain, not only in the traditionally female subjects but also in some of the sciences.

TABLE 2.4 THE EMPLOYMENT OF WOMEN IN PROFESSIONAL OCCUPATIONS IN THE UK AND FRANCE (AS A PERCENTAGE OF ALL WORKERS IN EACH CATEGORY), 1960s-80s

	1960s	1970s	1980s
UK			
PUBLIC SECTOR MANAGEMENT			
Civil service grades 1-7	-	4.2	7.6
TEACHING/LECTURING			
Local authority teachers	57.2	-	61.4
University academics	12.7	-	17.1
Professors	1.4	-	2.8
Readers/senior lecturers	7.0	-	7.6
Lecturers	12.7	-	18.8
MEDICAL PROFESSION			
Consultants	-	9.2	13.6
Senior registrars	-	18.8	24.9
Medical practitioners (public sector)	0.3	14.3	20.9
Medical practitioners (private sector)	10.5	-	-
Dental practitioner	14.4	10.2	17.7
Pharmacist	17.7	29.9	36.9
LEGAL PROFESSION	5.0	-	-
Barristers	3.2a	-	12.3
Solicitor	1.9a	-	12.3
High court judges	0	-	3.8
Judges and magistrates	0	-	4.6
MEMBERSHIP OF PROFESSIONAL INSTITUTES			
British Medical Association	-	21.8	25.6
Law Society	-	11.8	15.2
Institute of Marketing	-	2.4	7.9
Institute of Personnel Management	-	30.0	45.9
Institute of Bankers	-	13.0	18.2
Institute of Chartered Accountants	1.1	2.3	7.6

	1962	1968	1975	1982
France				
PUBLIC SECTOR MANAGEMENT	11.1	14.8	26.6	34.7
Senior officers	-	-	-	8.9
TEACHING AND RESEARCH	-	-	-	45.1
Qualified teachers	-	-	-	54.0
Head teachers/inspectors (secondary)	-	-	-	25.7
Secondary school teachers	50.7	55.6	54.0	53.6
Higher education lecturers/researchers	20.6	23.1	34.2	33.6
University professors	-	-	-	9.1b
Senior academic staff	-	-	-	30.8b
Assistant lecturers	-	-	-	34.4b
MEDICINE	14.7	18.2	13.5	29.5
General practice (public sector)	-	-	-	51.5
Hospital medicine (public sector)	-	-	-	34.0
General practice (private sector)	-	-	-	13.2
Specialists (private practice)	-	-	-	22.3
Dentists	28.1	26.7	23.1	27.9
Pharmacists	48.4	48.1	58.5	59.7
LEGAL PROFESSION				
Judiciary	10.4	6.6	15.8	34.5
Lawyers	14.3	16.4	23.0	33.3
Notaires	4.6	1.8	2.7	6.1
PRIVATE SECTOR MANAGEMENT				
Administration/management	13.3	12.6	12.4	16.6
Commercial/financial branch	-	-	13.5	18.8
Banking	23.2	26.1	33.8	51.5
Accountancy (chartered/taxation, etc)	10.8	9.9	17.2	24.9

a Data for the 1950s
b Data for 1986-87

Sources: Civil Service Department, 1976: Table 3; Crompton and Sanderson, 1990:96; Equal Opportunities Commission, 1986: Table 6.5, 1987: Tables 6.10, 6.12, 6.14, 6.15, 6.16, 6.19; French Census data for 1962, 1968, 1975, 1982; Grosvenor, 1988:44; HM Treasury, 1987: Table 4; *Note d'information*, 87-35; Podmore and Spencer, 1986:36; Universities' Statistical Record, 1987: Table 26.

National differences in the extent to which women have established their position in professional occupations may be a result of different perceptions of the status of the professions concerned, as illustrated by the examples of law and accountancy. In Britain women remain in a minority in the legal profession and they are very poorly represented in the judiciary. The profession has continued to be much more closed and exclusive than in France, where women have entered law in large numbers and have established a firm position in the judiciary by gaining access to the *écoles de la magistrature*. Although women in Britain were close to achieving parity in the professional examinations for law in 1983 (Equal Opportunities Commission, 1985: Table 5.6), many barriers have been blocking their progress in the professional judiciary, since appointments as judges and barristers still depend upon conditions of practice which it is difficult for women to satisfy (Hansard Society, 1990:44).

In accountancy the status of the profession is very different in the two countries: while in 1988 the Institute of Chartered Accountants in England and Wales had an estimated 88,000 members (Grosvenor, 1988:39), in France under 12,000 qualified chartered accountants were registered with the relevant professional body. Whereas accountancy recruits and trains graduates from any discipline in Britain, the profession is exclusive and closed in France, recruiting only those who have obtained the appropriate qualification, which requires up to 10 years of study both in the educational system and in the professional context. Despite these differences, the position of women within the profession would appear to be very similar: women constituted fewer than eight per cent of members of the ICAEW in 1986-87 (Grosvenor, 1988:45) and approximately 11 per cent of all members of the Ordre des Experts-Comptables et des Comptables Agréés in 1990 (according to data from the Conseil Supérieur de l'Ordre des Experts-Comptables et des Comptables Agréés). The profession is, however, attracting much larger numbers of younger women: they made up 27 per cent of all new admissions in Britain and 32 per cent of trainee chartered accountants in France by the late 1980s. Whether they will increase their representation in the profession commensurately in later years is difficult to predict at this point in time.

Where women have gained access to the educational credentials and professional qualifications needed for a particular occupation, it can be argued that they should be eligible, irrespective of gender, to obtain the rewards associated with that occupation (Crompton, 1987:421). The examples of accountancy and the legal profession suggest that women may be able to establish a stronger position in occupations which have been dominated by men and that their presence may be associated with changes in the way a profession is structured. When the relevant skills are applied in an organizational context, women are, however, still likely to find themselves confronted by gender exclusion. Where women have entered male jobs, they often display a different career profile which is taken to 'justify' lower pay and status, as is the case for part time work in pharmacy

or in certain specialties in medicine (Allen, 1988:59), thereby contributing to the maintenance of a dual labour market. From the examples given above, it would seem that the low skill ratings of what have come to be classified as women's jobs, for example in teaching, do result in low pay and status.

Towards greater accountability of women's employment

The starting point for the present study was that, in accordance with human capital theory (Bruegel, 1983:155-7; Crompton and Sanderson, 1986:26; Dex, 1984:102), women who undergo higher education would want, and be expected, to capitalize on their personal investment of time and effort by seeking to embark on an employment career at a suitably high level of status. It was also postulated that the educational system and its paymasters would be seeking to ensure longer term returns on their financial investment. In a context where higher education is required, increasingly, to be accountable to government and the economy, issues concerning the employment of well educated women are particularly relevant to the human capital debate.

In the first chapter, women in France were shown to have established their position more firmly in higher education than was the case in Britain. French women also appeared to have made greater inroads into some of the traditionally male subject areas. In both countries women have gained ground in the elitist institutions of higher education over the past 20 years. Although they have not yet reached parity in most fields, women would seem to have established a stronger footing in the *école* sector in France than in the Oxbridge colleges in Britain.

The materials examined in this chapter illustrate the different reactions in the two countries to the political pressures forcing higher education to become more responsive to the needs of the labour market. The French system has gone further in creating professionally oriented specialist courses and in offering programmes leading to a wide range of professional qualifications at different levels. The British system has continued to give precedence to generalist skills and to the first degree as the main qualification, and employers still accept it as an indication that candidates have reached the 'required' standard irrespective of their subject area.

As more jobs are advertised for unspecified degrees (40 per cent in 1989) and if, as predicted, the total number of graduates entering the labour market declines, women may find themselves in a less constraining situation. Although specialization is being taken further and occurs at an earlier stage in higher education in Britain (the first two years in French universities provide a more broadly based foundation course than the first two years of an English, as opposed to a Scottish, degree programme), the emphasis placed in the British context on acquiring a professional qualification after graduation could operate in favour of women in that the lack of recognized and specific occupational skills is not necessarily seen as a disadvantage in finding employment. The current realization amongst

employers of the value of qualities such as communicative skills, information handling abilities and language proficiency, which are most closely associated with the degree subjects in which women predominate, could also improve their opportunities in the labour market.

The trend towards further in-service training within companies may, however, operate to the disadvantage of women: while the non-relevance of their degrees may not reduce their chances of obtaining a traineeship, the need for employers to invest in training increases their concern to recruit individuals who are committed to a long term employment career, thus ensuring a return on investment. This is an argument which may already be used against women, even if it is not made explicit.

When factors are considered that affect the speed with which qualifiers enter employment, women are found to be more likely to have studied subjects which show poorer employability ratings; they are less likely than men to have attended the most prestigious institutions. Women's expectations of employment emphasize different qualities from those sought by men, and they tend to enter sectors which are characterized by low status and low pay. When men and women who have followed the same programme of studies are compared, women tend more often than men to occupy jobs for which they are overqualified and underpaid, suggesting that a process of discrimination may be in operation against women employees (Chapman, 1989:31).

If their status is considered in relation to the working population as a whole, women are still found to be present in very small numbers in the higher grade occupations, although the younger generations have made progress in comparison with their predecessors. Where they are in the hierarchical occupations, such as accountancy, medicine and teaching and the higher grades of the civil service, they are less likely to experience career advancement (Silverstone and Ward, 1980:217). In comparative terms French women would appear to have been more successful in entering employment of high status which brings them closer to their male counterparts. The improvement of their position in the educational system is, however, likely to be only one of a number of factors contributing to their progress. Others, such as the legislative framework governing working conditions, equal opportunities and social policy, may be equally or more important in encouraging women to plan and pursue an employment career or in deterring them from committing themselves to continuous working patterns.

3 Pursuing an Employment Career

The place of women in the educational system, and more particularly in higher education, and the conditions under which they enter the labour force have been shown to be determined to a considerable extent by sociocultural factors, such as the availability of different types of education and training, the recognition of qualifications and the status attributed to various occupations in each of the two national contexts examined. Despite socioeconomic and political developments, the progress made by women in the educational system over the past two decades in Britain and France does not appear to have enabled them to overcome gendered mechanisms which result in women entering lower status occupations than men.

Whereas for well qualified men entry into employment is the first stage in what will normally be expected to develop as an upwardly mobile career, for women who have undergone higher education, the longer term prospects are less likely to be so promising, not least because most women expect — or are expected — to perform the dual role of mother and worker and suffer consequent disruptions to their employment careers. In the absence of any far reaching change in work organization or in the division of labour within the home, if well educated women are to be able to compete with their male counterparts, they need to be in a position to adopt behaviour patterns at work which approximate as closely as possible to those of their male colleagues. Comparisons of the differential access of women to education and employment suggest that equality of opportunity in these two areas may still be impeded to a greater extent in Britain than in France by traditional expectations and institutional structures and that well educated women in France might therefore come closer to achieving more continuous full time work profiles.

Patterns of women's employment can be examined from a number of perspectives: economic activity and inactivity rates can be analysed in relation to age, marital status, occupational concentration and segregation, differential rates of pay and conditions of employment, lifetime patterns of work, occupational mobility and promotional opportunities. In the previous chapter the focus was on access by well qualified women to employment and on the opportunities available to them in professional occupations. Reference was therefore made to their situation in relation to

occupational segregation and concentration and to levels of pay. In the first section of this chapter, attention is devoted to discussion of general trends in women's economic activity in the two countries, with particular emphasis on the work histories and organization of working time amongst well educated women.

The ability of women to follow a full time continuous and mobile (geographically and occupationally) employment career similar to that of men with the same level of qualifications is likely to be influenced in different societies by prevailing economic and social conditions and also by political attitudes and public opinion. In the second part of the chapter the impact of women's rights legislation on their working patterns is examined in order to gain a better understanding of the ways in which demand side factors influence patterns of employment for women in general and, more especially, for well qualified women. Analysis of the main supply side factors affecting women's attachment to employment is reserved for the following chapter.

WOMEN'S PATTERNS OF EMPLOYMENT

The availability of the findings from large scale national surveys which have been conducted of women in employment (for example Euvrard et al, 1985; Martin and Roberts, 1984) and of data from the labour force surveys, which the EC countries are now under a legal obligation to carry out, have prompted several Franco-British comparisons of women's patterns of employment (for example Dale and Glover, 1987; Dex and Walters, 1989). Comparative studies such as these are producing an increasing body of evidence which reveals both similarities and differences in patterns of employment in the two countries.

More detailed scrutiny of national findings relating to different socioeconomic groupings indicates that well qualified women may not necessarily conform closely to the overall patterns in every respect although, due to the relatively small number of cases recorded, the data cannot be considered representative (Dex, 1987:44). The claim is, however, supported by the results from smaller scale single nation studies of women who have undergone higher education (for example Castelain-Meunier and Fagnani, 1988; Crompton and Sanderson, 1990). In addition, the Franco-British comparisons conducted for the purposes of the present study suggest that differences can be identified between the two countries for women who achieve a high level of educational qualifications.

Trends in women's economic activity rates

Women's employment patterns in Britain and France have fluctuated considerably since the beginning of the century. These fluctuations have been well documented from a comparative perspective in the literature on

the history of women's employment (for example Myrdal and Klein, 1956; Tilly and Scott, 1978). In both countries the proportion of women who are economically active has been increasing rapidly since the late 1960s, and 1968 is often quoted as the real take-off point for women in France. As shown in Table 3.1, by the late 1980s similar proportions of women had entered the labour force, and they accounted for almost the same proportion of the working population in the two countries. Two points emerge, however, from most of the Franco-British comparative studies of the development of women's economic activity which are worth reiterating since they may have had a lasting impact on the way in which women's employment has been socially constructed. They also distinguish patterns in Britain and France from one another and from those in some other North European and North American societies.

TABLE 3.1 WOMEN'S ECONOMIC ACTIVITY RATES IN THE UK AND FRANCE, 1911-87

	% of all women		% of women aged 15/16-64		% of labour force	
	UK	France	UK	France	UK	France
1911	25.9	36.0	37.6	52.6	29.3	35.5
1951*	27.6	31.0	30.1	46.9	30.7	35.9
1968	31.0	28.6	49.8	47.1	35.7	35.4
1971	31.0	29.7	50.6	49.0	36.5	36.3
1975	33.7	31.1	55.1	51.1	38.7	37.6
1977	34.7	32.5	56.3	53.0	39.3	38.5
1981	35.9	34.1	57.2	54.4	40.6	39.8
1985	38.7	35.3	60.6	54.9	42.2	41.5
1987	40.0	35.8	62.6	55.7	43.1	42.0

* 1954 for France

Sources: Census of England and Wales 1911, 1913: Table 13; General Register Office, 1956: Table 3; Huet and Schmitz, 1984:26; OECD, 1989: Table II.

Firstly, as illustrated in Table 3.1, female economic activity rates have not followed the same pattern of growth. In France the rate started from a higher level: at the beginning of the century the proportion of all women in employment was similar to that reached in the 1980s, whereas in other comparable countries at the turn of the century fewer women were classified as belonging to the labour force. In the United States, for example, in 1900 18 per cent of all women were in employment (Mallier and Rosser, 1987: Table 2.9). From the early 1920s the level fell continuously in France until the beginning of the 1970s since when it has been rising steadily. In Britain the proportion of all women in employment at the beginning of the

century was much lower than today; it remained more or less stable until the Second World War, then followed a steadily rising curve at a level above that for France.

The figures in the table which show the most marked and most lasting increase are those for the economic activity rates of women aged 15/16-64, and here women in Britain have displayed consistently higher rates than in France since the 1960s due, to a great extent, to the much larger proportion of the 16-19 age group in France who continue their education after completing compulsory schooling, as noted in the previous chapter, and who are not therefore available for employment. In both countries the rates have continued to increase over the past decade, despite the economic recession. In neither case, however, is the economic activity of women of working age so high as in countries such as Denmark and Sweden, with 76 per cent and 79 per cent respectively in 1987 (OECD, 1989: Table II).

If the proportion of women in employment has not grown even further, this is explained in part by the fact that the size of the working population as a whole has declined since the beginning of the century due to longer schooling, the introduction of compulsory retirement at an earlier age and the effects of the economic recession. As these factors had a greater impact on male economic activity rates, women in both countries have almost consistently increased their share of the labour market in relation to men since the Second World War, and to a slightly greater extent in Britain. On the demand side, the argument may not be without foundation that the restructuring of the economy in the 1970s and 1980s created more opportunities for women than for men since they offered the characteristics of a more flexible workforce which employers have been seeking (Hagen and Jenson, 1988:10). This was particularly true in Britain where, in the absence of strict regulations regarding conditions of employment, female labour was readily available on terms which could be set by individual employers (Yeandle, 1984:123).

The second point worth noting about trends in women's economic activity is that, although the rate for all women in France was similar in the 1980s to that at the beginning of the century, the figures conceal major changes in the nature of women's work, which, although in the same general direction, are more marked than those which have occurred in Britain over the same period, as shown in Table 3.2. France remained a predominantly agricultural society until the 1950s, with more than a third of the working population still employed in agriculture at the end of the Second World War. The apparent suddenness of the decline in the proportion of the female population employed in agriculture from 1954 is due largely to a change in the system of classification used in the census. At that date women who did not specify that they were in employment ceased to be counted as active. A large proportion of women carrying out unpaid work on family farms or in small family businesses were therefore no longer included in the working population. The 1954 figure for the sector probably represents a shortfall of almost 10 per cent for this reason.

TABLE 3.2 WOMEN'S EMPLOYMENT IN DIFFERENT ECONOMIC
SECTORS IN THE UK AND FRANCE, 1901-87

	Agriculture	Industry	Services
As % of women			
in employment			
UK			
1901	2.1	39.8	58.1
1954	1.7	41.5	56.8
1970	1.8	30.5	67.7
1980	1.3	22.6	76.1
1987	1.1	17.3	81.6
FRANCE			
1906	44.8	27.2	28.0
1954	28.4	25.9	47.7
1970	11.9	25.1	63.0
1980	7.5	22.1	70.4
1987	5.5	18.1	76.4
As % of sector			
UK			
1911	7.7	36.3	41.1
1954	7.4	29.0	46.1
1970	19.8	24.8	46.0
1980	20.0	24.1	50.3
1987	19.6	24.2	51.5
FRANCE			
1906	37.5	34.0	38.9
1954	35.1	24.4	42.7
1970	31.7	23.0	45.3
1980	34.1	24.3	47.9
1987	32.9	24.7	49.8

Sources: Census of England and Wales 1911, 1915: Table 50; Department of Employment and Productivity, 1971: Table 108; Eurostat, 1986: Table 28, 1989c: Table II/9; Mallier and Rosser, 1987: Table 3.2; OECD, 1965:171-3, 1989: Table IV; Le travail des femmes, 1966:6 .

As the British census definition was changed some 70 years earlier, comparisons of women in employment in the first half of the century may be distorted, although the marked difference for employment in the agricultural sector remains whatever classification system is adopted. Since

women in France were employed characteristically on family smallholdings and in small shops and firms as family workers over a much longer period, they continued the pattern of household production which predominated in nineteenth century France and depended on an abundant supply of female labour (Tilly and Scott, 1978:230). During the greater part of this century for a substantial proportion of women, being in employment therefore implied combining family life with almost uninterrupted full time work, as determined primarily by seasonal needs (Bouillarguet-Bernard et al, 1981:97). In Britain, by contrast, a large scale factory based system was established much earlier, drawing on a different pool of labour and making different demands on women.

Another effect of the more recent shift away from agriculture in France has been that women were able to move directly into the expanding service sector rather than into industry. The service sector became the main employer of women in the 1950s, much later than in the UK. Employment in the sector has grown rapidly ever since but without reaching the British level. Although the proportion of working women in industry in France is similar to that at the beginning of the century, the numbers involved have actually declined. The shift towards the services has been accompanied in both countries by a marked increase in the proportion of women who are wage earners (to 93 per cent in the UK, and 87 per cent in France by the late 1980s, according to Eurostat, 1989c: Tables II/11, II/13). Women have also entered public sector employment in large numbers, especially in education and the health services: by 1985 the sector accounted for 31 per cent of women in employment in the UK and 29 per cent in France (Central Statistical Office, 1987: Table 4.7; CNIDF-INSEE, 1986: Table 42).

In relation to total employment in each of the economic sectors, women have continued to make up about a third of workers in agriculture in France throughout the post-war period and less than a fifth in the UK. The proportion of women in the industrial sector has remained almost constant since the Second World War in the two countries with a quarter of all workers. While women have made up more half of the service sector for over a decade in the UK, they did not reach this level until the end of the 1980s in France. By the mid-1980s women accounted for a slightly smaller proportion of all wage earners in France, with 42 per cent, than in the UK, with 45 per cent (Eurostat, 1989c: Tables II/12, II/13) and for a larger proportion of all workers in the public sector in France, with 55 per cent, than in the UK, with 47 per cent (CNIDF-INSEE, 1986: Table 42; HM Treasury, 1985: Table 4).

These overall trends in women's economic activity rates and in the nature of their employment conceal two important differences: French women follow more continuous patterns of economic activity, displaying a greater attachment to full time employment, and they also appear to have more flexibility in the worktime structures which are possible within full time employment; the activity patterns of women in Britain show less

continuity, part time work is much more widespread and constitutes the main form of flexibility.

The persistence of these differences in recent years is relevant to the comparative analysis of the employment patterns of well qualified women in the two countries, since women who undergo higher education might be expected to exploit their qualifications by pursuing more continuous full time employment than women with lower levels of education.

Continuity of employment

When women's economic activity is considered over time in relation to age, a rather different picture emerges from that for the overall rates in the two countries. As shown in Table 3.3, at the beginning of the century in England and Wales levels of employment were very high for women aged 15-24. In the next two age groups they fell steeply and thereafter remained at a low level. In France patterns of employment changed much less with age, most probably since, in their capacity as family workers, women could more easily combine work located at home with childcare responsibilities and were not recorded as having left the workforce when doing so.

TABLE 3.3 ECONOMIC ACTIVITY RATES FOR WOMEN BY AGE IN ENGLAND AND WALES AND FRANCE, 1911-62

	UK 1911	France 1911	UK 1961	France 1962
15-24	65.4	57.8	66.7	48.5
25-34	33.8	52.8	38.4	41.5
35-44	24.1	52.8	43.0	40.4
45-54	23.0	51.9	43.8	45.3
55-64	20.4	46.0	37.2	38.1

Sources: Census of England and Wales 1911, 1913: Table 13; General Register Office, 1966, Table 2; Michal, 1973: Table 1; and data supplied by the Institut National d'Études Démographiques.

In the immediate post-war period in England and Wales women were leaving the workforce by the age of 24, and the level of employment decreased until retirement age. By the 1950s women in France were making a break in employment at the age of 25 and then returning at 35. In 1961 for the first time the census recorded a new pattern in England and Wales, similar to that found in France, with women returning after the age of 35.

By the late 1960s, as illustrated in Table 3.4, the economic activity rate was almost as high for women in Britain aged 45-54 as for 20-24, suggesting

that women were re-entering employment later in life after having completed childrearing, resulting in a distinct bimodal pattern (Hakim, 1979:4), such as had been established earlier in France. By 1968 in France the usual pattern was for women to make a break of several years but, as more women entered employment, particularly women of childbearing age, a new pattern of more continuous employment was emerging. By the mid-1970s, in both Britain and France rates were above 50 per cent for each age group from 20-55, but different patterns had been established in the two countries.

TABLE 3.4 ECONOMIC ACTIVITY RATES FOR WOMEN BY AGE IN THE UK AND FRANCE, 1968-88

	1968		1975		1981		1988	
	UK	France	UK	France	UK	France	UK	France
16-19*	63.6	33.1	59.7	23.4	70.0	17.1	76.5	10.0
20-24	61.3	65.2	63.9	67.4	68.8	66.9	60.1	60.2
25-34	42.1	48.9	51.8	62.0	56.4	68.4	66.0	74.5
35-44	54.7	47.1	66.1	55.9	67.7	65.0	74.1	72.9
45-54	57.1	49.2	66.3	53.5	67.6	57.6	70.8	61.1
55-59	48.1	45.9	52.4	43.5	53.1	46.6	54.8	45.3
60-64	27.4	35.9	28.6	29.8	23.3	25.3	19.3	17.3

*15-19 for France

Source: OECD, 1988: 482-3, 500-1, 1989:482-3, 500-1.

In France during the 1970s the conclusion was being drawn from an analysis of women's working patterns that the standard classification of women as being 'in employment' or 'not in employment' should be replaced by an analysis of women's employment patterns according to whether they were continuous or discontinuous (Labourie-Racapé et al, 1977:148). It was suggested that a distinction should be made between women who participated fully in the labour force and who worked continuously, those who made a short break in employment but soon returned to work and those who were out of employment for a prolonged period of time. A similar classification is used in a comparative analysis of women's employment in Britain and the United States, based on data from the Women and Employment Survey and the US Labour Force Survey over the period 1967-80 (Dex and Shaw, 1986:27), and it provides a useful instrument for measuring and comparing developments across countries.

At the end of the 1970s the vast majority of women in Britain still expected to have a break in employment although, according to the findings of the Women and Employment Survey, they were returning to

work much more quickly after pregnancy. The overall increase in women's economic activity rates was attributed to the higher rate amongst women in their thirties and forties. They were also spending a larger part of their lifetime in employment (Martin and Roberts, 1984:136). Women's wages were said to have become a vital component in household income, and paid employment was giving them a greater degree of economic independence. By 1982 50 per cent of women aged 35-39 in France had pursued an uninterrupted pattern (Desplanques and de Saboulin, 1986:53). This was taken as an indication that paid employment should no longer be considered simply as a means of earning pin money to supplement family income; rather it had assumed a recognized and accepted social function. Women's greater attachment to employment was described as having moved them closer to the pattern for men.

The graphs shown in Figure 3.1, compiled from data for 1988, clearly illustrate the major difference which remains in the work histories of women in the two countries. Whereas in Britain women's economic activity falls steeply when they are in their late twenties and then rises to a peak as they reach their forties, in France employment profiles follow a more even curve, which peaks at an earlier age, in fact the age at which the rate falls steeply in Britain.

FIGURE 3.1 CONTINUITY OF WOMEN'S EMPLOYMENT IN THE UK
AND FRANCE (20-59 AGE GROUPS), 1988

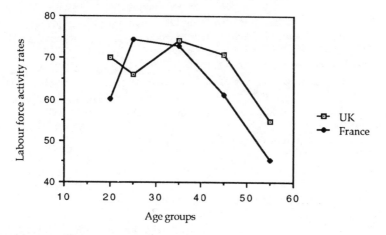

Source: OECD, 1989:482-3, 500-1.

These distinctions between women's patterns of employment in France and Britain are not dissimilar to those found between Britain and the United States. While the rapid increase in continuity of employment since the 1960s has been slowing down in the United States, British women are only gradually making progress towards greater continuity and may still have a

long way to go before they reach the level of their American counterparts (Dex and Shaw, 1986:44). Comparison of the three countries using the labour force surveys have also shown Britain to be the country where women have the least continuous employment patterns (Dale and Glover, 1987). The more recent data analysed here demonstrate further that the overall increases in activity rates amongst British women have not eliminated the bimodal pattern. Read in conjunction with data about other West European countries, Britain would seem to be lagging behind in the league table for continuity of employment, whereas women in France appear to be well placed.

The more continuous employment patterns in recent years for women born in the post-war period have been attributed to longer schooling and better opportunities for girls within the educational system, which has motivated them to follow employment careers along the lines of the male model. The higher earnings they can command may also be an important factor affecting their career expectations. It has been argued that work is no longer seen as a question of choice or necessity but rather as an irreversible fact of life, with the result that the domestic sphere is not the only source of social identity for women, nor are marriage and childrearing their only destiny (Battagliola and Jaspard, 1987:53). In Britain more and better schooling for girls have also been used to explain more continuous employment patterns (Crompton and Sanderson, 1987) but without being attributed the same inevitability as in France. The explanation given above for the much lower figures for women's economic activity in the 15-19 age group in France (namely the greater length of schooling for girls) may not be unrelated to their subsequently more continuous working patterns, if the link between education and employment is well founded.

Analysis of women's work histories does point to a clear correlation between the level of education and qualification and a continuous pattern of employment. Since the 1970s well qualified women in high status employment in both countries have been found to display more continuous patterns than other categories (Dex, 1987:43; Euvrard et al, 1985:9; Labourie-Racapé et al, 1977:67), and continuity would seem to be an important factor in preserving occupational position. Amongst French women aged 40-44, three-quarters of those in administrative and managerial occupations had not interrupted their employment according to data for 1982, an interruption being of two or more years (Desplanques and de Saboulin, 1986:53).

Despite the fact that well educated women in both Britain and France have more continuous careers than women who have not pursued their education to this level, an important difference is found between the two countries in continuity of employment: in the matched sample of well qualified British and French women questioned in the survey conducted for the purposes of this study, 53 per cent of the British women had temporarily withdrawn from the labour force when they had children compared with 16 per cent of the French women, suggesting that this major

distinction between the patterns of employment of women in the two countries is not eliminated by the effects of higher education.

Worktime flexibility

As women's economic activity rates were increasing in the 1970s and 1980s, not only was the nature of employment changing but also the conditions under which women entered the labour market. New non-standard forms of employment were being developed, requiring a more flexible organization of work. The advantages to employers of maintaining a flexible labour force have become more apparent within the context of economic recession. Increasingly, interest has been focused on the development of flexibility as management has shifted its attention to the structural components of the labour process, with the object of improving efficiency and productivity. In these circumstances, the less continuous relationship of women to the labour market and what is seen as their lower level of attachment to employment may, as already suggested, be making them attractive as employees.

Until recently, flexibility had not figured prominently in international comparisons of women's work histories, except for discussion of continuity of employment and part time working, which are only two of its many manifestations. Flexibility of worktime patterns, when working hours can be chosen to fit in with personal needs, is, however, particularly important for women, and especially for well educated mothers, if they are to be able to follow an employment career.

A distinction is generally made in the literature between functional and numerical flexibility (for example, Boyer, 1986; Lane, 1989): functional flexibility concerns the possibility for workers of moving from one job to another; numerical flexibility enables the amount of employment to be adapted, either by adjusting working hours, by taking on staff for short term or temporary contracts, so that the workforce can be altered in response to demand, or by laying off workers in the absence of institutional or legal constraints governing terms of redundancy. This second type of flexibility is of most relevance to the analysis of women's patterns of employment in the context of the present study.

Flexibility and the restructuring of worktime seem to have developed differently in Britain and France; they rest on different assumptions and involve different mechanisms. In comparison with Britain, France was classified in 1985 as having a lower degree of flexibility, defined in terms of the ability of employers to make workers redundant, the amount of temporary employment, the length and organization of worktime and levels of pay (Bommel et al, 1985). Britain was said, in the same study, to have a high degree of flexibility as far as temporary employment, length and organization of worktime were concerned and a fairly high level for the other two measures.

An aspect of flexibility which is central to an understanding of women's employment is that the term can assume different meanings for employers and employees. What is advantageous for one party may not be so for the other. In France flexibility has been associated more especially with new forms of temporary employment which have developed amongst the female population as, for example, in the public sector (Bouillarguet-Bernard et al, 1981:160). In this case, women usually hold low skilled less secure positions on short term contract work which exposes them to economic fluctuations and where flexibility is to the advantage of the employer.

Studies in France of the effects of new worktime structures on employees (for example Bouillarguet-Bernard et al, 1986) have confirmed that flexibility not only has a different meaning for employers and employees but also that it has a different impact according to demographic characteristics. Flexibility has been shown to be used to greater or lesser advantage by different socioeconomic groups: the higher grade occupations, for example, generally afford more opportunities for flexitime (Bue, 1987; Kergoat, 1985). Worktime flexibility is also found to be gendered (Maruani and Decoufle, 1987:21). Some non-standard worktime patterns are more common amongst men (night and weekend work) and others amongst women (non-standard hours in the service sector or the short working week). Non-work factors have been found to impinge more on women than on men when it comes to accepting or refusing non-standard working hours. In Britain too different forms of worktime flexibility are offered to men (overtime) and women (part time), to the extent that part time jobs may be created only if the intention is to attract women workers. Flexibility is gendered in another sense in the British context: where new forms of work organization are introduced in male dominated jobs, advantageous terms are likely to be offered to persuade workers to accept changes in their work practices; women are expected to accept having their working hours restructured without even being consulted (Beechey and Perkins, 1987:177).

Flexibility is not necessarily always to the disadvantage of female employees. The evidence from studies of women in different professional occupations suggests that feminization in both countries may tend to occur when women are able to adapt their working conditions to suit their personal needs, a situation which is not confined to lower grade occupations such as in large scale retailing. In Britain women in medicine, pharmacy, banking and accountancy are found to be attracted by options which give them flexibility (Allen, 1988; Crompton and Sanderson, 1990; Silverstone, 1980). They may, for example, opt for community rather than hospital pharmacy because of the flexibility it affords. French women in higher grade occupations are more likely than those in most other categories, with the exception of retailing, to be able to choose their work schedules (Villeneuve-Gokalp, 1985:278). In France medicine offers more convenient and shorter working hours for women employed in the public sector but also the advantages of independence for those who are in general

practice. The opportunity introduced in France in the 1970s for women in publishing, banking and insurance to work from home one day each week proved to be a very popular form of flexibility amongst women with young children (Lallement, 1987), and in the British context telecommuting may become an important means of retaining a qualified workforce.

In both countries public sector employment tends to afford greater flexibility in worktime organization than the private sector and generally shorter working hours. The civil service was one of the first employers in Britain to introduce flexible working hours on a large scale. Flexitime, which is becoming widespread amongst white collar workers, is most common in the public sector, with an estimated two million employees able to make flexible arrangements for their working hours by the beginning of the 1980s (Moss, 1988:69).

In some professional occupations flexible work schedules are not, however, readily available, as for example in the legal profession, chartered accountancy or the higher ranks in banking. The structure of these professions is based on male models of employment and may demand very long hours of work at unsocial times (Bue, 1987; Huppert-Laufer, 1982), with the result that a career break or less than full time status cannot readily be accommodated (Ward and Silverstone, 1980:16), and the search for flexibility may adversely affect promotional opportunities (Allen, 1988:59). In France chartered accountancy is seen as a particularly difficult occupation for women to engage in because it requires complete availability (Rebérioux, 1982:65). In Britain breaks in employment may mean that women cannot reach partner status in this as well as a number of other professions. Women who qualify in engineering in France tend to be under-represented in the more prestigious category as engineers and managers in companies, where factors such as mobility and availability are crucial in deciding initial employment and in shaping career development. As in many other professional occupations, women are therefore less likely to be in production and maintenance than in the public sector or research and development work, where working conditions are more amenable to women's needs but where opportunities for promotion are less likely to occur (Marry, 1989:324-5).

Comparisons using our matched sample of well qualified British and French women confirmed the importance of flexibility of worktime organization as a factor influencing the ability of women in this category to pursue an employment career. They also revealed the limitations women experienced in occupations where employees are expected to work long hours and to be available at all times to respond to the demands of their clients. Teaching, particularly in France, was quoted as an occupation which is ideally suited for women because it maximizes flexibility. Respondents described how hours of work could be negotiated at the beginning of the school year and how teaching could be organized into blocks of time, thereby releasing whole days when it is not necessary to be on the premises. Women in the teaching profession in France also spoke of being able to

make arrangements easily with colleagues in order to cope with unforeseen circumstances. The British women teachers appeared to have much less flexibility in organizing their working hours and considered it as a privilege rather than a right if they were able to make special arrangements to suit their own needs. Freelance translation was another form of activity which gave maximum flexibility, but here too British women experienced greater difficulty in meeting the occupational demands made of them than did women in France who were self-employed.

When questioned about the opportunities they had for adapting their working hours, more of the French women answered in the affirmative. Several women in the health professions in France mentioned the fact that public sector employment provided the opportunity to work reasonable hours and to adjust working time in accordance with personal needs. In a number of cases, flexibility was used to free a Wednesday in order to be available to look after young children during their midweek break from school. Women in the private sector or those who reached the highest ranks in their profession were, however, much less likely to take advantage of this option on the grounds that their workload did not allow them to be absent and they did not want to distinguish themselves from their male colleagues. Underlying their attitude was the feeling that a less than full commitment to work, interpreted largely as presence at the workplace, is not acceptable in high status employment.

Full versus part time employment

The second major difference between employment patterns in Britain and France, highlighted by comparative studies of national data, is that British women returning to the labour market after a break in employment are more likely to opt for the flexibility which can be gained from working part time. EC and OECD data show that Britain is the European country with the highest level of part time working. The marginally higher overall rates for women's economic activity in Britain (as in Denmark and Sweden) conceal the fact that women are frequently working on a part time basis, as shown in Table 3.5, indicating a lower degree of 'attachment' to employment than in France.

Much has been written about the nature of part time working and the way it has developed in the two countries (for example Beechey and Perkins, 1987; Humphries, 1983, in Britain; Belloc, 1986, 1987; Kergoat, 1984; Nicole, 1984, in France). Cross-national comparisons have also been made which provide detailed analysis of the nature of part time and attitudes towards it (for example Barrère-Maurisson et al, 1989; Dale and Glover, 1987; Gregory, 1987). Some of the main characteristics of part time working can usefully be summarized here insofar as they are relevant to Franco-British comparisons and are likely to affect well qualified women.

TABLE 3.5 WOMEN EMPLOYED PART TIME IN THE LABOUR FORCE IN THE UK AND FRANCE, 1973-87

	Women's share of part time		As a % of women in employment	
	UK	France	UK	France
1973	92.1	82.1	38.3	11.2
1981	94.3	84.6	37.1	15.9
1987	86.2	82.5	44.6	23.0

Note: In the *Enquête emploi*, part-timers were defined between 1975-82 as those working less than 30 hours a week, which is the usual definition in the UK. Since 1982 self-definition of part time has been adopted in France. Officially part time is anything less than four-fifths of full time, the authorized weekly working hours being a maximum of 39.

Sources: Eurostat, 1989c: Table VI/2, 1989d: Table 41; OECD, 1985:16.

In the UK and France part time working varies according to age, marital and parental status. In both countries from the age of 25 full time employment rates fall in favour of part time work, but to a greater extent in the UK, where married women account for a much larger proportion of all part time workers, with 72 per cent compared with 60 per cent in France (Eurostat, 1989d: Table 41). Amongst women with pre-school age children, part time levels are much lower in France and they remain fairly constant as children reach school age, while in Britain many more women enter part time work when their children begin schooling (Moss, 1987: Table 1).

Although British women may be spending a shorter period away from the workforce during childrearing, their return to employment is most often on a part time basis. This is said to be the result of the way in which the need for women's labour grew in a context where they were also expected to bear major responsibility for raising children (Barrère-Maurisson et al, 1989:51; Beechey and Perkins, 1987:10). Part time therefore satisfied the needs of employers for a relatively flexible workforce, while giving women a means of organizing their work around their family responsibilities. The view has consequently developed that part time is voluntary or freely chosen by women and provides a satisfactory answer for all parties concerned. Most women in Britain have, in fact, claimed to be satisfied with the balance achieved between work and home (Martin and Roberts, 1984:192). Studies of women employed part time in Britain demonstrate convincingly that the status and earnings commanded by part time working are, however, markedly inferior to those of women in full time continuous employment (Beechey and Perkins, 1987:2-3; Joshi, 1984:47). A clear relationship has also been established between part time

and downwards occupational mobility in Britain (Dex and Shaw, 1986:107), leading to the conclusion that part time may be more advantageous to employers, particularly where it provides a means of reducing non-wage costs, than to the majority of women who have no option but to engage in it for practical reasons. The satisfaction they express with their working arrangements may be primarily an indication of their relief with having at least found a manageable solution to a pressing personal problem.

In France, by contrast, where more women were employed for a much longer period after the Second World War on family smallholdings or in family businesses, part time work was not offered by employers to attract women into the labour force and has not come to be associated with the same imagery of convenience. It has, consequently, remained at a relatively low level, as illustrated in Table 3.5. Studies of part-timers show that the type of employment involved is generally poor status with little responsibility and in small firms where the hours worked are subject to a number of constraints (Bue and Cristofari, 1986). Women with discontinuous employment profiles are more likely to be working part time (Desplanques and de Saboulin, 1986:62). Those taking part time work are not, as in Britain, mainly women with young children. They are more likely to be younger women (under 25) entering their first job and unable to find full time long term employment, or older women (aged 40 or more) who no longer have childcare responsibilities (Belloc, 1987:44-6). The conclusion can be drawn that this type of flexibility is by no means providing a satisfactory answer to most of the problems it might have been expected to solve either for the workers themselves or for employers.

Part time work does not necessarily always result in downwards occupational mobility, as illustrated by the example of the United States (Dex and Shaw, 1986:74). When legislation was introduced in France in the early 1980s in an attempt to increase the level of part time working, emphasis was placed on the fact that it should bring the same advantages as full time employment in terms of social insurance cover, paid leave and promotional opportunities. In Britain women who take part time work often find they have to forego a number of employment rights: employees working under eight hours a week are not covered by National Insurance and those with less than 16 hours are subject to reduced rights and generally lose fringe benefits. Their situation in this respect did become more secure in 1977 when women working part time and with an income above the earnings threshold could no longer opt out of paying National Insurance contributions. Further changes in 1989 sought to make it more advantageous for women on lower wages to opt to pay the full rate.

Legal provision had already been made for part time work in 1970 for public sector employees in France. Legislation enacted in 1981 and 1982, with the express intention of expanding part time, placed greater emphasis on the rights of employees. Those who accepted part time jobs were guaranteed the same rights as full time workers with regard to paid leave, seniority, probation, redundancy pay and pensions. Full time workers were

given preference for any part time posts created in the firm where they were employed, and part-timers must be given preference when full time jobs become available within the company. From the employer's point of view part time working does not therefore afford so much flexibility as in Britain, particularly in the absence of substantial advantages in terms of the reduction of non-wage costs.

Under the 1980s legislation women were given the opportunity to move in and out of part time work in accordance with their personal needs. They can now opt to work a 'reduced' week, for example of four-fifths time, which enables them to take off Wednesdays when young children are not at school. In 1986 27 per cent of all part-timers in France were women in this category, known as *mercredétistes* (Belloc, 1987:116). Technically this qualifies as part time, but it does not have the same negative connotations as work which is created specifically for part-timers, since it is clearly advantageous for the women concerned who do not thereby suffer a loss of status, pension rights and other income related benefits and can return to full time as and when they choose. The example of the public sector, where part time work is more likely to be voluntary, has been widely followed by the private sector, where part time hours are, however, a negotiated arrangement rather than an automatic right and are much more likely to be involuntary or imposed as a condition of employment (Huet, 1985:14). An important consideration for public sector workers is that for a reduction to 80 or 90 per cent of full time working hours, the reduction in salary is not directly proportional: 14 per cent for 80 per cent of full time and 8.5 per cent for 90 per cent. Since the public sector also makes generous provision for other forms of flexibility (flexitime, leave to care for sick children), the take-up rate of part time has, however, been very similar to that in the private sector for work of equivalent status (Huet, 1985:25).

Generalizations about the level of part time and the age groups most likely to be working part time hours conceal differences between socioeconomic groups. In both Britain and France better educated women in higher occupational categories are not only the most likely to have more continuous employment patterns, they are also said to be least likely to work part time (Dale and Glover, 1987:38). Given the small proportion of women in the higher occupational groups, not unexpectedly, few part-timers are found amongst them in comparison with the total labour force: in 1984 four per cent of women part-timers in Britain were in the categories for professionals, employers and managers (OPCS, 1986: Table 6.30); in France in 1986, five per cent of part-timers were in the equivalent category of *cadres et professions intellectuelles supérieures* (Belloc, 1987:117); in the public sector 18 per cent of women workers were classified as part-timers, but only three per cent of those in the top grades (Huet, 1985:25).

When the amount of part time work is considered within the groupings for professional, semi-professional and management occupations, an interesting contrastive situation begins to emerge. According to the Women and Employment Survey, 22 per cent of teachers were working

part time in the late 1970s, and teaching is considered as an area where part time work is relatively limited in comparison with the overall proportion for non-manual working women of 34 per cent (Martin and Roberts, 1984:25). Data on subcategories of the professional grouping for women in Britain for the mid-1980s from the labour force surveys indicate that female part-timers accounted for 24 per cent of all teachers, for eight per cent of workers in occupations classified as literary, artistic and sporting, for five per cent of general management and two per cent of professional and management related or non-general managerial positions (Equal Opportunities Commission, 1987: Table 3.12). In France, according to national survey data, in the early 1980s, 21 per cent of women in the grouping for professional and higher administrative grades were working part time, compared with 11 per cent of women in the intermediate non-manual grades (Villeneuve-Gokalp, 1985:274). Amongst teachers 21 per cent were classified as part time, a level close to the national average for part time and very similar to that recorded for Britain (Huet, 1985:25).

Comparative analysis of women with children, based on the Women and Employment Survey in Britain and research conducted in France on working mothers with children (Euvrard et al, 1985), showed a relatively high level of part time amongst women in professional occupations in France bringing them close to their British counterparts (Dex and Walters, 1989:207). The authors of the comparison gave as a possible explanation the progressive nature of income tax which might lead women in the higher grade occupations to prefer reduced working hours.

The findings from our survey of well qualified British and French women also suggest that women in the higher occupational grades do not conform to the overall patterns highlighted by national studies, but the tax incentive was not identified as a consideration. Although these results cannot be considered significant, due to the relatively small number of women in the category concerned, they do indicate that part time rates for women in higher grade occupations require further unravelling.

Amongst the women in our study who had undergone higher education, a slightly larger proportion of part time working was observed in France than in Britain, and the rate for France was above that recorded nationally for all socioeconomic groups. The level in Britain was about half the national average and close to that recorded in the Women and Employment Survey for women in the higher grades. While a quarter of the French women in our study were working part time when the study was conducted, a further 14 per cent had in the past changed to part time hours and had subsequently returned to full time employment, indicating that part time may not be a marginal or long term phenomenon within this category. Almost all the women continuing in part time when the survey was undertaken had three or more children or a very young child. A third of the part-timers were in teaching and another third in dentistry, pharmacy or medicine.

This distinctive pattern amongst the French women could be explained to some extent by the fact that more of them had children, and those with children, unlike their British counterparts, had more often continued working. Part time was therefore a convenient compromise, but also generally a temporary expedient, which was not considered to be detrimental to status and promotional opportunities and could readily be exchanged for full time when their children were older, as demonstrated by the fact that the women concerned had not been dissuaded by the tax situation from resuming full time employment.

Part time working and the break in employment are two of many possible adaptations to worktime structuring. Flexibility, as measured by discontinuity, the availability of part time and flexitime, is central to an understanding of the ability of women to be in employment. The popularity of pharmacy amongst women in Britain has been explained by the availability of part time employment (Crompton and Sanderson, 1990). Similarly medicine offers opportunities for part time work, but these are generally in what are considered as 'non-career posts', in community care or a limited number of hospital specialties where appropriately trained full time staff cannot easily be recruited (Humphries, 1983:145). In this case, part time acts as a constraint on a career since it is taken as evidence of a lack of commitment to employment (Allen, 1988:36). In the civil service part time is relatively difficult to obtain in higher grade employment, and this has been a subject for criticism amongst women civil servants (Management and Personnel Office, 1982:29).

The main forms of flexibility in Britain — the career break and part time — are most often associated with a discontinuous employment pattern, loss of status and income. The consequences of this form of flexibility would seem to be almost entirely negative as far as income and promotion are concerned and would appear to prevent women from being able to pursue the type of linear career which would bring them closer to the male model of employment. In that they resort to forms and conditions of flexibility which do not prevent them from maintaining their attachment to full time continuous employment, well educated women in France, by contrast, are increasing their chances of developing and pursuing an employment career.

WOMEN'S RIGHTS LEGISLATION AND PATTERNS OF EMPLOYMENT

While the advantages to employers of women's flexibility as workers should not be underestimated, when patterns of employment are interrupted for family reasons women may be considered more expensive to employ and they may be thought to constitute 'unreliable' workers in comparison with men. Legislation designed to protect women's rights to equal pay and equal treatment can be interpreted in this second context as part of a package of measures which are made necessary because the labour market situation of male and female workers is construed as being

inherently different. If it is accepted that inequalities at the workplace are structural, the arrival of more and better qualified women on the labour market will not automatically result in women achieving equal opportunities, hence the importance of legislation as a means of redressing the imbalance.

Within the OECD and the EC the theme of equal rights for women in employment has figured prominently and resulted in a number of international comparisons of women's labour market position, often commissioned by the relevant organizations (for example OECD, 1980, 1985; Peemans-Poulet, 1984). Comparative studies suggest that, in relation to most of its neighbours, British government intervention in the area of women's rights can be described as 'hesitant' and 'limited' and its programmes as 'incremental and fragmented' (Ruggie, 1984:xiii). The assumption underlying government action is that women's two roles are in conflict and that this conflict inhibits women's participation in the workforce. The solution to the problem is not, however, considered to lie with the state, which will only intervene to give support to those who fail to cope for what are considered as reasons of personal inadequacy. Britain has never had a ministerial appointment for women's rights and the topic has not been high on the political agenda. Recent policies to promote sexual equality were formulated as part of broader measures under the general umbrella of racial equality, which means that women's rights have been pursued in conjunction with those for ethnic minorities, the handicapped, homosexuals and lesbians.

In France, by contrast, women's rights have been enshrined in the Constitution since 1946. More recently, society has been described as having put itself under a legal obligation to ensure equality between the sexes (Laufer, 1987:7). Not all French governments have, however, been equally enthusiastic in their support for women's rights, and changes in government have been associated with different ideologies which are reflected in the approach to the issues involved.

In the 1970s women's rights were given particular prominence through government appointments and were the subject of concerted policies. This burst of interest in women's affairs coincided with a period when women were joining the labour force in large numbers and adopting much more continuous patterns of employment. Françoise Giroud was appointed as the Secrétariat d'Etat à la Condition Féminine in 1974 and immediately set to work producing a blueprint of far reaching policy recommendations to improve women's rights (published as *Cent mesures pour les femmes*, in 1976). In 1978 Nicole Pasquier was appointed to a ministerial post with responsibility for women's employment, but some of the momentum was lost at the end of the 1970s when the focus was primarily on women as mothers rather than as workers and mothers. The first left wing government under François Mitterrand's presidency in 1981 gave a new impetus to the cause of women's rights. It included a Ministère des Droits de la Femme, headed by Yvette Roudy, who spearheaded a series of major

reforms. Between 1986-88, the return to power of the centre right resulted in a cooling off period, and the emphasis shifted back to family policy as in the late 1970s. When it resumed power in 1988, the new left wing government did not seek to initiate a further wave of reforms. The Mission Égalité Professionnelle, established under the first Mitterrand presidency, was, however, still in operation at the end of the 1980s under the auspices of a less well supported (financially and morally) Secrétariat d'État Chargé des Droits des Femmes.

Through its women's rights legislation, in recent years the state in France has demonstrated its commitment to policies which are intended to break down the barriers to greater equality, both of opportunity and of results, through positive action programmes. The assumption underlying policy, which is diametrically opposed to that in Britain, is that women should not be left to their own devices to resolve the conflict with which they are faced and that the state should intervene to provide support systems and services for all women who want to be economically active.

Not only do the level of government commitment and the attitude to women's rights differ between Britain and France, but also the extent to which publicity is given to this area of policy. Whereas the British system is criticized for not making clear the rights that women have (Cohen, 1988:88), French policy is highly visible. Since the 1970s government sponsored organizations in France have commissioned publications which describe in straightforward terms the rights of women in society, the home and at work and the procedures for exercising them. Yvette Roudy's ministry published a *Guide des droits des femmes* in 1982, of which the 700,000 copies printed sold out within a year. A government funded Centre d'Information Féminin was established in 1972 with the aim of providing objective information and advice for women free of charge. In 1981 its name was changed to include women's rights and Yvette Roudy became its president. In 1987 the title was further adapted to reflect the shift in policy towards the family focus, becoming the Centre National d'Information et de Documentation des Femmes et des Familles.

These differences in perspective between the British and French governments are apparent in the women's rights legislation which has been drawn up and enacted in the two countries since the beginning of the 1970s and provides a substantial framework within which to view and compare the progress made in this area in the two countries over the past 20 years.

The legislative framework for women's rights

The European Commission has given a strong impetus to national governments to introduce or refine legislation on women's rights. EC member states are legally bound by Community directives, which set out the timetable for implementing objectives. Each country is able to choose the most suitable form and method within its legal system for bringing its

own national legislation into line with Community law, and the Commission has the right to take infringement proceedings against member states which fail to comply. In some cases, national legislation has preceded or accompanied Community directives, reflecting the growing importance of the issues involved in all EC countries; in others, it has still not conformed fully with European standards.

Although women are not given special mention in the Treaty of Rome of 1957, Article 119 does lay down the principle that men and women should receive equal pay for equal work. Throughout the 1960s the Commission regularly reported on the difficulties of putting this principle into practice. In the 1970s concern over the persistence of inequalities between men and women at work led the Commission to issue directives to member states in an attempt to prevent discrimination against women at work. A resolution was adopted by the Council of Ministers in 1974 affirming its intention to pursue a social action programme in order to achieve greater equality between men and women with regard not only to pay but also access to employment and vocational training and working conditions. A memorandum to the Council from the Commission demonstrated its commitment to taking all necessary measures to ensure that the principle of equality of treatment of men and women workers could be implemented. Three directives were adopted: 75/117 in 1975, relating to the application of the principle of equal pay for men and women; 76/207 in 1976, extending the principle to equal treatment in access to employment, promotion, training and working conditions; 79/7 in 1978, on the implementation of equal treatment for men and women in matters of social insurance, supplemented by 86/378 and 86/613 in 1986, which extended the principle of equality of treatment to self-employed men and women.

In addition, two Community action programmes have been organized by the Commission, covering the promotion of equal opportunities for women for 1982-85 and 1986-90. The first programme stressed the need to put equal opportunities into practice (particularly as in Directive 76/207) by means of positive action programmes aimed at enabling women to overcome their disadvantage in relation to men. The second reiterated the Commission's support for these programmes and recommended that the public sector should serve as an exemplar. It also placed emphasis on equality in working conditions for jobs involving new technologies and on more equal sharing of professional, family and social responsibilities.

BRITISH LEGISLATION ON WOMEN'S RIGHTS

The decision was taken in 1969 in Britain to legislate on equal pay, following more than a decade of implementation of equal pay for non-manual workers in the public sector. The influence of the EC on the decision to legislate can therefore be considered negligible (Davies, 1987:26). The Equal Pay Act is probably one of the most significant pieces of legislation in Britain in more than two decades. The Act was passed in 1970

with a five year period of voluntary compliance. It brought Britain into line with the spirit of the Treaty of Rome and went beyond what was required by the EC at that time. The Act was intended to eliminate discrimination in matters of pay by giving all workers the right to equal treatment with an employee of the opposite sex in the same employment, for the same or 'broadly similar' work or for work rated as equivalent under a job evaluation scheme. Britain was subsequently accused by the European Court of Justice of infringing the right to equal pay for work of equal value by not having a procedure whereby workers for whom no job evaluation existed could obtain recognition of equivalence.

The Conservative government elected in 1979 was reluctant to intervene to extend the legislation on equal pay on the grounds that the state should not interfere with the internal workings of the labour market. The amendment to the Equal Pay Act, introduced in 1984, can therefore be attributed to the influence of the EC following on from a decision of the European Court. Under the amendment a mechanism was established for employees to claim discrimination over unequal treatment for work of equal value by recourse to an independent expert, even where a job evaluation scheme is in operation. The individual applicant is now entitled to an equal value assessment. The burden of proof remains, however, on the complainant.

The Equal Pay Act did not tackle the question of equality of opportunity in access to jobs. The second major piece of British legislation on women's rights was the Sex Discrimination Act which came into force in 1975. The aim of the Act was to promote equal treatment of women by preventing direct and indirect discrimination and by imposing penalties for infringements, in accordance with the EC directive. The Equal Pay Act was subsequently incorporated into the 1975 Act, making it one of the most comprehensive in the EC. Again the EC's requirements would not appear to have provided the initiative. Rather the Act can be seen as the outcome of strong domestic pressure for legislation on equal opportunities for women which had been building up in the early 1970s. Recognition was thereby given to the fact that, although women were entering the labour force in increasing numbers, occupational segregation had not been reduced and women were still concentrated in the poorly paid and low status occupations (Davies, 1987:35-7).

Unlike other countries in the EC, the British closely linked their legislation to that on racial discrimination and framed it in similar terms. The Act makes discrimination on the grounds of sex unlawful in education, in the provision of goods, facilities and services to the public. It covers issues such as appointments, promotion, dismissal and redundancy and complements the Equal Pay Act by dealing with non-contractual aspects of employment as well as contractual situations which were not otherwise included. No reference is made to social insurance, pension rights and taxation, thereby leaving an important area of discrimination intact (Bruegel, 1983:152). Nor was explicit reference made to women's

circumstances, which means, for example, that a pregnant women has no legal recourse if dismissed.

Direct discrimination, as defined in the Act, concerns the less favourable treatment of an individual on the grounds of sex in comparison with a person of the opposite sex. Indirect discrimination refers to practices which, although applied equally to both sexes, can have a discriminatory effect, for example by setting an age bar for recruitment. Job advertisements must not be couched in such a way that they give preference to one sex over the other. Some provision is made for positive discrimination in training, but employers are not under an obligation to set up positive action programmes, and the Act does not allow them to apply any reverse discrimination at the point of selection or recruitment. An employer may provide training to existing employees or encourage them to take up work in a job employing comparatively few members of one sex. In recruiting new employees encouragement can be given to applicants from the minority sex, providing it is made clear that recruitment will be based solely on merit.

Although legislation was introduced in 1983 to eliminate some of the anomalies in the treatment of men and women in the social insurance system, the British government is still a long way from complying with the EC directive in this area. Britain continues to operate different retirement ages for male and female workers, and women have not enjoyed all the same entitlements to social insurance benefits as men.

The 1975 Act established the Equal Opportunities Commission to enforce the law, monitor its operation and advise governments about the impact of different areas of social policy on women. The EOC can undertake formal investigations into the workings of the law, issue codes of practice for employers and initiate proceedings in cases of discrimination where the victim is not identifiable.

FRENCH LEGISLATION ON WOMEN'S RIGHTS

The principle of equal rights for men and women was recorded in the French Constitution of 1946. In 1950 a minimum wage was created, and in 1972 new legislation on equal pay for work of equal value was introduced in line with EC thinking. Legislation was enacted in 1975 to prevent employers from refusing to employ a woman or making her redundant for reasons associated with pregnancy. The most comprehensive antidiscrimination law with respect to equality at work (*égalité professionnelle*) was passed in 1983, eight years after the British Sex Discrimination Act. It was heralded as the most significant piece of legislation on women's rights ever created in France and was written into employment law (*Code du travail*) and the penal code. In the following year the law was extended to public sector workers. The French government considers that it does not need to take any action to comply with the EC directive on equal treatment in social insurance, since it claims that anomalies in this area have already been resolved.

The 1983 *Loi Roudy*, named after the minister responsible for guiding it onto the statute books, was much wider in scope than any previous legislation and, in several respects, it contains some of the most far reaching legislation within the EC. It was designed to tackle three problems areas: access to training and promotion, pay and unemployment. Explicit reference was made to sources of discrimination relating to sex or family circumstances. A job advertisement can no longer specify the sex of the candidate being sought. Except in a very small number of cases, a job cannot be reserved exclusively for members of one sex. Different types of leave and working hours must not be offered to men and women, with the exception of leave relating to maternity. The principle of equal pay was extended to cover work of equal value, as measured by comparable skills, knowledge and professional competence based on either formal qualifications or experience and the physical and psychological requirements of the job. A case can be brought for infringement either by the complainant or on her behalf by a union. Both equal rights and equal opportunities are covered, but unlike the British legislation, no reference is made to indirect discrimination. When a case is contested the onus is on the employer to prove equality of treatment rather than on the employee to prove inequality.

The new legislation was innovatory in two important respects: firms are placed under a legal obligation to produce an annual report on the relative situation of men and women employees in order to ensure that the principles defined in the law are being put into practice; following the recommendation contained in the EC directive, compensatory measures in the form of positive action programmes, can be established to correct inequalities (Ministère des Droits de la Femme, 1983). The law on equal rights and opportunities at work included a proposal for companies with over 50 employees to set up annual schemes designed to improve the position of women workers. Smaller firms are also encouraged to adopt such schemes but are not obliged to report back on an annual basis. In their reports employers must produce comparative figures showing the relative position of women in terms of recruitment, training, promotion, qualifications, job status, working conditions and real pay, and also formulate plans for improving the situation. Reports must be presented to the works committee (*comité d'entreprise*) and union representatives and must be made available to any employee who asks to see them. Quantitative and qualitative targets are set for recruitment, training, promotion and the organization of working conditions. In order to ensure that women gain access to a wider range of employment, some positions can be reserved exclusively for them.

Within the positive action programmes (*plans d'égalité professionnelle*), provision for training opportunities can be made available only to women, and training programmes can be organized in such a way that women's family constraints are taken into account, for example by ensuring that the hours and place where the training is

provided are compatible with personal arrangements. Quotas can be operated for promotion to positions where women are under-represented. Employers are also encouraged by financial incentives, in the case of schemes which are judged to be outstanding, to draw up positive action programmes, setting out objectives for a period of two, three or five years. Financial support from the state can cover 50 per cent of the cost of training, 50 per cent of other costs involved in the scheme and 30 per cent of the wage bill for employees while they are undergoing training.

The 1983 law created a statutory body, the Conseil Supérieur de l'Égalité Professionnelle, to oversee its implementation. The Council is a government body with responsibility for carrying out research and initiating action. Its functions include enabling representatives of employers and unions to meet together with other interested parties to review the situation and draw up proposals for action. Another body, the Mission Égalité Professionnelle, acts as a mediator between firms and the state providing information and ensuring a dialogue takes place. These two organizations oversee the production of the annual reports required from firms; they help companies to formulate their own positive action programmes and direct them in how to apply for financial support by contracting agreements with the state.

The impact of women's rights legislation on patterns of employment

The influence of the EC legislative framework on Britain and France may be of both symbolic and practical significance. The EC can add weight to the argument for introducing antidiscriminatory laws: criticism from the European Court of British equal pay legislation, for example, did serve as additional evidence that the law needed to be changed. The French government, for its part, appears to have used membership of the EC as a springboard for extending its own practices in an effort to bring other countries into line with its policies, as for example with equal pay legislation where France, as a leader in the field, feared competition from member states with lower labour costs.

By the end of the 1980s both countries had a body of law which covered equal pay for work of equal value and sex discrimination in training, recruitment and promotion. In comparison with the United States, the British legislative framework has been described as relatively incomplete (Meehan, 1983:170). A similar criticism could be directed against Britain in comparison with the national legislation on women's rights in France, particularly since 1983, both in terms of the level of protection and the amount of encouragement afforded to women by law. Because the influence of legislation is as often indirect as direct — if not more so — tangible results are, however, difficult to detect and measure. Differences in timing as well as in socioeconomic and cultural factors mean that any progress which can be recorded may not be attributable solely, or even in part, to legislative change. It is nonetheless worth trying to assess the

impact of legislation in three areas where it can have a bearing on women's motivation and their ability to pursue an employment career: pay, following equal pay legislation; occupational segregation and concentration, with the implementation of sex discrimination laws; and equality of opportunity, as a result of positive action programmes.

PAY DIFFERENTIALS

Despite the problems of identifying causal relationships, it has been argued that equal opportunities legislation may have had some impact on pay differentials between men and women in Britain in the first few years of application. From the available evidence it has been demonstrated that the earnings gap was probably narrowed initially but has widened again since 1977 (as reported by Dex and Shaw, 1986:14-16). Hourly wage rates for full time work did begin to converge in the mid-1970s, but the improvement was not sustained (Bruegel, 1983:136). Whereas incomes policies were thought to have had only a short lived effect on female relative wages, the antidiscriminatory legislation of the 1970s has been identified, using an econometric analysis, as the main factor in the improvement because it had an impact on differentiated female rates (Zabalza and Tzannatos, 1985). The fact that so many women in Britain work part time and interrupt their employment is, however, such a powerful determinant of women's wage levels that the positive effects of any legislation on equal pay for work of equal value are easily cancelled out.

Comparisons of levels of pay in France over the five year periods 1970-75 and 1976-80 show that, overall, average and individual wages rose much faster for men as well as women in the first period and that women's wages rose more than those of their male counterparts in both periods and at a greater rate in the second of the two. Women in higher levels of employment saw their wages increase less than those of their male counterparts in the first period. The trend was reversed between 1976-80. Men in the younger age groups (up to the age of 40) performed better than their female counterparts, suggesting that women may be able to command higher wages at a later age (Choffel, 1987:154-5). By 1983, despite an overall decline in the differential from 1979 and some closing of the gap for the category, the difference between male and female wages was still greatest (at 35 per cent) for women in the highest occupational grades (Huet, 1985:29). Salary differentials in the higher grades of the civil service were found to be much smaller than in the private sector (Meron, 1987:174). Since the persistence of differentials cannot be attributed to direct discriminatory practices, the gap between men and women must be interpreted as the effect of women not reaching the highest ranks in professional occupations, as argued in the previous chapter.

International comparisons, such as those conducted by Eurostat, suggest that pay differentials between men and women may be much greater in Britain than in France and that during the 1980s the gap between the two countries may have been widening: at the beginning of the decade

women's gross monthly earnings for non-manual workers were 55 per cent of men's in the UK and 62 per cent in France; by 1988 women's rates as a percentage of men's had increased by 0.3 per cent in the UK but had risen by 3.2 per cent in France (Eurostat, 1989b: Table II/3). This discrepancy between the two countries may be due, amongst other factors, to the strictness with which the principle of equal pay has been enforced and controlled. A number of other explanations can, however, be posited: different management attitudes to the selection and promotion of women; differences in incentives or opportunities for women to pursue continuous and upwardly mobile careers; differences in women's education and training; and the existence in France since the 1950s of a minimum wage, which, because of its comprehensiveness, may have been more effective over a longer period of time than the action of Wages Councils in Britain. The various factors involved cannot easily be untangled since moves to intensify equal pay and to implement equal opportunities legislation coincided with a period of economic recession and a time when more women were entering the labour force and taking increasingly insecure forms of employment.

OCCUPATIONAL SEGREGATION AND CONCENTRATION

In the absence of other compensatory mechanisms, legislation on equality of opportunity in access to jobs on the basis of equal qualifications or equal pay for work of equal value cannot be expected to change the firmly entrenched characteristics of occupational segregation. Some examples are quoted of women gaining access to employment from which they were previously excluded, as in engineering, but legislation on sex discrimination may not be the only or the main reason. The law alone may be limited as a tool in changing the structure of the labour market (Ruggie, 1984:131). Whereas the Equal Pay Act had an identifiable target, and therefore more measurable effects, the operation of the Sex Discrimination Act is difficult to monitor. As the Act was aimed at increasing equality of opportunity for women in their access to training, jobs and promotion, trends in occupational segregation and the concentration of women in particular occupations can usefully be considered in an attempt to determine whether the legislation may have had some tangible effects.

The Women and Employment Survey found that, at the end of the 1970s, over half the working women in the sample were in jobs which only women did at their workplace, and more than 80 per cent of the men interviewed worked only with other men. Occupational segregation was, however, lower in the service industries than in manufacturing and lowest among the high level occupations (Martin and Roberts, 1984:26-7). Compared with the beginning of the decade, the concentration of women in women's work appeared to have increased: in 1971 74 per cent of women were in occupations which had 50 per cent or more women workers, and 88 per cent of men worked in occupations which had 50 per cent or more male workers; by 1981 the respective proportions had risen to 77 per cent for

women and fallen to 86 per cent for men (Mallier and Rosser, 1987:3.11). When single sex occupations were examined in 1987, fewer women in full time employment, 43 per cent, were found to be working only with women compared with 58 per cent in 1980 (Witherspoon, 1989:178).

The concentration of men and women in different occupations is less marked in France than in Britain and it has also been increasing more slowly: 66 per cent of women were in occupations which were predominantly female in 1975 and almost 68 per cent in 1982. The concentration for men had fallen by 0.1 per cent and was just below 82 per cent in 1982, according to the relevant census data.

While women are still confined to a narrower range of occupations than men, as illustrated in the previous chapter, they have been increasing their share of positions in a number of the higher grade occupations in both countries. Women in these grades also represent a steadily growing proportion of all women in employment, as also indicated in Chapter 2. Despite very considerable advances in some professional occupations, vertical segregation remains very marked, however, in the higher grades.

Since the public sector has tended to act as a trail blazer in both Britain and France in introducing measures to give women more equal opportunities, and on occasions preferential treatment, comparisons of the situation in this sector in the two countries may be expected to give some indication of the potential effectiveness of government intervention. In Britain the civil service has operated a policy of equal pay for equal work since 1961, and no distinction is made between men and women for the age of retirement. The proportion of women reaching the highest grades has increased to only a limited degree since the early 1970s, and they still represent a relatively small number of all workers in these categories. In France the proportion of women in the higher grades increased at a faster rate between 1962-85 in the civil service than in the private sector (Seys, 1987:46).

The evidence from the United States suggests that a steadily growing number of American women have found employment in management positions, and this has been attributed, in some cases, to sex discrimination suits brought against large employers (Dex and Shaw, 1986:28). The conclusion has been drawn that the aggressive equal opportunities policies pursued in the United States have, for example, opened up a wider range of higher grade non-manual occupations to women and enabled more women to take managerial and administrative jobs. Following from the American model, because of its more comprehensive nature, the 1983 law in France might be expected to have a more marked effect than British legislation on sex discrimination, but it may be some time before the full impact is felt. By the same token, if legislation can influence occupational segregation, British women should be in a more favourable position since the Sex Discrimination Act has been in operation for longer. However, as previously argued, the legislative framework may not have been applied with the same sense of commitment as in France.

EQUALITY OF OPPORTUNITY

In comparisons between the United States and Britain, the role of affirmative action policies is often quoted as an important means of accelerating the rate of desegregation of employment (for example, Meehan, 1985:178). Unlike the French, the British Government decided not to follow the EC recommendation to extend antidiscrimination by legislating on positive action. The British Sex Discrimination Act does not explicitly prohibit such action but leaves it very much to the individual discretion of employers to adopt measures designed specifically to give women equal opportunities. France was one of only a small number of EC countries to adopt legislation in this area. The formal justification offered for the stronger legislative stance in France was the ideological need to achieve greater social justice combined with the importance of promoting economic development and efficiency. Employers were said to be depriving their firms of a major human resource by wasting the potential of women if they leave the workforce. The 1983 French law, in compliance with the EC recommendation (although it actually preceded it by one year), does not impose positive action on employers but seeks to 'establish a framework of appropriate provisions designed to promote and facilitate the introduction of legal positive action measures' (Docksey, 1987:16).

The law was based on three principles: equal rights, equal treatment and equal opportunity and has been interpreted as the culmination of two centuries of gradual progress towards equality in human rights. Unlike previous legislation, it recognizes women's special needs as workers because of inequalities which have not been eradicated by legislation on equal rights and equal treatment (Laufer, 1984). The legislators thereby make the admission that only by unequal treatment can equality be achieved.

In the first year of enforcement, under the 1983 law, firms with more than 300 employees (smaller firms were not initially included in the scheme) were legally bound to submit an annual report on the relative situation of their women workers regarding recruitment, training, promotion, pay and working conditions. Guidance was given for writing the reports in a booklet, entitled L'égalité professionnelle, issued in 1985 by the Mission pour l'Égalité Professionnelle. In 1984 3,000 reports were submitted to works committees. The reports clearly demonstrated the relative disadvantages which women were facing compared with their male counterparts. The EDF-EGF (nationalized Electricity and Gas Companies) produced factual evidence, showing, for example, how women with the same level of qualification and of the same age did not follow the same career progression as men. Promotion took much longer, they less often reached positions of responsibility, and this was said to explain their lower earnings (Meynaud and Auzias, 1987:21).

In the first five years of operation 17 positive action programmes were drawn up, of which 11 were given financial backing from the ministry. Firms such as Moulinex, Sofinco (a credit company), Aérospatiale, CEA

(nuclear energy), EDF-EGF, the Banque Régionale de l'Ouest, Bull Angers, CIN (bank), DIAC (Renault credit), all included measures designed to encourage women to obtain promotion to higher grade positions (Secrétariat d'État Chargé des Droits des Femmes, 1989). The most widely quoted form of action proposed by the companies concerned was in training opportunities. Examples from some of the schemes which have been implemented suggest that women may be targeted for promotion if they are thought to have management potential. Particular attention was paid to ensuring that maternity leave should not have an adverse effect on opportunities. Some firms went so far as to use parental leave as a reason for encouraging functional mobility of women in higher grade positions. Positive action programmes also made it possible for works premises to be adapted so that it would be more feasible for firms to employ women.

A further experimental scheme was introduced in France in 1987 in six administrative regions in an attempt to encourage occupational desegregation (contrats pour la mixité des emplois). After the trial period the scheme was extended to the whole of the country in 1988. It was aimed primarily at firms employing fewer than 200 workers. The object was to help women to gain access to employment in areas previously dominated by men where, for example, more than 80 per cent of jobs were occupied by men or where jobs associated with new technologies were being introduced and women were under-represented. In this case individual agreements can be drawn up and signed by the state, the employer and the employee concerned, making the necessary provision for further training or changes in physical working conditions.

Although the law was criticized within the first five years of enforcement for the relatively small number of schemes it attracted, it was credited with having placed the onus on firms for human resource management of the female component of their workforce. Companies were encouraged to assume responsibility for the career development of their female employees. In assessing the impact of the positive action programmes implemented as a result of the 1983 legislation, it has been claimed that the legal framework forced employers to take account of the principles of equal rights and equal opportunities (Laufer, 1986). An important shift occurred in policy from the traditional approach to motherhood, involving protection of women for demographic reasons, to a situation where employers are being actively encouraged to ensure that motherhood does not adversely affect the development of a woman's employment career. A gender difference (motherhood) is no longer acceptable as a reason for inequality between men and women. Four objectives have been followed by firms and are relevant to the issues examined in this chapter: legitimation of concern for the special needs of women workers; economic efficiency through more effective use of human resources, particularly in an environment where new technologies are requiring different skills and a higher level of qualification; greater employee involvement in the enterprise culture by giving female workers

new incentives; greater social awareness of questions concerning women's employment, making them part of public debate (Laufer, 1987:9).

The implications of equal rights legislation for the professional lives of well educated women

In assessing the place of women in the economy in relation to the impact of government policy in Britain and Sweden, the basic difference between the two countries has been said to lie in their perspectives (Ruggie, 1984:61). Intervention in Britain has been in an *ad hoc* fashion and the outcome largely unpredictable. In Sweden, by contrast, the government has manipulated all the factors shaping the economy and has been more active in directing the process of change. The same difference is apparent when Britain and France are compared. In France the state has played a much more strongly interventionist role in all aspects of the economy: successive governments have, for example, followed a concerted and uninterrupted system of economic planning over the entire post-war period, and the 1980s have been characterized by far reaching policies aimed at restructuring the economy and work organization practices. In the area of women's rights the French have shown a much greater degree of commitment to legislation designed to increase equality of opportunity. The legal framework has undoubtedly played an important part in ensuring the effectiveness of positive action in countries such as Sweden and the United States (Docksey, 1987:15). The French schemes have not been in operation long enough to allow any firm conclusions to be drawn. They do seem, however, to have served the purpose of raising the level of awareness of the issues involved nationally, and they could therefore have a cumulative effect on attitudes as well as behaviour.

Women who undergo higher education have been found to display a stronger attachment to continuous full time employment. They also differ from women who have not gained such a high level of qualification in that they seem better able to exploit opportunities for flexibility. They might therefore be expected to show greater awareness of their rights at the workplace and to seek to take advantage of any schemes intended to improve their working conditions and accelerate their promotion, thereby gaining higher returns on their investment in their education.

Women in France should be in a more favourable situation than their British counterparts to pursue a continuous and upwardly mobile career for a number of reasons: more French women reach higher levels of academic qualification; they more often display continuous work profiles and are more likely to benefit from the different forms of worktime flexibility available to them, such as part time or flexitime arrangements, without loss of status; they receive greater support and encouragement from the state in their efforts to gain access to equal opportunities through the stronger legislative framework governing women's rights.

In Britain, in the absence of any nationally organized and state supported equivalent to positive action programmes, a number of companies have introduced their own equal opportunities provision, often in the form of equal opportunities audits, monitoring and training or the more widely publicized career break schemes (as discussed in the next chapter), to encourage women to return to work. In a context where the number of qualifiers from higher education is declining (a situation which is not paralleled in France), these schemes can be seen as the response of employers faced by skill shortages. Employers recruiting and training well educated women are thereby seeking to avoid wastage of their financial investment by training women who subsequently withdraw from the full time workforce at the point when they could be producing maximum returns. The incentive to take account of women's special needs is not founded on an ideological concern with equality of opportunity and is not being actively promoted by government policy as in France. Rather, practically minded businessmen are being forced by economic necessity to find ways of extending the available pool of skilled labour.

The net effect for well qualified women may not be dissimilar in the two countries in that their special needs are being duly recognized, and working conditions are being adapted to accommodate them. The discrepancies may be greater between women with different levels of qualifications and competence in Britain compared with France, since positive action programmes apply to all women, whereas equal opportunities audits, training programmes and career break schemes are aimed primarily at women who are not easily replaceable. In addition, although positive action programmes are not likely to be reversed without considerable political opposition, management development and career break schemes could cease the moment employers realize that the effects of the demographic downturn on the availability of well qualified workers are not so severe as they had been led to suppose or find alternative sources of suitably qualified workers.

Comparative analysis of the position of women in the labour force, as conducted in this chapter, suggests that French women in general, and well qualified women in particular, may be more securely attached to employment than women in Britain. Although in both countries women have been marginalized, they would seem to be in a stronger position in France in relation to their male counterparts because of their more continuous pattern of employment and their more frequently full time status. In a period of economic recession, the stronger attachment to employment and the greater proximity to the male pattern may be less advantageous in that employers are seeking a flexible workforce, such as is offered typically by women in Britain. In the higher grade occupations, especially in the public sector, which is a major employer of female workers, women may, however, be protected from many of the side effects of changes in the structure of the demand for labour. The fact that several of the large firms which have introduced positive action programmes in

France are under semi-public control may also be of relevance to an analysis of the ways in which public policy can have an impact on women's employment careers.

The influence of government policy cannot be discounted or discredited in producing a more favourable situation for women in France. But other factors should not be ignored: the importance of agriculture and small family firms as a source of employment for women over a much longer period; the rapid rise in economic activity rates at a time when women's rights were on the political agenda; and the perpetual concern of French governments over the falling birthrate and the consequent need to ensure women do not neglect motherhood. The intention in this chapter has been to analyse and contrast the patterns of employment of well educated women in Britain and France and to gain a better understanding of their position in the labour force primarily from the demand side. In the following chapter attention is paid to explaining how women's family life affects the supply of labour and how public policy impinges on the way in which family building is organized in relation to professional life.

4 The Impact of the Family on Women's Working Lives

When, as in wartime or as in Britain at the end of the 1980s in anticipation of a downturn in the number of young qualifiers seeking employment, women's work serves as a means of increasing the available supply of labour, employers are prepared to change work structures to accommodate women. After each of the two world wars, women in Britain were pulled back into the home, and the arrangements which had been introduced in wartime to make it possible for them to do men's work turned out to be temporary (Braybon and Summerfield, 1987:281). Since the 1940s many changes of an apparently more lasting nature have occurred, affecting the place of women in the labour market and their lifetime patterns of employment. Analysis of trends over the post-war period in Britain and France demonstrates that more women of working age are displaying a stronger attachment to employment, although the manifestations of this trend differ between the two countries. These shifts have been accompanied by the implementation of legislation on women's rights within the context of directives from the European Commission. Attempts to change the status of women's employment through legislation on equal pay, equal treatment and equal opportunities cannot, however, be shown to have brought any marked improvement in women's working conditions by reducing occupational segregation or by substantially increasing women's access to promotion and higher levels of pay. Nor can it be assumed that positive action programmes will bring about significant long term changes in women's professional lives if they are restricted to working arrangements, and unless the contribution of women to society in their capacity as mothers is recognized.

Just as government intervention in the area of women's rights could be described as hesitant and fragmentary in Britain, in comparison with the stronger commitment of successive French governments to more comprehensive and far reaching policies, the same difference applies in respect of family policy. Whereas British governments have been reluctant to intervene in what are considered as the private lives of citizens, France has placed family policy high on the agenda for social reforms since the interwar period and particularly in post-war years. In the 1970s, when economic planning was extended to encompass social life, the future of the family was a central concern for ideological as well as demographic reasons.

François Mitterrand marked his first term of office as president in 1981 by creating an Institut de l'Enfance et de la Famille in 1984 and by extending the remit of the Haut Conseil de la Population, a national consultative body founded in 1946, to include family matters. When the centre right government was in power from 1986-88, some of their most publicized social legislation was in the area of family policy. At the workplace, positive action programmes can be interpreted as recognition that employers have become aware that they must take account of the special needs of women workers, as suggested in the previous chapter. Recent family policy in France would seem to reflect the recognition that women are making an important contribution to the nation both as mothers and workers and that the state has a duty to ensure that family and professional life are not incompatible.

From a comparative perspective, it is useful to try to measure the impact of the differences in approach to family and employment policy as they affect working mothers in Britain and France and to examine the relationship between policy and patterns of family formation and employment. The example of well educated women is especially relevant to an analysis of the work-family relationship since women in this category tend to show a stronger attachment to continuous full time employment than those who are less well qualified and they may be establishing trends which will later be followed by other social groups.

CHANGING FAMILY PATTERNS

Comparisons of family formation in Britain and France, using national census data, show that the size of the population and the number of households are very similar (Marpsat, 1989). In both countries average family size is declining as the divorce rate and the number of single parent families increase, and several generations less frequently live together. However, these overall similarities conceal differences both within each of the two countries, for example between social categories and age groups, and cross-nationally, as in patterns of age at marriage and of childrearing in relation to employment.

Trends in marriage patterns

In both Britain and France marriage rates, which reached a peak in the early 1970s, have since been declining steadily, while divorce rates and the number of cohabiting couples have been rising steeply. The higher marriage rate in Britain compared with France, as shown in Table 4.1, can be attributed to a great extent to the fact that a larger proportion of British women do contract marriage: almost 84 per cent in 1986, compared with 72 per cent in France (Marpsat, 1989:7). Within the EC the UK is the country with the highest marriage rate, and France has the lowest (*Population et sociétés*, 1989:1).

TABLE 4.1 TRENDS IN MARRIAGE RATES IN THE UK AND
FRANCE (PER 1,000 POPULATION), 1950-87

	1950	1961	1971	1975	1981	1987
UK	8.1	7.5	7.8	7.5	7.0	7.0
France	8.0	7.0	7.5	7.4	5.8	4.7

Source: *Population et sociétés*, 1986:2, 1989:1.

In the UK the proportion of women in professional and managerial occupations who remain unmarried is greater than the average for all women and for all other social categories across the different age groups (Haskey, 1983: Table 6). Analysis of celibacy rates in France for women in the 35-44 age group shows that eight per cent of all women are not married by the age of 35, but the level reaches 18 per cent for women who have pursued higher education for four years or more after taking the *baccalauréat* (Desplanques, 1987:488).

As shown in Table 4.2, age at first marriage is very similar in the two countries and has been rising since the early 1970s but, whereas British women were marrying at a slightly later age on average in the early 1960s, by the late 1980s French women were older than their British counterparts when they contracted their first marriage. Although women marry at approximately the same age in the two countries, their ideal age for marriage differs: the average age at which French women would prefer to marry is below 23; for British women it is 24 (Zucker-Rouvillois, 1987:120). British women therefore come closer to achieving their ideal.

TABLE 4.2 WOMEN'S AVERAGE AGE AT FIRST MARRIAGE IN THE
UK AND FRANCE, 1960-87

	1960	1970	1980	1987
UK	23.3	22.4	23.0	24.2
France	23.5	22.4	23.0	24.9

Source: Eurostat, 1989a: Table VI.

Again variations can be noted according to social categories. In Britain median age at marriage is several years higher for women in professional and managerial occupations (Haskey, 1983: Table 3). In France average age at marriage for women between 38-47 who were married by the age of 35 is higher for those who have pursued their education to degree level or

above: they normally marry by the age of 25, compared with an average age of under 22 for women who left school with the minimum educational qualification (Desplanques, 1987:489). In the past women who continued their studies after leaving school generally married several years after completing their education, whereas women in this category now tend to do so immediately they finish studying. For one in three French women with a qualification at degree level or above, marriage will precede the completion of their course, reflecting both the length of studies and the fact that security of employment is no longer a precondition for marriage.

British women also divorce more frequently than their French counterparts, as shown in Table 4.3, and the divorce rate has been rising faster in the UK since the mid-1970s. In France the higher the level of educational qualification achieved by a woman the more likely she is to divorce: 12 per cent of women married between 1965-69 who had completed higher education were divorcing in the early 1980s, compared with nine per cent of women with the minimum school leaving qualification (Desplanques, 1987:492), suggesting that a woman's level of academic attainment may be an important factor determining the likelihood of divorce. As divorce rates have risen, however, the rates for couples with the husband in the higher occupational grades have remained below the average.

TABLE 4.3 DIVORCE RATES IN THE UK AND FRANCE (PER 1,000 POPULATION), 1960-87

	1960	1970	1980	1987
UK	0.5	1.1	2.8	2.9
France	0.6	0.8	1.5	2.0

Source: Eurostat, 1989a: Table VI.

Not only are marriage and divorce rates higher in Britain but also the proportion of cohabiting couples, which has been increasing rapidly in both societies in recent years. Differences in the accounting systems adopted in the two countries may, however, affect the comparability of the figures. The British data are derived from self-definition by individuals, whereas French census data are reconstituted in order to identify cohabiting couples. In Britain almost 18 per cent of women under 35 were cohabiting in 1986-87 (Haskey and Kiernan, 1989:26), compared with three per cent in 1979. The proportion of cohabiting women who are single has been increasing at a faster rate than for divorced and separated women. In France 16 per cent of women in the same age group were cohabiting in 1986, a rise from about five per cent in the mid-1970s (Audirac, 1987:504). In Britain women with a degree are more likely to be cohabiting than other single women (Haskey

and Kiernan, 1989:29). Women in the higher grade occupations in France also have higher cohabitation rates than those in the lower grades (Audirac, 1987:506).

The effect of marriage on women's patterns of employment

Although today a marriage bar no longer prevents women's employment, marriage can still have an effect on their working patterns, albeit to a lesser degree than motherhood. As shown in Table 4.4, the impact of marriage on women's employment has fluctuated in Britain and France during the course of the twentieth century. In Britain few married women were in employment at the beginning of the century. Their activity rate started to rise in the 1950s, reached a plateau in the 1960s and was rising again in the 1980s. In France about half of married women of working age were in employment in 1901, the rate fell after the Second World War, it has been rising since the 1960s but has remained below the level for the UK. The lower marriage rate for women in France may, however, affect the comparability of the figures.

TABLE 4.4 ECONOMIC ACTIVITY RATES OF MARRIED WOMEN IN THE UK AND FRANCE, 1901-87

	1901	1931	1951/1954	1968	1975	1981/1982	1987
UK	10	10	20	49	51	51	55
France	50	44	32	34	40	48	51

Sources: Eurostat, 1989d: Table 04; Fernandez de Espinosa, 1981:5; INSEE, 1987b: Table 6.2; OPCS, 1989a: Table 9.3; Tilly and Scott, 1978:214.

Women's full time economic activity rates are nearly 20 per cent lower in Britain for married women without children in comparison with single women: 60 per cent and 79 per cent respectively in 1985 for women aged 16-59 (Equal Opportunities Commission, 1988: Table 3.18). In France rates are slightly higher for married than for single women, and marriage would seem to have a negligible effect on women's employment patterns (Desplanques, 1987:496). More economically active married women are employed part time in the UK than in France: 46 per cent compared with 26 per cent in 1987, and part time rates are particularly high in the UK for married women in the 25-29 age group: 56 per cent compared with 25 per cent in France (Eurostat, 1989d: Table 41).

 Although by the late 1980s relatively few women were leaving employment because they married, marriage could bring about other changes. Analysis of the responses of the well qualified British and French women who were questioned for the purposes of this study showed that,

for about a fifth of each sample, marriage had affected the choice of occupation. Priority was almost always given to the husband's career on the grounds that he was earning more and was more likely to be promoted. Where they had married before qualifying or had been planning to do so, the women concerned had looked for employment, for example in a specialty area, which would be compatible with marital life. In a few cases they had changed employment for the same reasons. In Britain teaching and clerical work were thought to be most adaptable and, for women in the medical profession, laboratory work or general practice were sought in preference to hospital or clinical medicine. In France teaching was considered particularly amenable but also the public rather than the private sector. Several of the French women explained a change of direction on marriage by the fact that they wanted to avoid working in the same job as their husbands, whereas for some of the British women a professional partnership was considered a desirable and convenient option.

For more than half the British and a smaller proportion of the French women marriage had had an impact on the location of their work. The need to follow their husbands implied geographical mobility and flexibility on the part of wives, often at the expense of their own promotion. In the public sector in Britain women have been found to turn down promotion because it would mean a change of location (Management and Personnel Office, 1982:35). Women in France quoted the advantage of employment in the public sector after several years of service because they were able to request a transfer, whereas initially they could find themselves posted a long way from their husbands' place of work. Two-thirds of the women interviewed in a study of the medical profession in Britain saw marriage as a constraint on their career because of the need to find a job where their husbands worked (Allen, 1988:34). The problem was not, however, peculiar to female doctors: a third of male doctors felt that their own career prospects were being affected by the need to consider their wives' employment. Geographical mobility not only imposed strain on careers but also on marriage itself. Analysis of national survey data collected in the early 1980s by the INSEE showed that, while women in the higher occupational grades were less likely than women in other categories to leave employment for family reasons, they were more likely to do so because of their spouse's geographical mobility (Desplanques and de Saboulin, 1986:59).

A third of the British women and under a fifth of the French in our Franco-British study referred to the effect of marriage on their chances of promotion. A spouse's geographical mobility and the priority given to his career had generally had negative effects on the wife's opportunities by reducing availability and mobility. The decision not to pursue a particular specialty in medicine because of marriage meant that women found themselves in areas of employment with poor promotional prospects. In the teaching profession, examples were given of the way in which the constraints associated with marriage had resulted in demotion for some of the British women. The prejudices amongst employers against married women were mentioned as a reason for reduced opportunities. Many

women spoke of their own loss of ambition because of the difficulties they had to face and the feeling that if they pursued their own career they would be acting selfishly. In a few instances in both countries the effect of marriage had been positive: some women mentioned the moral and financial support given to them by their husbands. Divorce also provided an incentive, either to launch out professionally in a new direction, as exemplified by some of the French respondents, or to become more committed to employment and return to full time work.

Cost benefit analysis of the family and professional careers of well qualified men and women shows that the opportunity cost of getting married is likely to be negative for women but positive for men. In Britain the importance of a woman's supportive role for her husband has been demonstrated (Finch, 1983), whereas marriage is seen to be to the woman's disadvantage in terms of her own professional life. Analysis of the career progression of women graduates from polytechnics and colleges produces similar findings, illustrating how men's views of their career prospects can be enhanced if they marry, whereas those of women deteriorate (Chapman, 1989:101). In France a male bachelor graduate has been found to have a 79 per cent chance of employment in the higher grade occupations, compared with an 83 per cent chance for a woman who remains single; the chances for a man rise to 90 per cent if he marries but fall to 79 per cent for a woman who contracts marriage (de Singly, 1987:225).

Trends in family building, household size and composition

In the 1980s the birthrate, as measured by the number of births for women who have finished childbearing, was at the same level in both countries, as shown in Table 4.5. In the UK the rate started to increase in the early 1950s, but from a lower level than in France where it had risen rapidly during and following the Second World War. Nor has the subsequent decline followed the same pattern. After reaching the same level in 1964 in both countries the rate fell to its lowest point in the UK in the mid-1970s before rising again to the same level as in France, where the decline has been almost continuous since the 1950s.

TABLE 4.5 TRENDS IN THE BIRTHRATE IN THE UK AND FRANCE (TOTAL PERIOD FERTILITY RATES), 1950-87

	1950	1965	1970	1975	1981	1987
UK	2.10	2.83	2.43	1.79	1.94	1.82
France	2.93	2.84	2.47	1.92	1.95	1.80

Sources: Biraben, 1978: Table 2; Monnier, 1986; Table 3; Tabah and Maugué, 1989:42.

While actual average family size, as measured by the number of children, has fallen below two in both countries, comparisons of ideal and actual family size, based on European data for social values, indicate that the preference of British women is nearer to two children and that of French women nearer to three. As with age at marriage, British women seem to be finding a closer match between the ideal and reality. Whereas a majority of British women in the same survey expressed the view that a woman can achieve self-fulfilment without being a mother, this opinion was held by a minority of women in France (Zucker-Rouvillois, 1987:123-5). Despite the declining popularity of marriage, French women would appear to have a greater attachment to family life.

The difference between the two countries in the fall in fertility rates is also reflected in trends in household size. As the two countries do not use the same definition in their national censuses for households, the data are not directly comparable: in Britain reference is made to the unit of housekeeping, while in France the concept of a household dwelling is used. The effect of this difference in definition is, however, thought to be small and to have become less important as household size has decreased and the composition of households has simplified (de Saboulin, 1989:4). As shown in Table 4.6, although household size has been declining since the 1960s in both countries, the decrease has been greater in Britain where it started from a higher base. At the beginning of the century mean household size in England and Wales was larger than in France. By the early 1960s the size was very similar and has remained so.

TABLE 4.6 TRENDS IN MEAN HOUSEHOLD SIZE IN ENGLAND AND WALES AND FRANCE, 1911-82

	1911	1921	1951/1954	1961/1962	1981/1982
England and Wales	4.36	4.14	3.07	3.06	2.70
France	3.50	3.31	3.19	3.10	2.70

Source: Marpsat, 1989, Table 1.2.

In both countries the decline in the number of children per family and in household size has been accompanied by growth in the number of households composed of a person living alone or in a couple without children. The similarity in the composition of households at the time of the last national censuses, as illustrated in Table 4.7, is striking, although the proportion of single parent households and couples without children is slightly greater in Britain. France shows higher rates for single person households and couples with children. The model of a couple with two children applies to about 25 per cent of households in both cases, and a significant decline has occurred in the number of three children families.

TABLE 4.7 HOUSEHOLD COMPOSITION IN ENGLAND AND WALES
AND FRANCE (AS A PERCENTAGE OF ALL
HOUSEHOLDS), 1981/82

	England and Wales 1981	France 1982
Single person households	21.5	24.6
Single parent families	5.4	4.3
Couples without children	28.3	26.7
Couples with children	37.3	39.5

Source: Marpsat, 1989: Table 2.1bis.

Women with high levels of educational qualifications are more likely than
women in other occupational groups not only to remain unmarried but
also to be childless, or at least to postpone childbirth. In Britain highly
qualified women are increasingly likely to be childless at the age of 25: 65
per cent in the 1950-54 cohort compared with 54 per cent in the 1940-44
cohort (OPCS, 1986:29). Wives of men in the professional and intermediate
social classes generally wait for more than three years after marriage before
having their first child (Central Statistical Office, 1985: Table 2.23). In France
the pattern of delayed childbirth was established in the late 1960s by better
qualified women and has since been followed, but to a lesser degree, by
other social categories as average age at first childbirth has increased. At the
age of 35 25 per cent of women in France in the 1935-44 age cohort did not
have any children, compared with 10 per cent for women with only the
minimum educational qualification. Well qualified women are also likely
to have a smaller number of children than other social groups, the
difference being of 1.75 and 3.04 between the two extremes (Desplanques,
1987:478). However, these figures are deceptive. Because a relatively large
proportion of well educated women do not marry or have children, the
average for the category is low. Analysis of women in higher grade
occupations who do have children reveals that, when they decide to start a
family, women in this category have, on average, more children than in
the intermediate occupational groupings.

The effect of motherhood on women's employment

The decline in the birthrate has been accompanied by compression of the
period during which childbearing takes place. Family building now begins
at a later age than in the 1960s, when women were having more children,
and it finishes at an earlier age, which means that women can expect to
spend a shorter period of their potential working lives producing and
caring for young children.

When the continuity of employment in relation to age was considered in the previous chapter, as illustrated in Figure 3.1, the bimodal pattern was found to be characteristic of British women, whereas the graph for French women peaked at the point at which British women were leaving employment and then followed a decline to retirement age. If the age curve is matched with data on the number of children, these differences between the two countries are confirmed, as illustrated in Table 4.8. Although French women in the 25-29 age group may leave the workforce when they have children, and at a steadily increasing rate as family size grows, returning as their children grow older, the fall in economic activity rates is nowhere so marked as for women in the UK, where the rate of return is also consistently lower, except after the age of 40 with a large family size.

TABLE 4.8 ECONOMIC ACTIVITY RATES BY AGE FOR WOMEN WITH CHILDREN IN THE UK AND FRANCE, ACCORDING TO NUMBER OF CHILDREN, MID-1980s

	Wife's age			
	25-29	30-34	35-39	40-44
UK				
0	83.3	79.8	75.9	70.0
1	40.2	49.4	63.9	69.1
2	33.1	47.5	63.2	63.8
3	21.9	34.0	48.9	56.3
4+	8.2	33.5	32.2	29.9
France				
0	89.0	84.6	81.6	74.9
1	80.6	85.1	81.4	72.3
2	62.4	70.3	73.1	64.1
3	30.2	42.7	50.5	49.8
4	20.9	27.3	37.0	39.0
5 +	11.9	10.8	13.2	14.3

Sources: Desplanques, 1987:496; from secondary analysis of Labour Force Survey data for 1984 supplied by the ESRC Data Archive and OPCS.

In Britain economic activity rates for mothers with children aged 0-4 increased from 25 per cent to 30 per cent between 1973-85 and to 37 per cent by 1988, when they reached 52 per cent in France (according to Eurostat data collected for the European Childcare Network). Within the EC France is one of only three countries where more than 50 per cent of women with children aged under five are in employment. Analysis of the ages of dependent children, as in Table 4.9, shows that it is still age rather than number which is the critical factor determining whether women in the UK

work at all and whether they work part time. The UK and Ireland, together with the Netherlands, have the lowest rates for children under five (Moss, 1988:10-11). The UK is the only country in the EC where economic activity rates and hours of work are higher for women with children aged 5-9 than for children under five. Although part time working is a dominant characteristic of women's employment in the UK, part time rates are also lowest for women with children of pre-school age, regardless of the number. As children reach the age of 5-9, economic activity rates for mothers in Britain working part time rise rapidly and after the age of 10 they increase for full time work, while in France only a small change is recorded in part time rates for mothers with older children as compared with the level for women with children aged 0-4.

TABLE 4.9 ECONOMIC ACTIVITY RATES FOR WOMEN WITH CHILDREN IN THE UK AND FRANCE, ACCORDING TO CHILDREN'S AGES, 1985

| | Wife aged 15/16-59* | | |
| | UK | | France |
	ft	pt	
No dependent children	47	17	42
1 child 0-2 (UK) 0-3 (France)	8	12	70
1 child 3-4 (UK)	14	20	-
1 child 5-9 (UK) 3-5 (France)	13	38	79
1 child 10+ (UK) 6-17 (F)	26	39	75
2 children youngest 0-2 (UK) 0-3 (France)	3	25	69
2 children youngest 3-4 (UK)	5	35	-
2 children youngest 5-9 (UK) 3-5 (France)	13	45	68
2 children youngest 10+ (UK) 6-17 (France)	28	44	60
3 children youngest 0-2 (UK) 0-3 (France)	1	20	45
3 children youngest 3-4 (UK)	8	25	-
3 children youngest 5-9 (UK) 3-5 (France)	12	35	36
3 children youngest 10+ (UK) 6-17 (France)	23	40	31

* 15-59 in France

Sources: INSEE, 1987a: Table Men 09; OPCS, 1986: Tables 6.5, 6.14.

In France the ages of dependent children seem to have relatively little impact on whether women remain in employment, and the number of children appears to be of greater importance. The fall in economic activity rates which now occurs characteristically when women have three rather than two children is a relatively recent phenomenon dating from the 1960s, Until then as many women with two as with three children were taking a break in employment. By 1981 as many women with two children were

economically active as with one child in 1975. Expressed in slightly different terms, the economic activity rate of women aged 30-39 with two children aged under 16 more than doubled between 1968-82 and reached a higher level than for women in the same age group without children in 1962 (Lery, 1984:25).

Rather than being evidence that it becomes impossible for women to cope with employment if they have three children (Lery, 1984:29), the break can be interpreted as an indication that women who decide to devote themselves to childrearing as their main activity leave the workforce at the point when they want to put this plan into action (Desplanques, 1987:497), which may even be at the birth of the first child (Lollivier, 1988:29). For women on low incomes the decision to stop work when they have three children may result from the fact that the financial benefits of continuing are outweighed by the costs. The compensation afforded by generous family benefits and other allowances may also enter into the calculation for women in poorly paid jobs. The more positive interpretation of the decision of women to stop work (namely because they want to devote themselves to a family career) is supported by data which show that women who leave the workforce when they have children are not necessarily returning when their offspring reach nursery school age (Desplanques, 1987:497).

The main reason why women in the higher grade occupations in both France and Britain have more continuous employment patterns than other categories would seem to be that they are less likely to leave the workforce when they have children. Analysis of work histories based on the Women and Employment Survey in Britain has shown that a larger proportion of women in higher occupational categories had worked after every birth (Dex, 1984:44-8). From the same data it has been concluded that better qualified women are more likely to return to work between births than those with lower levels of qualification: 38 per cent with GCE 'A' levels compared with 28 per cent with CSE passes (Martin and Roberts, 1984:131). In France six per cent of women in the higher occupational grades left employment in the year following the birth of a child in 1982, compared, for example, with more than 25 per cent of women employed in retailing. For each child well qualified women are less likely than other social categories to leave the workforce and more likely to return, except after the third child (Desplanques, 1987:498-9). Nonetheless, the economic activity rate for women in the higher grade occupations with three children is the same as that for women in the intermediate occupational grades with two children and for industrial workers with one (Desplanques and de Saboulin, 1986:55). Part time rates amongst women in the higher occupational grades are lowest with two children (16 per cent) and highest with one child (26 per cent). They also rise for three children (23 per cent) (Villeneuve-Gokalp, 1985:273), suggesting that it may be most difficult to make suitable caring arrangements for the first child.

While not only marriage but also parenthood may increase men's chances of a successful career, marriage and more especially motherhood,

are likely to jeopardize women's professional opportunities. This situation is not peculiar to Britain and France. A comparative study of patterns of interaction between paid work and family life in Finland, Hungary, Norway, Poland, the Soviet Union, Sweden and Yugoslavia confirmed that, everywhere, the impact of family on work is negative for women, whereas for men it is the impact of work on the family which is the negative force (Cernigoj-Sadar, 1989:151).

The detrimental effects of motherhood were amply demonstrated by the comments received from the women questioned in our Franco-British study of well qualified women. Women with an equivalent level of qualifications in the two countries had different expectations of their careers. Their reactions to employment reflected the degree to which they felt the conflict they experienced could be resolved at an acceptable cost, both financially and psychologically. The arrival of children meant that they had less time and energy to pursue their career, particularly in private sector management where very heavy demands were made on them. Several British women commented on their loss of ambition and motivation to succeed professionally. Others felt that they had had to defer their career until their children reached school age. The views expressed by a number of the French women were more positive: children had forced them to rethink and improve the way they organized their lives; maternity leave had given them the opportunity to undertake further study and to reassess their professional situation. These findings about the detrimental effects of raising children are confirmed by other studies in Britain: four out of five of the women interviewed in the medical profession, for example, saw children as a career constraint forcing them to restrict their work commitment (Allen, 1988:35).

Measured over a lifetime, the economic opportunity cost of childbearing involves not only loss of earnings while away from the workforce but also reduced earnings after a return. Calculated in terms of lost earnings, in the mid-1980s a woman in Britain in her late twenties with two children who took an eight year break in employment could expect to forego earnings of £135,000 over her lifetime, compared with a women with no children. About 40 per cent of the loss in earnings is explained by the break and the remainder by shorter working hours and lower hourly rates (Joshi, 1986).

The impact of family formation is both to shorten a woman's working life and to change it (Joshi, 1984:47). The shorter working life due to the career break and the greater probability of long term part time work imply that the opportunity cost of having children is greater for British than for French women, and especially for those who are in the higher grade and better paid occupations.

EMPLOYMENT POLICY AND WOMEN'S FAMILY LIVES

Although many aspects of women's employment are covered in law by what can be described broadly as employment protection legislation, others

are embodied in legal provision aimed specifically at ensuring that women are not put at a disadvantage in the labour market because of the special needs associated with their sex. Employment law is therefore relevant to an analysis of the relationship between the family and professional life of well qualified women.

In Britain the state can be said to act to remedy some of the inequalities resulting from market forces (Ruggie, 1984:13), while in France, as in Sweden, the objective of achieving greater social equality determines the way in which governments intervene through planned economic growth in an attempt to influence market forces and change traditional attitudes and practices. Whereas women in Britain have been drawn into the labour force largely as marginal workers, women in France or Sweden seem to be much more integrated into employment and expect to be treated as permanent workers with entitlements at least equal to those of their male counterparts (despite the fact that more women are employed part time in Sweden than in Britain). Since the Second World War the implicit assumption in social policy, and more especially in employment policy, has been that women in Britain should be taking primary responsibility for homemaking. They are therefore dependent on their spouse's income and on any benefits that may accrue to him in his capacity as the main or sole wage earner, rather than being able to earn them in their own right. Under the social insurance scheme as conceived by Beveridge, married women could opt out of paying full contributions and rely on those of their husband. On marriage they lost entitlement to the full rates of sickness and unemployment benefits. Although subsequently women in full time employment have gained the right to most of these benefits, the attitude that women should be at home caring for children is still prevalent in the treatment given to women as part time workers.

Perceptions of the desirability and feasibility of adopting different patterns of employment are likely to be shaped by the attitudes of governments as manifested in legislation and policy. Not only have British governments been reluctant to intervene in areas which they consider as belonging to personal life, but they have also sought to avoid burdening employers with legislation, which could improve the employment conditions of women on the grounds that jobs would be placed in jeopardy (Cohen, 1988:16). The main body of legislation currently governing working conditions is that determined by the Employment Protection Act of 1975 and the Employment Protection (Consolidation) Act of 1978, which expanded the statutory rights of employees. These acts were followed in 1980 and 1982 by further legislation under the Conservative government, which introduced more restrictive conditions for the implementation of individual employee rights.

Since employment law in Britain tends to make minimum provision in order not to limit the freedom of action of employers, additional arrangements are often made independently of the legal framework. As already illustrated in the previous chapter, the civil service can serve as a prototype for the introduction of improvements in working conditions,

thereby circumventing the need for more direct government intervention through legislation. A departmental committee was set up by the civil service in 1970 in response to concern about the 'growing wish of women to combine a career with the raising of children' and the loss to the service of women who resigned for family reasons (Management and Personnel Office, 1982:21). The committee recommended that it should be made easier for women with children to continue with or resume work. More recently measures have been introduced to improve the representation of women in senior grades. As a consequence, the public sector may offer arrangements which are more favourable to women with children than those in the private sector, where the initiative is left to employers to set up their own schemes over and above any minimal provision made in legislation.

In France working conditions in all sectors are governed by employment law as contained in the *Code du travail* which sets out in detail comprehensive regulations for all categories of workers. Individual employers must observe the *Code du travail*, but they can also make their own arrangements for more favourable provision than that stipulated by law. The public sector has acted as a trail blazer by setting examples which the private sector may follow. As a large proportion of working women are employed in the public sector, its influence is far from being negligible.

The main areas of employment in which policies regarding women's working conditions have been implemented in Britain and France — many under the impetus of the European Commission's directives — concern benefits and arrangements for leave associated with maternity, unfair dismissal on grounds of pregnancy, reinstatement after maternity leave and the different forms of leave (paternity, family and parental), aimed at enabling both parents to participate fully in the parenting process. Although the areas involved are broadly similar, the base line in the provision made is rather different in the two countries and reflects the divergence already mentioned in the approaches of governments to the interventionist role of the state.

Maternity leave

Differences in the conception of state intervention in Britain and France have had an impact on the development of maternity leave and benefits. Britain is the only country in EC which does not have statutory maternity leave; rather legislation provides for the right to 'stop work' and then to be reinstated. France is, by contrast, amongst the European countries with the most generous provision.

Prior to the introduction of statutory schemes for maternity provision in Britain through the Employment Protection Act, it was left to the initiative of employers to make their own arrangements. Even after the relevant section of the Act came into operation, cover was far from being universal, since restrictive qualifying conditions were imposed requiring women to have worked for at least two years with the same employer by

the beginning of the eleventh week before the expected date of birth and for at least 16 hours a week. For women who worked 8-16 hours a week, the length of service required was five years. About half of pregnant women were excluded from the national scheme because of the length of service condition, which subsequent legislation has made even more constraining. At the beginning of the 1980s an estimated 15-20 per cent of employers were making their own provision for pregnancy and maternity in order to compensate for the relatively low level of statutory cover (Moss and Fonda, 1980:121).

Employment protection legislation in Britain allows for a period of absence of up to 40 weeks, followed by reinstatement. Women have the right to stop work 11 weeks before the birth of a child. In the public sector maternity provision is more generous, with the possibility of extended leave and a shorter qualifying service condition. The civil service and local authorities allow 52 weeks, and longer periods of up to 60 weeks are available in some employment. When women take the statutory maternity break they are deemed to have terminated their contract. Although they have a guarantee of re-employment in work of similar status and are considered as employed for the purposes of social insurance and state pensions, they forfeit their rights to non-statutory benefits, such as paid leave, bonuses, pay rises or promotion during the period of absence.

Harsh judgement has been passed on the British provision, both on the part of the state and employers. It has been described as 'a partial entitlement, grudgingly granted, with no sense of commitment or belief in its rightness and importance' (Brannen and Moss, 1988:18), and employer interest groups are said to have reacted to maternity rights as a 'potential and real source of administrative inconvenience, disruption and costs' (Daniel, 1980:103).

Maternity leave is conceptualized differently in France where it has been shaped by the concern with demographic issues. It has a long history dating back to the beginning of the century when, as early as 1909, pregnant women were granted the right to suspend their work contract. This same principle has continued as the basis for the arrangements under which leave is granted today. While not formally on the payroll, women on maternity leave continue to be considered as employees. The length of leave for which pregnant women are eligible varies according to the number of children but is much shorter than the break allowed under the British legislation. For the first or second child leave is six weeks before and 10 weeks after the birth. For the third child it is eight weeks before and 18 weeks after the birth (or 10 before and 16 after). Legally a women must take at least eight weeks leave, including six following the birth. Although it is not part of maternity leave, public sector employees who are breastfeeding their babies are allowed to take a further three months on full pay or six months on half pay.

Since 1988 maternity leave has been counted as a period of employment in estimating length of service. Some employers in France assimilate maternity leave to absenteeism, but it cannot be used as a pretext for

reducing service benefits and bonus payments. Although for many employers it may be seen as a source of disruption, instances are quoted of firms (for example Bull) which take very seriously their responsibility for ensuring that women's promotional opportunities are not impeded by arranging interviews with employees before and after maternity leave in order to discuss how their career development can be preserved.

Maternity pay and benefits

In Britain, where no statutory provision is made for the protection of the health of pregnant women in employment, with the exception of night work or jobs in dangerous industries, individual employers have made special provision, for example by allowing longer rest periods and avoiding work which may be hazardous, such as with VDUs. Employers are, however, obliged to allow women to take time off work without loss of pay to undergo medical check-ups, irrespective of the length of service.

The minimalist approach of the British government underlies the provision made for maternity grants. Changes in the 1980s have reduced the level of benefits: the maternity grant payable to all mothers was abolished in 1987 and replaced by a means tested lump sum payment of £80.00 for low income families.

Although the length of absence allowed from work is longer than in other EC member states, benefits are payable for only part of this time. Statutory maternity pay replaced previous allowances in 1987, merging maternity allowance (paid under National Insurance) and maternity pay (paid under the Employment Protection Act). An earnings related element equivalent to 90 per cent of earnings is paid for six weeks to women who qualify by having worked two years full time with their employer or five years part time by the fifteenth week before confinement. A flat rate element (£32.85 per week in 1987) is payable for 18 weeks to women who stop work six weeks prior to the birth and for 12 weeks for those receiving six weeks' earnings related pay. To be eligible pregnant women must have completed 26 weeks of service and receive average earnings over the lower earnings limit for payment of National Insurance contributions for at least eight weeks. Statutory maternity pay is taxable and subject to National Insurance.

The creation of two different rates of benefit is said to have resulted in confusion, and coverage has been substantially reduced by changes in the qualifying conditions (Cohen, 1988:88). Some employers offer additional pay and other contractual benefits for women while they are on leave, and the qualifying conditions may be waived, a practice followed by a few employers, including some local authorities. The civil service, for example, provides three months' paid leave. At the beginning of the 1980s very few employers in the private sector (about eight per cent of larger businesses, according to Daniel, 1980:65) were making provision for maternity benefits beyond the statutory minimum. In addition to differences associated with the type of employer, it has been found that higher grade women are more

likely to receive favourable treatment than those in lower paid positions (Daniel, 1980:118). This may be due not only to their greater eligibility but also to their ability to manage the complexities of the system.

Within the context of policies designed to increase family size, the protection of mothers during pregnancy and the health of the new born child are seen as paramount in France. Whereas medical expenses for most conditions of ill-health are not fully covered by social insurance, all medical care is free of charge on the condition that regular ante-natal examinations are carried out for a pregnant woman who has been employed for more than 120 hours in the month preceding the date when she becomes pregnant or 200 hours in the preceding four months. Employers are not, however, obliged by law to pay women who take time off for medical check-ups during pregnancy, as in Britain. The maternity grant (*allocation pour jeune enfant*), which is paid for all children from the fourth month of pregnancy to three months after the child's birth, is also dependent upon the child undergoing medical examinations and provides an illustration of the way in which benefits can be used as a lever to ensure that parents observe minimum health standards. The level was set at 803.01 francs a month in 1988, and a higher means tested benefit is payable to mothers in need.

Provision for maternity pay in France, which was introduced initially in 1913, is more generous than in Britain. A collective agreement on maternity pay was reached in 1971. Throughout maternity leave the Caisse Primaire d'Assurance Maladie pays a replacement salary to women in France at a level of 84 per cent of earnings up to a ceiling set nationally (with a maximum of 9,950 francs a month in 1988). The service requirement is 200 hours in the preceding three months. Women in public sector employment continue to receive their full salary for 16 weeks, as do employees in firms which have made special provision, sometimes including a service requirement. In this case employers pay the difference between the social insurance rate and full salary. While women on leave are not being paid in full by their employer, the work contract is not suspended, which means that pension rights, paid leave and seniority are not affected.

Unfair dismissal

In both Britain and France an employer cannot dismiss staff for reasons of pregnancy during the period prior to maternity leave. In Britain protection is ensured against unfair dismissal related to pregnancy, and a woman has the right to suitable alternative work where, for health reasons, her job is considered to endanger her pregnancy. A woman may be fairly dismissed if a suitable alternative is not available but retains her right to maternity pay and reinstatement after childbirth. The qualifying condition for eligibility to protection against unfair dismissal on grounds of pregnancy is a two years' service requirement with the same employer for 16 hours a week or five years' at eight hours a week.

In France employers must not refuse employment because of pregnancy, and a candidate for a job is not obliged to reveal that she is pregnant when being considered for a position. During a probationary period pregnancy cannot be used to justify termination of a contract, and dismissal is not authorized during pregnancy. An employer is obliged to continue to maintain the same level of pay even if pregnancy necessitates a change of job within the firm. Normal periods of notice do not have to be served by a woman who is pregnant and wants to leave her job.

Reinstatement after pregnancy

Britain has not endorsed the right to reinstatement for women after maternity leave, as stipulated in the Council of Europe Charter, and is the only country in the EC where employment protection in this respect was actually reduced in the 1980s (Moss, 1988:61). The conditions laid down for the right to return to work after childbirth are also more restrictive in Britain than in any other EC member state. Since 1980 employers are not obliged to reinstate women in the same job, and employers with fewer than five employees are exempted when reinstatement is not practical. Eligibility for reinstatement has been made more complicated by the introduction of new procedures requiring three written notifications of the intention to return to work.

A study of women's experience of maternity rights before the changes were made suggested that less than two-thirds of women in employment qualified for reinstatement (Daniel, 1980:37). It seems likely that the number of qualifiers has since become smaller. Women in higher status employment were more likely to qualify, give notification of their intention and actually return to the same employment but, even in this case, the proportion of qualifiers was found to fall at the second birth, and relatively few women were actually reinstated (Daniel, 1980:53). Since 1974 the civil service has operated arrangements instituting a right to apply for reinstatement. By the end of the 1970s the results were considered disappointing, particularly amongst women in the higher grades (Management and Personnel Office, 1982:51). In the late 1980s the scheme was still being extended to cover all departments (Hansard Society, 1990:37).

Employers are not required by law to allow flexibility or a reduction in working hours in order to accommodate family responsibilities, and women who are reinstated must immediately resume the same hours. Most women who return to work after pregnancy do so, however, on a part time basis, thereby generally foregoing any rights they might have had to reinstatement. Where special schemes have been introduced, as in some of the banks, women may have the option of taking part time employment without foregoing their grade.

By comparison, women in France are in a much more favourable position. On returning to work, an employee must be reinstated in her previous position and cannot be dismissed for at least four weeks. She does not lose any of the benefits previously accrued, such as bonus payments or

long service leave. A part time contract can be requested for an employee who has been with a firm for more than a year up to the child's third birthday. Worktime can be reduced by an hour a day for mothers who are breastfeeding, although employers are not obliged to pay for this time. Any employer with more than 100 employees must provide a room for mothers to breastfeed their babies. While no direct causal link has been proven between the arrangements for maternity leave, maternity pay and reinstatement, evidence from the Women and Employment and CERC Surveys about the greater propensity of women in France to remain with the same employer and to return to work after the normal period of maternity leave would seem to suggest that it is easier for them to resume work under favourable conditions after pregnancy than is the case in Britain.

Paternity and family leave

While in France men are allowed to take three days paid leave at the birth of a child, in Britain no statutory provision is made for paternity leave. Some local authorities and publishing firms make their own arrangements. Since 1987, all employers in France are obliged to grant paternity leave, but it is not covered by social insurance. The law also takes account of cohabiting couples: fathers who admit paternity and live in a 'permanent' relationship with the mother are eligible for leave in the same way as married men living with their wives.

Family leave, for example to care for a sick child, is not covered by law in Britain, and few contractual arrangements are made. While no statutory provision exists in France either, in 1984 about half of all national collective agreements made it possible for employees to take time off to look after sick children. Women and men in public sector employment are allowed to be absent for the equivalent of a working week plus one day every year to look after a sick child aged under 16. This period of leave is doubled if the person concerned is a single parent or if the spouse is not eligible for paid family leave under his or her conditions of service. Where leave is with pay the time allowed is generally one week a year. The nationalized industries, EDF-EGF, allow women half a day each month, known as the day off for mothers (journée mère de famille). Provision for public sector employees is open to both men and women, although in practice it is generally women who are found to take advantage of leave for family reasons. If both husband and wife are civil servants, they can choose how to share the 12 days they are allowed between them

Parental leave and the career break

While the period of maternity absence has been gradually extended in Britain, no legal provision is made for parental leave. Within the EC the UK and Ireland are the only two countries with no state provision or plans to introduce some form of leave. The European Commission's draft

directive of 1983 on parental leave was opposed in Britain not only by the government but also by the Confederation of British Industry on the grounds that legislation imposing entitlement would have a detrimental effect on competitiveness because of its cost and would reduce employer flexibility.

By contrast, France is the EC country with the most generous arrangement. Parental leave was first introduced in 1977 in firms employing at least 200 workers. In 1981 provision was extended to firms with 100 employees and in 1984 to all employees. In 1984 both men and women became legally entitled to take parental leave for one year in the first instance, and in 1986 the right was extended to cover up to three years for each child at the end of maternity leave, on the condition that the employee concerned has been with an employer for at least one year. Either parent can choose to take leave to look after children, and the period of leave can be alternated between them. An employer has to be given one months' notice of the intention to take parental leave, and firms with more than 100 employees cannot refuse permission.

Employers are not legally bound to pay employees who take parental leave, but provision is made by some collective agreements for payment of a full or partial salary. From 1985 as part of government policy to encourage families to have a third child, parents with three or more children were paid flat rate benefits during parental leave (at 2,488 francs a month in 1988, which was less than half the national minimum wage). Since 1984 leave can be taken part time, in which case benefits are reduced accordingly. After parental leave an employee must be reinstated without reduction in pay in the same or a similar position and is eligible for retraining with pay.

The period of leave is counted for half time in calculating length of service, and employees maintain their entitlement to health insurance and maternity benefits. Pension rights are enhanced for women in France who stop work to raise children. For example, since 1975, most salaried workers outside the public sector (covered under the *régime général* of the social insurance scheme) are able to gain two years for each child without paying employee contributions. Some firms make special arrangements for women to retire early: EGF allows women who have raised three or more children and completed 15 years of service to retire from the age of 40. A third of EGF employees were reportedly taking up this option by the mid-1980s (Meynaud and Auzias, 1987:21).

Britain is also one of the countries in Europe with the lowest rate of return from maternity leave. In the absence of provision for parental leave or other arrangements which might enable them to maintain their employment status, the majority of British women are forced to make a break of about four years from paid employment when they have children and do not expect subsequently to return to the same employer. Although the years spent out of the workforce may be disregarded in the calculation of pension rights, women still need to ensure that they have 20 years of contributions to be entitled to the flat rate pension. While maternity absence does not constitute a break in employment, it is not considered as

leave, and the situation regarding occupational pension entitlement and other contractual rights is therefore unclear. Many employers do pay their own and their employee's pension contribution and count the absence towards service related benefits, such as mortgage subsidies, but they are not under a legal obligation to do so.

A small but growing number of employers, who are aware of the expense of recruiting and training staff who leave after a few years of service have begun to develop their own arrangements for childcare leave, including career break schemes. The examples most often quoted are the National Westminster and Barclays Banks, which allow women (and men in the case of Barclays) with management potential to take a break of up to five years, without loss of pension rights, to care for children, on the condition that they keep themselves informed of developments. On rejoining, service qualifications for staff benefits are waived, and the break does not interrupt continuity of service for pension entitlements. Some local authorities (for example Humberside County Council) as well as private companies (the engineering firm Marconi) operate schemes enabling women who resign when they have children to be considered on the same terms as internal candidates when they seek re-entry to employment. Under the 'keeping in touch' schemes introduced in the civil service women who want to take a break of more than one year must resign and apply for reinstatement. Contact is maintained through literature and attendance at meetings, and the opportunity is provided for work experience and training. Another possibility is to take special leave of up to five years which does not entail resigning from the service.

The overall implications of the differences in approach to the provision of leave and entitlements for maternity are that British women can expect to receive relatively little moral or practical support from government and widely differing amounts from employers. By contrast, French women know that they have an array of legislative measures and a supportive network of provisions which legitimize their intention to pursue employment and encourage them to remain with the same employer.

FAMILY POLICY AND WORKING WOMEN

Britain and France have adopted dissimilar approaches to family policy over the post-war period. Governments in the two countries reacted differently in response to the demographic decline, which was common to a number of EC countries in the early part of the twentieth century. Concern in the first half of the century was primarily about a diminishing population and the depleted labour force following two world wars. More recently, a declining birthrate has been coupled with an ageing population: by the year 2025, according to United Nations estimates, almost 19 per cent of the population will be aged over 65 in Britain and France (Tabah and Maugué, 1989:45). British governments have not pursued overtly pro-natalist policies in response to demographic trends, whereas in France

concern about demographic issues has led successive French governments to intervene in order to reverse population trends through what can be described as generous and active family policies.

While governments in France have been pursuing concerted family policies since the late 1920s (as exemplified in the *Code de la famille* of 1929), with the specific intention of promoting demographic expansion and consolidating the family unit for economic and ideological reasons, the British context has been characterized by a much lower level of government intervention in an area which is considered as belonging to private life. Britain has, for example, never had a ministerial appointee with explicit responsibility for the family, whereas no French government is complete without at least a junior minister with the family as part of his — or more often her — attributions.

Because their objectives frequently coincide, family policy is easily confused with demographic policy, and the two may come into conflict. Measures designed to increase family size inevitably focus on providing higher benefits and other incentives for couples who raise large families, irrespective of their level of income. Policies intended to reduce inequalities between and within families, regardless of the number of children, concentrate more on raising the standard of living of low income earners to a higher level and of families to that of couples and individuals without children. When the state began to intervene in France to formulate national family policies, the underlying concern was with demographic issues. Since then emphasis in policy has fluctuated between the two orientations.

In Britain, where family policy has been criticized as a 'tool for the worst kinds of nationalism' (Wicks, 1983:41), demographic issues have not been accepted as a sufficient justification for state intervention in family life. The choice about whether to have children and, if so, how many, is left entirely to parents, and it is considered morally wrong for governments to seek to influence personal decisions. In any case, doubts are expressed about the ability of government policy to affect the birthrate. State intervention is accepted as legitimate only if it is seen to be fulfilling a protective function or assisting individual family members in times of need.

The effects of this fundamental difference in approach are apparent in the provision made for family benefits and childcare in the two countries, and it has shaped the way in which the taxation system takes account of family responsibilities. Whether or not the intention is explicitly to influence women's patterns of employment, family policy may not be neutral in its impact and can be an important consideration for some women in determining the feasibility and desirability of pursuing an employment career.

Family allowances and child benefit

From their inception in the 1920s in France and in the 1930s in Britain, family allowances have been organized according to different principles.

Similarities between the French and British systems can be found in that, unlike other social insurance payments, in both cases child benefit and family allowances are not income related and are paid directly to the mother, but in most other respects the two systems diverge.

Child benefit in Britain is financed entirely from general taxation and administered solely by central government with no special consideration being given to local needs. Employers do not contribute directly to the cost of providing benefits. When the present scheme was conceived in 1945 allowances were paid to áll families with at least two children, but any pronatalist principle which might have been involved was subsequently removed. The same benefit is now paid for each child, including the first, at a level which is unlikely to compensate for the cost of raising additional children. The rate does not rise automatically with inflation and was frozen between 1986-90. When the family allowance scheme was first established, the advantage for higher income earners was reduced by the fact that benefits were taxed. Since the abolition of the child tax allowance, however, benefits are no longer taxable.

The first state family allowances scheme was introduced in France in 1923, and a comprehensive package of family policies was formulated and adopted in 1929 in Edouard Daladier's *Code de la famille*, almost 20 years before the French social insurance scheme came into operation. Family welfare differed from other areas of social insurance in that allowances were funded directly and solely by employers, whereas health and old age depended on contributions from employers and employees, thereby upholding the insurance principle. While it was many years before the whole population was covered for other contingencies, family allowances were made immediately available for all children, without reference to household income. Although the state sets the level of contributions and benefits, the scheme is administered at national and local level by the Caisses des Allocations Familiales (family allowance funds), which are independent bodies able to respond to local needs. When family allowances were first introduced, they formed part of a wages policy, whereby employers sought to attract and maintain a stable workforce. In the 1930s they were used to depress wages. Despite proposals that benefits should be funded from general taxation, employers continue to have responsibility for contributions. Arguments presented against funding from taxation reflect the dominant ideology of national solidarity towards the family. The underlying principle behind this method of funding is that resources should be redistributed horizontally, rather than vertically, from those without children to those who are contributing to the nation's well-being by raising a family. However, whereas the ceiling for other social insurance contributions has progressively been removed so that the same proportion of total earnings is paid to the relevant fund, contributions for family allowances still have a ceiling, suggesting some ambivalence in the attitude of governments about the role of employers in this respect.

Over the past decade in France emphasis has shifted between the family and demographic policy orientations. In the late 1970s under the presidency

of Valéry Giscard d'Estaing, and with a centre right government in power, the falling birthrate prompted measures, such as higher levels of benefits, longer maternity leave and additional income tax relief, for parents who had three or more children. At the same time, policies were enacted to help low income families. In the early years of his first term as president, for ideological and economic reasons, François Mitterrand relied on support from a left wing government to promote a policy designed to give equal status to all children within a family, irrespective of its size, by making benefits less progressive. The tax incentive for higher income families to have three or more children was reduced by setting a ceiling on child tax allowances. Proposals were also made, but not implemented, for family allowances to become earnings related. A new parental allowance (*allocation parentale d'éducation*) was, however, created in 1985 for parents of three or more children who decided to stop work or reduce their hours in order to be able to stay at home to look after children.

The return to power of a centre right government in 1986 heralded a reversion to the 1970s pro-natalist policies by once more giving priority to the third child, while at the same time emphasizing freedom of choice and the need to provide additional support for low income households. The left wing government, brought to power in 1988, did not attempt to revise this policy orientation. Fixed rate family allowances are now paid from the second child. As shown in Table 4.10, unlike the British child benefit, they increase as children grow older. Allowances continue to be paid up to the age of 17, or above if children are still in full time education.

TABLE 4.10 CHILD BENEFIT AND FAMILY ALLOWANCES IN BRITAIN AND FRANCE (MONTHLY RATE), AS AT 1 JANUARY 1988

Number of children	Rate	
	Britain in £	France in francs
1	29	0
2	58	558.52
3	87	1,274.14
4	116	1,989.75
5	145	2,705.37

Sources: Data from the Department of Social Security for 1988; Ministère des Affaires Sociales et de l'Emploi, 1988:122.

If financial factors are a consideration for couples in determining family size, the figures presented in the table would seem to suggest that women in France, especially those on low incomes, may have more of an incentive than in Britain to raise large families. The income tax system and cost of

childminding (discussed below) are further factors entering into any calculation of the finances of childraising.

When family allowances and child tax allowances were replaced in Britain in 1976 by child benefit, it was on the grounds that tax relief gave excessive benefit to the high paid and none to low income earners who were exempt from taxation. The neutrality of the benefit as far as women's employment is concerned has long been the subject of controversy. The removal of child tax allowance and the absence of parental or childminding allowances would seem to confirm that in the British context neutrality means non-intervention, whereas in France the term means positive action to create choice by making a range of options feasible. The confusion between family and pro-natalist policy can mean that, on occasions, the balance operates in favour of incentives for women to remain at home and raise large families.

Childcare provision

Another form of intervention which is an important consideration for women when they are deciding whether to remain in employment is the provision made for childcare. Governments intervene to affect the supply of childcare by making available their own services, by direct subsidies to services or by financial support for private organizations. Alternatively, and less often, they may offer subsidies to parents for the specific purpose of childcare. In its Second Action Programme the European Commission stressed that the development of adequate childcare facilities was vital if true equality at work was to be achieved (Commission of the European Communities, 1986:5). Priority was attributed not only to demographic issues but also to equal opportunities for children and freedom of choice for parents between family, social and occupational responsibilities.

Within the European context Britain and France offer examples of the two ends of the spectrum for childcare provision (Moss, 1988). The level of provision in Britain and France in the 1980s is illustrated in Table 4.11 for different types of care. Because the figures are not based on the same criteria, they are not directly comparable; for Britain in most cases they refer to the number of places, whereas for France they record the number of children aged 0-3 who are attending, giving the misleading impression that provision is more extensive in Britain. While British governments have been reluctant to become involved, except for children considered to be at risk, one of the results of interventionist family policies in France, which closely reflects the concerns of the Commission, has been the creation of an extensive support network of public provision for young children as well as subsidies to providers and users, placing it amongst the EC member states with the highest levels of support.

In Britain the two world wars created a stimulus for childcare provision because of the need to encourage women to enter the workforce, but the number of nurseries was cut immediately the crisis was over. At the end of the Second World War more than twice as many places were available in

public day nurseries compared with today (Cohen, 1988:2). The British social insurance scheme was predicated on the assumption that women would stay at home to look after their husbands and raise children, and this unpaid labour was considered vital for the nation. Although it is generally accepted that women should not forego employment in order to support their husbands (except in the church, medical profession or diplomatic service, where they are 'married to the job', according to Finch, 1983), the common understanding is that women should be the primary care givers for children and the elderly, and that public provision of care should not be increased other than to meet special social needs. While less widespread than in the 1960s, the view that women with children under school age ought to stay at home continued to be held by 45 per cent of respondents in a survey conducted in 1987 (Witherspoon, 1989:192).

TABLE 4.11 CHILDCARE PROVISION IN THE UK AND FRANCE, 1985

	UK No of places children aged 0-5	France Children attending aged 0-3
LEA nursery class/school	338,541*	260,930
Local Authority day nursery	32,964	63,068
Registered childminders	144,908	189,768
Private and voluntary day nurseries	27,533	15,636
Crèches familiales	-	40,270
Private schools	35,000	-
Playschools	468,945*	-
Nannies, au pairs	30,000)	
Non-registered childminders	16,000)	260,930

* Number of children attending aged mainly 3-4

Sources: Cohen, 1988: Table 5.1; Leprince, 1987:511-2.

By comparison with the childcare arrangements in Britain, French women are well provided for. While nurseries were being closed after the Second World War in the UK, the French government was setting up *crèches* in an attempt to attract women into the workforce at a time of acute labour shortage. The high demand for labour continued for almost 30 years during the period of economic reconstruction (known as the *trente glorieuses*). In the early 1970s further efforts were made to increase the number of places in *crèches*, again with the aim of encouraging female employment. In Britain, by contrast, when governments have wanted to attract women into the workforce in response to labour shortages, as in the early 1960s, they have done so by encouraging employers to create part time jobs rather than by providing childcare facilities.

Although post-war governments in Britain supported the principle of educational provision for children from the age of two, it was nevertheless to be on a part time basis to avoid lengthy separation from their mothers. Most of the provision in the 1980s continued to be part time and for a very small number of hours in the day. The guidance given to local authorities for admitting children stresses that priority should be given to children in special need (Cohen, 1988:3). By focusing on compensating for inequality and family breakdown, the state is implicitly discouraging mothers with young children who are not at risk from working by not supporting them with childcare provision.

The reluctance of the state to be involved in providing facilities for women who are not in difficulty is reflected in the treatment of the childcare issue in the civil service. Following the Kemp-Jones Report on women in the service an experimental purpose built nursery was set up in 1973 for officers in the Inland Revenue in Cardiff to accommodate children aged two and a half to five years, but it was subsequently closed in 1978 on financial grounds. Instead, a self-help scheme was organized with the service covering the cost of a childcare organizer (Management and Personnel Office, 1982:89-90). More recently, although all government departments have been given permission to set up childcare facilities, none had been established by the end of 1989 (Hansard Society, 1990:36).

At the age of 0-2 only two per cent of children in Britain are in publicly funded services, and an estimated 5-10 per cent of two year olds attend play centres for a few hours a day. While the number of separate nursery schools has been declining over the past two decades, more primary schools now have nursery classes attached to them. Approximately 20 per cent of 3-4 year olds were attending nursery schooling in 1985, but about 83 per cent of places were part time (Cohen, 1988:42). An estimated 40-45 per cent of 3-4 year olds attend play centres for a few hours a week, but only one in four with support from public funding (Moss, 1988:96). The opening hours of pre-school facilities are such that they cannot be construed as a means of ensuring childcare for working mothers, and very few make provision for extended hours (Cohen, 1988:43). The lack of out-of-school schemes for children after school hours and during school holidays implies that most working mothers must either resort to informal arrangements or not work at these times (Petrie and Logan, 1986:16). The number of workplace nurseries, which were originally set up for workers in the manufacturing and textile industries, is gradually expanding, as local authorities and industry come to see them as a means of retaining well qualified female workers, but they accommodate relatively small numbers of children.

The inadequacy of public nursery places and other forms of public provision has been partly compensated for by the development of registered childminding, which is seen in official circles as the best substitute for care by the mother or a relative, in preference to a nursery (Cohen 1988:20). Registered childminders are not required to have formal qualifications. A few may have attended short courses, but otherwise registration is a fairly straightforward process. Rates of pay in 1985 ranged

from £0.50-1.00 per hour, with most childminders working between 8.00 and 18.00 on weekdays. Only registered childminders earning over the National Insurance threshold are eligible for welfare benefits, provided their employers pay contributions. Nannies, defined as people minding children in their employer's home, *au pairs* and mothers' helps are not required to register. Many nannies may have a qualification from the Nursery Nurses Education Board, but *au pairs* and mothers' helps generally have no formal training. The cost of private provision is prohibitive for most women, even the better qualified. As a result of the inadequacy of public facilities and the expense of private provision, about 45 per cent of economically active women with children under three and 41 per cent with children under five were relying on care by their partners in the early 1980s (Dex and Walters, 1989:210).

In France, by contrast, only one per cent of children under five are looked after by their fathers. Almost all (94 per cent) children aged 3-6 and more than a third (35 per cent) of 2-3 year olds in France attend nursery school (Leprince, 1987:510). The proportion of three year olds attending nursery schooling has increased rapidly since the 1960s, and extensive public provision has been made for care both before and after school hours. Parents working full time complement nursery schooling with other forms of minding, including non-residential leisure centres, after hours childcare centres, holiday centres, childminders and relatives or neighbours, often with support from the state. An important network has also developed throughout France of registered childminders, closely supervised by local authorities. Most *crèches* are run by social services or local authorities, with parents contributing a quarter of the cost. The Caisses d'Allocations Familiales have become increasingly involved in subsidizing childcare services over the last two decades and may contribute as much as 80 per cent of the capital and running costs of *crèches collectives* and *crèches familiales*. Workplace *crèches* account for 29 per cent of all collective provision of *crèches* (Leprince, 1987:511). Parents who decide to set up their own *crèche parentale*, which could be compared to the British playgroups, are also eligible to receive subsidies.

The *crèches familiales* schemes, introduced in the early 1970s, provide an important form of publicly supported family care, whereby local authorities or a private organization recruit, supervise and occasionally train care-givers in their area. In some cases a weekly group session is held where the women concerned can meet together. The cost of a place with a minder organized through a *crèche familiale* is estimated to be about 80 per cent of a place in a standard *crèche* (Moss, 1988:89). In addition to the many other forms of 'approved' daycare for young children with working mothers, the French have instituted *halte-garderies* which are intended as casual group care for children of pre-school age with non-working mothers.

For children under three the main form of care is by their own mother (59 per cent), particularly when she works from home, which may be the case for many women in the professions. Of the remainder, 11 per cent are cared for by another relative, a further 11 per cent are at nursery school,

eight per cent are looked after by a registered childminder, and three per cent are at a *crèche* (Leprince, 1987:510, 513).

Recent legislation making it possible to deduct a higher proportion of childminding expenses from taxable income has provided a financial incentive for parents to have their children minded. An allowance (*allocation de garde d'enfant à domicile*) of 2,000 francs per month is given to working mothers towards the cost of having a child looked after in their own home by an approved minder (*assistante maternelle agréée par la Direction Départementale des Affaires Sanitaires et Sociales*) until the child reaches three years of age. The allowance is intended to cover the childminder's social insurance contributions. An *assistante maternelle* can expect to earn about 75 per cent of the minimum wage for minding three children.

The Caisse Nationale des Allocations Familiales calculated the relative cost of childminding for different income levels in 1987 once allowances had been deducted: for an income of 25,000 francs a month, it was estimated that, at Paris rates, a group or family *crèche* would cost a couple under seven per cent of income, a childminder (*assistante maternelle*) almost six per cent and a home helper (*emploi domestique*) over 17 per cent (Caisse Nationale des Allocations Familiales, 1986:54).

In low income families in France the level of family benefits and other payments made to parents who stop work to look after their children may be an important consideration determining whether women continue to undertake paid work outside the home. A woman with three or more children in receipt of the minimum wage has a distinct financial advantage in leaving the workforce. Women with higher incomes will probably not be encouraged by these financial incentives to leave employment, but they are given substantial monetary support towards the expenses of childminding. In Britain, on the other hand, child benefits cannot be seen as a financial incentive likely to encourage women on low incomes to have more children or to abandon employment. For well qualified women the problems and cost of making satisfactory arrangements for childcare are likely to present a major impediment to continued employment.

Tax allowances

From the time when it was introduced at the end of the eighteenth century, and for almost 200 years, the British income tax system has been based on the model of the family where the husband is in paid employment and the wife stays at home to look after the children and is dependent on her husband's income (Land, 1983:75). At the end of the Second World War when concern was being expressed about labour shortages, encouragement was given to women if they were economically active by the provision of an allowance for the working wife, which was equivalent in the 1980s to the tax allowance for a single person. Even if the wife was earning, the husband was still eligible for a married man's allowance, which was worth more than the single person's allowance. Until 1971 the wife's income, for

the purposes of taxation, was always aggregated to that of her spouse. Since that date women have been able to opt for separate taxation on earned income, in which case each member of the couple claims relief as a single person. Separate taxation was economically advantageous for those in the higher income bracket when tax was steeply progressive.

The system was widely criticized in the 1970s because two earner married couples were better treated than single income couples and single people. When proposals to change the system were being debated at the end of the 1970s, an important issue was whether income tax should be neutral or whether mothers should be encouraged to stay at home and look after their children rather than going out to work. Since 1976 no deductions of income tax can be made for children on the grounds that tax relief gave excessive benefits to the high paid and were of no value to those whose incomes were too low for them to pay tax. With the introduction of independent taxation in 1990 each spouse now receives the same personal allowance (set at £2,785 in 1990), but the married couple's allowance (of £1,590) continues to be paid to a married man living with his wife. A married woman can have part of this allowance transferred to her income only if her husband cannot use it himself.

Whereas the tax unit in Britain centres on the (married) couple, in France income tax is calculated on the basis of the family (married, divorced, widowed or separated couple with children or single parent family or cohabiting couple). When the income tax system was established in its present form in 1945, absolute priority was given to children, to the extent that a clause was introduced (but repealed 10 years later) whereby part of their tax relief was lost if a couple had not had any children after three years of marriage (Sullerot, 1984:55).

At a time when cohabitation was the exception, an effort was made to ensure that children in single parent families would be adequately protected. A higher rate of tax relief was therefore granted to two single persons living together with two children than to a married couple with two children, thereby producing an anomaly between married and cohabiting couples in a context where cohabitation has become an increasingly common lifestyle. Another anachronism in the system is that it is advantageous to be married if the wife is not working or earns a very low income since married couples are taxed jointly. If the earnings of each member of a couple are the same or similar, it is to their advantage to be unmarried and taxed separately, since the entitlement to relief is for two persons.

Family size affects tax relief in that the first and second child give entitlement for a deduction, calculated as a half unit, and since 1980 the third and any subsequent child count as a whole unit each. The effect is that for the same income a family pays less tax than a couple without children, and a couple with three or more children receives proportionally greater relief. A ceiling has been introduced on tax relief in order to reduce the advantage to high income families. In 1989 it was set at 11,800 francs per

annum for each half unit after the first two children for a married couple (Syndicat National Unifié des Impôts, 1990:127).

Since the tax threshold is higher in France, low income earners are likely to be paying less tax than in Britain. In France no tax is payable on taxable income of up to 36,360 francs per annum, and the rate progresses gradually after this level. In Britain only two rates operate: the basic rate of 25 per cent applies to taxable income from £1-20,700 in 1990 and the higher rate of 40 per cent for taxable income above this amount. In France a single person needed to have a taxable income of 134,000 francs in 1989 before reaching the 25 per cent level and of 313,000 francs before reaching the 40 per cent level. Thereafter the rate continues to be progressive. With the removal of higher rates of taxation in Britain in 1990 higher income earners were paying less income tax than their French counterparts, except if they had several children. A hypothetical couple with a joint income of approximately £53,000, where the husband was earning about £4,000 more than his wife, would have been liable to pay about 23 per cent of gross income in taxation, whether or not they had children. In France on a similar income a couple without children would pay approximately 26 per cent in taxation and a couple with three children 18 per cent, discounting allowances other than those made under the family quotient system.

In addition, in France tax relief of 25 per cent of childminding costs up to a ceiling of 15,000 francs in 1989 can be claimed for each child aged up to seven, where both parents are in employment. In Britain, by contrast, no tax deductions or allowances are made for working parents towards childminding on the grounds that this would contravene the principle that 'items of personal expenditure do not qualify for relief' (quoted by Cohen, 1988:18). Between 1984-90 the Inland Revenue counted the cost of subsidies to workplace nurseries as a 'perk' for higher paid workers (with earning over £8,500 per annum) and therefore included it in the users' taxable income. Not only was no tax relief provided for working women with children, but the tax system in Britain thereby also penalized women who used workplace facilities.

In the conclusions to a report on childcare and equal opportunities in the UK for the European Childcare Network, the British representative criticized the lack of coherence in government policy over childcare services, employment and taxation and the failure to locate any of them in relation to an equal opportunities programme. The example of workplace nurseries was quoted as an illustration of the way the government perceived the initiative as a useful form of provision but at the same time discouraged it by assessing employers' subsidies as a taxable benefit (Cohen, 1988:123), reflecting the philosophy that daycare services are primarily a matter for private arrangements. This attitude is further exemplified by the fact that guidelines issued by the Department of Education and Science for schools over the use of premises for out-of-school and holiday projects recommended that schools and education authorities should be sympathetic towards the use of buildings for care 'funded by employers and

others as an alternative to workplace-based facilities' (Hansard Society, 1990:88). In France, by contrast, such services are funded by local authorities.

While women are the recipients of a wide variety of benefits in France, because of their full time status and the higher rates of social insurance and taxation which they therefore pay, compared with women in Britain, they are also making a substantial contribution to welfare funding, and this needs to be taken into account in any calculation of the relative costs and benefits of women's employment.

The effects of family and employment policy on women's working lives

The official view of British governments throughout the post-war period has been that pre-school age children should be at home with their mothers and that the state should reserve welfare services for children in families with social problems. The comprehensive family policies formulated by governments of all political persuasions in France over the past two decades have increasingly emphasized the guiding principles of neutrality and free choice as far as women's employment is concerned. The relative influence of factors such as taxation, availability of childcare facilities and different forms of income support on women's employment are difficult to assess. The supply of female labour is, however, more elastic than that of men, and decisions about whether to continue in employment or to seek promotion are therefore more likely to be affected by these factors. For women in the higher income bracket, the availability of reliable childcare facilities, provision for parental leave and reinstatement and taxation arrangements may be of more importance than child benefit and other allowances associated with maternity in calculating the opportunity cost of women's employment.

From an analysis of childcare services within Europe the conclusion was drawn that Britain seemed to be amongst the countries where opposition to maternal employment and childcare was the strongest, whereas France was amongst those which were most supportive of women's employment and childcare provision (Moss, 1988:34). The assumption in Britain is that women should and do want to stay at home to look after young children, whereas the expectation in France is that, if women are to leave employment in order to care for pre-school age children, they should be given financial incentives to encourage them to do so (Hatchuel, 1989: Table 4; Witherspoon, 1989:192)

In 1986, with the centre right in power, French government policy was stated to have three main objectives, which reflect the general thrust of policy in recent years: to compensate households for raising children, to give individuals maximum choice and to encourage demographic growth. Accordingly, the state offers couples the choice between being dual earners, single income households or adopting other intermediate solutions. In the case of dual earner couples, adequate provision is made for childminding through good quality and reasonably priced childcare facilities. Where women decide not to work in order to raise their own children, the loss of

salary is compensated for by appropriate allowances. In the third case, opportunities are provided for a change to part time work on favourable terms or different forms of leave are made available without loss of pay. These objectives were reiterated in a policy statement emanating from the Haut Conseil de la Population et de la Famille in 1989, confirming the consensus of political opinion about the legitimacy of government intervention through family policy (Tabah and Maugué, 1989:57)

The French state sees itself as having the duty both to provide enabling legislation and to act as a model by offering more favourable terms to public sector employees, and it therefore comes close to the societal corporatist approach observed in Sweden (Ruggie, 1984:xiii). By contrast, in recent years British governments have continued to follow the liberal welfare approach, leaving women to display resourcefulness in coping with what are considered as individual problems. It has sought to react to changes in the birthrate rather than to influence them.

Since 1974 the EC has been adding its weight to measures for ensuring that family responsibilities can be reconciled with professional aspirations. While, within Europe, France seems to have been at the top of the league table for provision of childcare and other measures enabling woman to combine family life with employment, Britain has been reluctant to embrace the Commission's recommendations in this area. British governments have demonstrated their opposition to proposals from the EC by refusing to adopt or implement directives such as those on part time work, parental and family leave and temporary work, on the grounds that these are matters which can best be dealt with between employers and employees, according to individual needs and circumstances. The French state identifies itself closely with the Commission's objectives and considers that it has a major role to play in convincing other EC member states of the importance of family matters (Tabah and Maugué, 1989:47).

If the two countries now have the same birthrate and the same household size, this result seems to have been achieved despite the very different patterns of employment amongst mothers. It can be argued that family size is maintained in France while women are more often in full time employment because they have support from society and its institutions; in Britain family size is maintained because women adapt their employment patterns in accordance with the constraints imposed by family life. The role played by the state in shaping the family-employment relationship should not be underestimated. The legal framework may provide enabling legislation, as for example for reinstatement after maternity absence, but women cannot exercise this right if they do not have sufficient means for ensuring proper care for their children and if they do not feel that their economic activity is recognized as being legitimate.

5 Reconciling Family and Professional Life

Policy makers in France today make the explicit assumption that women want to be able to work while also being able to raise children. Work and family life are described in official pronouncements as being complementary but also in conflict with one another because they are competing for scarce resources (Haut Conseil de la Population et de la Famille, 1987:9). Women's employment is formally recognized as a major component in the economic well-being of the family unit, as an insurance against adversity, a guarantee of autonomy and a more important source of social identity than that derived from being a housewife. The state is therefore committed to finding ways of enhancing the complementarity of work and family, reducing the conflicts between them and making it possible for couples to exercise real choice between the different options available. In Britain, by contrast, where social policy has not been conceived with the object of providing the conditions needed so that women can combine employment with family life, the most obvious 'choice' for the majority of couples is either for both husband and wife to work full time and not to have children or, if they do decide to have children, for the woman to stop work temporarily or change to part time hours.

Women who have undergone higher education might be expected to be in a better position to pursue an employment career, irrespective of prevailing social attitudes as reflected in policy statements. The Franco-British comparisons conducted for the purposes of this study suggest, however, that policy and institutional structures may also be important factors shaping behaviour as well as perceptions of the feasibility for well qualified women of reconciling family and professional life in each of the two societies.

Even if they are well educated, women who marry and have children still implicitly bear the major share of the responsibility for finding compromise, which they do with greater or lesser assistance from society. On the assumption that women who undergo higher education will expect to maximize the returns on their investment by spending a considerable proportion of their working life in employment, without foregoing motherhood, they will require complex strategies in order to manage the situation. Priorities may need to be changed, schedules restructured and the distribution of labour within the home redefined if they are to cope with

the quantity of demands on their time. In a context, as in France, where women know that they can rely on an extensive support network and where employers, colleagues, relatives and friends accept that married women with children make an important and necessary contribution to the workforce and to family income, the constraints imposed by the double burden of working full time while raising children and the resulting conflicts may be more easily accepted and overcome than in a society, such as that in Britain, where women are expected to leave employment and take a career break of several years until their children reach school age.

CONSTRAINTS AND CONFLICTS FACING WORKING MOTHERS

Women who undergo higher education expect — and are expected — to provide returns on their own investment and on that of society. In previous chapters analysis of data on patterns of employment and family building revealed that well qualified women are more likely than other social groups to postpone marriage and childbirth and to pursue more continuous full time employment careers in order to exploit their education. Where women decide to combine employment with raising children, they are inevitably faced with physical and psychological constraints and conflicts since they are, in effect, carrying out two full time jobs. The results of a survey of women's living conditions and aspirations in the early 1980s indicated that French women in medium and higher grade positions were much more likely than other categories to be aware of the conflicts between work and family life (Grignon, 1987:2). At this level, the decision to limit family size may be less subject to economic pressures than to temporal factors, particularly amongst women who command a high income. Because it reduces the time which can be devoted to family activities and interaction, work operates as a constraint on family life. The family, in turn, imposes constraints on a woman's availability for work. The result is not infrequently the strain and stress of role overload and role conflict.

Time constraints

Considerable doubt has been expressed about the role of work as the main *Zeitgeber* or bench marker (Hantrais et al, 1984) and about the increase in flexibility of daily working hours as a means of reducing constraints on time organization (McRae, 1989:55; Villeneuve-Gokalp, 1985:290). The temporal structuring of paid employment is, nonetheless, still a powerful force affecting the way time is organized within the family (Allan, 1985:19). Actual working hours in different economic sectors are largely controlled by central government legislation and by employers' contractual arrangements, often as a result of collective bargaining. Whereas in Britain negotiations are more often conducted at plant level, in France central government exercises a stronger control over working hours, although

since 1982 more discretion has been given to employers with the shift towards shorter working hours and greater worktime flexibility. Part time working in Britain affords a good example of the way in which some employers may take the personal needs of employees into account in organizing worktime schedules, but most full time workers in both countries have only limited opportunities to influence the way their working day, week and year are structured, and the organization of household time is largely subordinated to external time frames.

Since the organization of the working day, week and year differs in several respects in Britain and France, comparisons of all three units are relevant to an understanding of the problems of synchronizing schedules which have to be faced by women seeking to combine employment with family life in the two countries.

DAILY AND WEEKLY TIME PATTERNS

Despite official rulings about the length of the working day and week, considerable variation can be observed in individual working hours. In Britain where working hours are not governed by law the standard 37-42 hour week generally includes lunch and other breaks. For manual workers weekly worktime may be much longer due to overtime. Higher grade employees routinely work more than standard hours. When the length of the working week was officially set at 39 hours in 1982 by the French government, with the intention of reducing it to 35 hours by 1985, weekly 'working hours' excluded lunch breaks but included other official breaks. Overtime, which is less widespread in France than in Britain, was limited by the same legislation to 130 hours a year.

When only full time workers are considered in both countries, working hours are generally shorter for women than for men, and the difference between men and women is greater in France than in Britain (Roy, 1990:224). The working hours of French women employed part time are longer than those of their British counterparts: more than 50 per cent of women part timers in the UK with children aged 0-4 work less than 19 hours per week compared with seven per cent in France (Moss, 1987: Table 1). Because fewer women in France work part time and their working hours are longer, on average French women are likely to spend a greater part of their daily time away from home in work related activities, particularly since the 'lunchhour', which is not counted in actual working hours in France, may also be of longer duration.

The length and organization of standard working hours influence the personal time organization of women both in their capacity as employees and as consumers of goods and services. In Britain public services (many of which employ a majority of women) operate relatively restrictive opening hours: most banks, for example, open from 09.30-15.30 Mondays to Fridays, with employees beginning their working day at 09.00 and finishing at 17.00. Insurance offices and building societies generally operate longer opening hours, including Saturday mornings. Typical office working hours in

Britain are from 09.00-17.00 with an hour's break for lunch, generally between 13.00-14.00. Women who are themselves working office hours must therefore make use of banks and other services during their lunch break.

Women make up 55 per cent of clerical workers in banks and 74 per cent in insurance companies in France (Seys, 1987:63), where daily opening hours are longer: many banks and insurance offices outside Paris open Tuesday to Saturday from between 08.30 or 09.00-12.30, and 14.00 or 14.30-18.00 or 18.30, although some close earlier on Saturdays. Public services such as *préfectures*, which deal, for example, with driving licences, might be open from 09.00-12.15 and from 13.45-15.45, with earlier closing on Fridays. Standard working hours in offices operating flexitime are Monday to Friday from between 08.30-09.30 to between 17.30-18.30, with a one or one and a half hour break for lunch. Women who are themselves office workers may only be able to use other services by taking time off, but some employers allow time to be taken during working hours to carry out administrative formalities.

While in Britain the standard weekly opening times for shops are Monday to Saturday, sometimes with mid-week half day closing, in France Monday closing is a common feature of the commercial sector. Many small retailers close at the beginning of the week but open on Sundays, at least until midday. Supermarkets and hypermarkets are prevented by law from opening on Sundays, except where a special dispensation has been granted by the prefect, but they do open on Mondays. Small retailers, like superstores, stay open until late at night, usually 19.30-20.00, with late night closing at 22.00 in supermarkets on Fridays and/or Saturdays. Many large retailers outside Paris close at lunchtime, often for several hours, typically 13-16.00 in the South of France. Bakeries open any time from 07.30, and in some towns or areas bakers may reach an agreement over Monday opening with other shops in the vicinity to ensure that customers can buy fresh bread every day of the week. Although hypermarkets on the outskirts of towns are used for bulk weekly shopping, French housewives expect to be able to make essential purchases from local shops or markets and respond to last minute needs at all times every day of the week. In addition, small grocery shops in the cities, often served by North Africans, remain open until late at night and later than most supermarkets. In Britain this function is also being filled increasingly by ethnic minorities, who are often prepared to work much longer hours than most indigenous shopkeepers. More small supermarkets are also operating seven day opening and extended hours. For women who themselves work long hours, as in France, and combine shopping with collecting children from *crèches* and childminders, the facilities available are part of a convenient support network which helps them to manage their daily lives.

The interests and convenience of the customer are not given the same priority by shopkeepers in Britain. The small butcher, fishmonger, greengrocer or shoemender in Britain may refuse customers as much as half an hour before closing time at 17.00. However, the British housewife

seems more willing to accept that she must organize herself accordingly and that shopkeepers, like everybody else, have a right to their own time.

In Britain consulting times for medical practitioners in general practice and surgery hours for dentists usually correspond closely to office hours, even in group practices, occasionally with a later evening surgery or a Saturday morning, but also sometimes with an early closing day. For women who work part time, these hours do not present problems, but full time workers need to take time off to attend for an appointment. In France, by contrast, most doctors and dentists work a much longer day, and the patient's convenience is paramount in a system which depends upon a commercial transaction between providers and users. Patients in France expect to 'shop around' and change their medical adviser if they are not satisfied. Doctors therefore have an interest in cultivating their clientèle and their reputation, whereas in Britain patients are registered on a doctor's list in their local neighbourhood and are not expected to change unless they move house or have strong reasons for being dissatisfied with the service provided. The patient's convenience is not therefore given the same priority.

Opening hours can be considered from the standpoint of the employer, the employee and the client, each with his or her own personal time schedules to manage. The interests of the employer are best served by maximum flexibility of workers so that peak flows can be met. The interests of the employee may also be in achieving flexibility, but in the service sector personal time preferences may not be compatible with those of customers. Where the public demand for a service is matched by commercial interests, opening hours in France are more generous than those in Britain, often with much less regard for the convenience of workers, as demonstrated when the structure of part time work in retailing is compared in the two countries (Gregory, 1989:381). Evening and weekend shifts are, for example, less likely to be sought voluntarily by women in France. A further illustration of this principle of commercial advantage is that consulting hours in public medical services in hospitals are very limited whereas private consulting times are less subject to restrictions.

The extension of flexible working hours in the public sector has not generally been matched by greater flexibility of opening hours in most public services and has not therefore made access to them any easier (Peemans-Poullet, 1984:51). Greater flexibility over the timing of arrival and departure in some sectors may be of limited value in this respect since the time frames imposed by other institutions, such as public services, still impinge on daily time structures.

A recurrent feature of working hours in France is that, with the exception of Paris, lunchtime closing has become common practice, whereas in Britain shops and offices more often remain open, with short staggered lunch hours for staff. A nationwide study of working mothers carried out in 1981 found that more than 50 per cent of French women with children used their midday break to go home for lunch. The proportion was higher for women with three or more children (Villeneuve-Gokalp,

1985:276). Within Paris the continuous working day is becoming increasingly widespread in public and commercial services open to the public, and the shorter lunch break (of one hour or less) makes it impossible for most women to return home. French workers still generally expect to have a cooked meal at lunchtime as well as in the evening. Firms which do not have a canteen often provide facilities on the premises for employees to cook their own lunch. In Britain much less importance is attached to the midday meal. A quick snack leaves the rest of the break free for other activities such as shopping.

The time frames of schools create another set of constrained hours which have a major bearing on the organization of family schedules. School hours in Britain are left to the discretion of head teachers. Infant and junior schools are usually open from 09.00, 09.15 or 09.30 until 15.15 or 15.30 with a one to one and a half hour supervised break for lunch. In France where the ministry stipulates official hours, schools operate from 08.30-11.30 and from 13.30-16.30, generally with no schooling on Wednesdays and on Saturday afternoons (17 per cent of children had classes on Wednesday mornings in 1980-81, according to David and Gokalp, 1984:73). Where the number of places for school meals is limited, preference may be given to children with working mothers in recognition of the need to ensure that they are properly catered for. The importance of the midday meal is further illustrated by the fact that schools which do not have canteens generally provide facilities for heating up food brought by young children.

From 1990, in consultation with parents and local authorities and subject to the approval of school inspectors, the opportunity was being given to primary schools to choose between different formulae: the standard nine half days with Saturday afternoon and Wednesday free; a variant with Wednesday afternoon and Saturday free; or a continuous week of 10 half days with Saturday free.

Secondary school hours are longer in both countries. In Britain classes may begin at 08.45 through until 15.45 or 16.00, with the possibility of voluntary extracurricular activities at the end of the day or on Saturday mornings. In France secondary school pupils may have classes from 08.00 through to 18.00 from Monday to Saturday, with as much as a two hour break at midday and no lessons on Wednesday afternoons. When pupils in the older age groups are not in class they are allowed to leave the school premises during the day, as is often the case for sixth formers in Britain.

Another aspect of scheduling which is relevant to an analysis of the coping strategies adopted by well educated women is the organization of after-school hours. Given that the standard working day in an office in France may not finish until 18.00-18.30, French people generally expect to arrive home later than their British counterparts. The survey of working mothers conducted in 1981 showed that more than 20 per cent of women with children left home before 07.30 in the morning and almost 30 per cent did not return home in the evening until after 18.30 (Villeneuve-Gokalp, 1985:276). Childminders in France may not be relieved of their charges until

as late as 19.30, whereas in Britain 17.30 or 18.00 would be a more usual time. No after-school provision is available in Britain, whereas in France supervision outside school hours is generally offered on the premises of nursery and primary schools, sometimes from 07.30 to 19.00.

Where workplace nurseries exist in Britain they often close at 17.00, which creates problems if meetings are continuing or an appointment with a client requires more time. In France too women's family responsibilities make it difficult for them to be as 'flexible' as their male counterparts, as shown by a study of women in banking in the late 1970s. It found that men took longer over lunch and were available at the end of the working day for informal discussions which were an important component in their career progression, whereas women could not afford to have extended lunch breaks and arrive home at unpredictable times (Labourie-Racapé, 1981:10).

The expectation in France that the evening meal should be of the standard three to four courses with a cooked main dish implies that it will not generally be consumed until at least 19.30 and will last longer than the light evening meal which is more characteristic of British eating habits. By the time the meal has been cleared away and other household chores completed, little time is left for leisure activities. For those who work long hours opportunities to spend time with children in the evening are strictly limited. Although it is customary for the father to be 'absent' and to see very little of his children when they are young, women who adopt male patterns of working hours may also find themselves returning home after their children's bedtime, which in their case is less readily accepted.

The well qualified British women respondents with children in our survey almost exclusively mentioned their children's schedules as the focal point of their lives, determining the way they organized their time. Few of the French women identified a single factor constraining their daily organization, such as time spent travelling to work, school schedules, opening hours or mealtimes. More often it was the multitude of different activities they were involved in which dictated time management. Women who had lived and worked in both countries made reference to the greater convenience of opening times of shops, banks and public services in France, which allowed more freedom and flexibility in scheduling daily tasks.

ANNUAL TIME ARRANGEMENTS

Working mothers, except in the teaching profession, are likely to face many problems in organizing holiday care for their children. In Britain school holidays generally total about 13 weeks a year, with six weeks in the summer, two to three at Christmas and Easter and a week for each of the three half terms. Parents working full time may have between 22-30 (working) days of paid annual leave, which can be taken at any time in the year, except if their workplace closes down for a week or fortnight. In most cases, they will need to make arrangements to cover at least part of the school holidays.

In comparison with most other Western nations, the French are renowned for the length of their school holidays, totalling almost 17 weeks, and for the way they are distributed over the year. In 1990-93 summer holidays were scheduled by the ministry to last nine weeks; Christmas and Easter breaks were of two weeks, the autumn half term break was of one week and the so-called winter holiday had been extended to over two weeks in February-March. The winter and Easter breaks were staggered between two geographical zones in order to avoid congestion on the roads and to prolong the peak period in ski resorts. When public holidays and other free days are added, the number of days in the year when children at primary level are actually at school is no more than 160. Children in France do, however, have one of the longest school days in Europe: in secondary schools pupils may have seven hours of classes a day, with teaching periods of 60 minutes. Chronobiologists have demonstrated that the organization of holidays and the school day in France runs counter to natural biological rhythms, causing trauma in many children (Montagner, 1983; Reinberg et al, 1979). Resistance to change has been strong, and in the late 1980s schools were still not empowered to choose how they organized their timetables and holidays, except at primary level where the reforms being proposed were intended to give them more autonomy at least as far as weekly scheduling is concerned.

Although the French have been criticized as a nation of skivers because of the amount of time they spend off work (Scherrer, 1987), arrangements for childcare during school holidays are a major concern for dual earner families. While relatively few French mothers complain of having problems in organizing childcare arrangements, those who do have difficulties most commonly mention holiday times (Villeneuve-Gokalp, 1985:269). The length of school summer holidays has gradually been reduced, despite the strong pressures exerted to maintain the *status quo*, not least by members of the teaching profession. Since 1982 statutory minimum annual leave for employees in France who are not on short term contracts is five weeks, with the obligation to take at least one week outside the summer vacation. It is far from unusual for firms to close for the month of August, thereby imposing the timing of family holidays and leaving long periods when provision needs to be made for children.

The problems which mothers who are working full time have to face in finding activities for their children during school holidays, particularly in Britain, are formidable. When the constraints created by daily childcare are considered in combination with the problems of prolonged holiday periods, it is easy to understand why British women with children are more likely to leave employment when they have children and subsequently return to work part time rather than full time once their children reach school age. In France policy makers do show an awareness of the problems of arranging childcare during school holidays, and difficulties in making satisfactory arrangements are less likely to be the reason why women with young children leave employment.

The feasibility of combining family and professional life

The vast majority of the well qualified women we questioned in Britain and France thought that, ideally, it should be possible to combine a family with a career, and this was the objective to which most of them aspired. A larger proportion of the French women considered that priority should be given to the family rather than a career (20 per cent compared with 13 per cent of the British). Few women (seven per cent of the British and three per cent of the French) were of the opinion that professional life should be given priority. When asked about their views on the feasibility of combining family responsibilities with an employment career, just over half the women in both countries felt that it was possible within the current context to reconcile the two commitments. A much larger proportion of the French women (35 per cent compared with seven per cent of the British) considered the feat was possible but difficult. More of the British women (39 per cent compared with nine per cent of the French) expressed the view that family life could not be successfully combined with a career. A Franco-British comparative study of men's perspectives on changing gender roles showed that this difference of opinion is reflected in men's attitudes: French men are more likely than their British counterparts to believe that women can both have children and pursue a career (Ferguson, 1987:59).

Many of the British women who felt that career and family could be combined expressed the reservation that the statement applied to mothers with children of over three or of school age and could therefore be put into operation only at certain stages in the life cycle. Reduced working hours were frequently quoted as a prerequisite for success, suggesting that the women concerned saw their work as an occupation rather than an employment career. For many of the French women, who could be classified as 'qualified optimists', problems were inevitably said to arise, but the view was strongly held that such problems could and should be resolved through compromise and concessions, provided certain conditions are met. In both countries respondents maintained that, if women are to be successful in combining family and professional life, they need, firstly, to belong to the more privileged social classes, implying a high level of income, the possibility of employing a full time nanny or home help and a readiness to subcontract housework and shopping. Secondly, the cooperation and availability of a spouse are essential; preferably one who is not too ambitious for his own career. Thirdly, reliable readily available support networks are crucial, supplemented by relatives close at hand and ready to help out in an emergency. Fourthly, the type and place of work are important considerations: employment must be found which offers flexible working hours and is located within easy commuting distance. In France, some respondents also suggested that the chances of success could be improved by limiting the number of children to two.

Although more of the British women expressed the opinion that it is not possible to combine an employment career with family life, women in

the two societies explained their negative attitude in broadly similar terms. The British women, however, placed greater emphasis on the lack of moral and physical support and the negative consequences which children had for promotional prospects on the grounds that a career structure must not be 'blotted by temporal default'.

The views of the French women who thought that reconciliation was impossible and that women are in a no-win situation were aptly summarized in the comments made by a respondent who was working long hours as a translator in a commercial company. In her opinion, one option open to women is to commit themselves fully to the pursuit of a career and to leave their children in a *crèche* or with a minder, which may be positive as far as the career is concerned, but negative from the point of view of motherhood. A second possibility is for the woman to forget about promotion, continue working full or part time (which is not readily available), and therefore feel frustrated either way; such a solution is unsatisfactory for career development and for the children and is therefore negative on both counts. Alternatively, she can stay at home and raise her children, but then she is trapped, her personal life is nullified, she has no leisure, no time for her own interests and self-development until the children reach school age and, moreover, she becomes uninteresting as a person.

According to the pessimists in both countries, whatever solution a woman adopts, she must make sacrifices and will feel guilty: if she works she feels guilty about not devoting enough time to her husband, children and home; if she stops work she feels guilty because she is inactive and not using her skills. For women who try to do everything, however, the result is overload and tension within couples. If work is abandoned, the outcome is loss of identity, income and independence. The price to pay for being independent and able to assert herself as an individual is that she still has to contend with adapting to constraints and schedules imposed not only by family members but also by outside agents.

Despite the finding that few women thought priority should be given to their career, a much larger number of the French women stressed the importance of maintaining employment status, to the extent, according to one dentist, that women in France tend to concentrate on their job and neglect their family life and children. The women's rights movement was attributed some responsibility for having convinced women that they should be working, but the economic situation was also mentioned as an important incentive for women to remain in employment since a single income is not enough for managing a household. The consensus amongst French women was that it is too late to turn back the clock: women are now an integral and permanent part of the workforce. A British graduate who had lived and worked in France felt that, in comparison with the French women she had observed, British women were defeatist and almost expected to give up work; French women would not even consider abandoning their career, which, in her eyes, made them far more interesting people than their British equivalents.

Other studies of well educated women confirm the view that women in France today have no option but to work, even though financial imperatives may not be their main motivation for pursuing continuous employment (Castelain-Meunier and Fagnani, 1988:51). There is no question of choosing between work and family: the women concerned see it as a personal challenge to find ways of managing the two successfully; pursuing a career is an absolute necessity for them. Rather than a shared commitment between home and work, they lead a double life, the conditions of which they are prepared to negotiate both at home and at their workplace (Pelosse, 1987:16).

Time pressure and stress

It has been suggested that stress associated with the family-work relationship arises primarily out of the social context, and in particular from gender role attitudes which are reflected in organizational and state policies (Lewis and Cooper, 1988:140). From the evidence assembled in this section, in comparison with the British household, a greater part of the daily and weekly time in the French family unit, especially where mothers are employed full time outside the home and have pre-school age children, seems to be subjected to or determined by external constraints. However, it can be argued that the support provided by organizational and state policies in France for women's two roles may serve to reduce the level of stress.

Socially imposed time structures, as well as their full time status, require French women who are economically active to organize more tightly packed time schedules than their British counterparts during the smaller number of hours when they are not at their workplace. As a result, they are constantly harried, frequently complain of feeling exhausted and suffering from time famine, as far as personal time is concerned. A number of comments by the French women in our study suggested that time organization at work was, in fact, more relaxed than in the home.

Because the school week is different from the standard working week, and the weekend is not free from work for about a third of women in the higher grade occupations, the period when family members can be engaged in activities associated with family togetherness is also more difficult to organize and is concentrated into a relatively small number of hours in the week. Saturday schooling may, however, give working mothers who are themselves free on that day the opportunity to perform household tasks without being encumbered by the demands of small children. The impact of externally imposed time frames is that French women may have to work harder at organizing their daily and weekly time routines but, as already suggested, they tend to see this as a challenge which can be met.

The main problem facing them is how to deal with the sheer quantity of activities while trying to ensure that family members have compatible temporal patterns or at least the capacity to adapt to new situations. This generally involves compromise. Many of the women we questioned emphasized how important it was for them to be available at their

children's mealtimes or to oversee their many activities and to be sure that children are never left at home by themselves. This tight time organization called for complex planning, which sometimes created problems in establishing priorities. The price paid was the lack of personal time and the feeling of guilt if (an unusual occurrence) any free time was not used to be with children. Most women consequently found that they had to forego their own free time and, in some cases, reduce the amount of sleep they had, so that their children did not 'suffer' from having a working mother. Despite their relatively long working day, when asked how they would like to be able to organize their time, French women generally express a preference for time blocks (long weekends, holidays) rather than a shorter or looser daily time schedule (Linhart and Tourreau, 1981; Villeneuve-Gokalp, 1985:290), suggesting that they prefer a system requiring tight time packing in order to release longer periods of relatively less constrained time.

For these different reasons, French women are more likely to feel under time pressure and to suffer from overload, but they may not be subject to so much stress and frustration as British working mothers trying to juggle with the same problems, because they have a greater sense of self-righteousness and legitimacy about what they are trying to do. If British women continue working full time, they have to contend with opposition from relatives, employers and society in general and the lack of support facilities. Women who take a career break or reduce their worktime commitment seem able to lead a more relaxed existence as far as their time organization is concerned, but they also have a price to pay. Well qualified British women may suffer to a greater extent from the role strain associated with motherhood because it signals the end of their career, at least temporarily. If they compromise by reducing working hours, they are aware that they may be placing their career in jeopardy and most probably sacrificing their professional life for their children.

STRATEGIES FOR COMBINING FAMILY AND PROFESSIONAL LIFE

One of the consequences for women of more continuous patterns of employment is that the employment calendar is coinciding more closely with that of the family (Langevin, 1984:79). A potential chronological clash may be avoided in one of two fairly obvious ways: the first is for women to leave the labour force, at least temporarily, if the family is given preference, thereby reducing the amount of overlap between work and family; the second is to forego mothering if priority is being given to employment. For those who do not want to accept the sacrifices required by either of these extreme solutions a third possibility is to exploit the various means available for reorganizing work and family life in an attempt to make employment compatible with family commitments and schedules and for a number of years to accept the problems associated with overload (Nicole, 1987:91).

The level of income, the intrinsic interest of their work and prospects for promotion are possible incentives which encourage well educated women to look for ways of overcoming the constraints created by the presence of children. As demonstrated in the previous chapter, for some well qualified women, the conflict of interest between family and professional life is avoided by not getting married and not having children, thereby removing the need to have a break in employment. For others the timing of childbirth is postponed while a career is established and/or the number of children is reduced. Better educated women have for a long time been amongst those most able to control family size and to plan births to fit in with their other commitments, and medical advances have reduced the risks involved in childbirth at a later age. Although not all births are carefully scheduled, the assumption can be made that most women in this category are achieving the family size they want and that they are timing births according to a strategy which is intended to ease the strain and complexity of simultaneously managing a family and a career. Since social pressures and the lack of adequate childcare facilities make it very difficult for women to remain in employment, most women in Britain still take a career break when they have children. The timing of childbirth has therefore become a critical issue in career planning. Childraising is generally combined with employment sequentially by taking a career break until children reach school age. The main advantage of postponing childbirth may be that a couple can command a higher salary and can therefore afford to pay for full time childminding. By the same token, a career break at this stage will mean sacrificing a larger income and all the benefits associated with it. A different strategy was adopted by most of the women in the study of British doctors: it was found that the women interviewed had had children while they were in training posts rather than waiting until they qualified (Allen, 1988:35).

In France, as shown in the previous chapter, the decision of well qualified women to leave the workforce when they have children can be interpreted as signalling a long term commitment to a family rather than an interruption of several years in an employment career. Relatively few women were found to stop working because they had one or two children, whereas women who left the workforce in order to raise a family were likely to have three or more children.

Where both members of a couple are intent on pursuing an employment career, the situation is inevitably complicated. A number of 'adaptive mechanisms' (Bailyn, 1978:166) are exploited by dual earner couples, including full time nannies and long distance commuting, which make it possible not only to resolve conflicts between work and family but also to adapt to them by capitalizing on the autonomy of each of the partners. The guarantees accompanying the career break when it is in the form of parental leave, as in France, mean that it can serve as a strategy for preserving career development during motherhood. Accommodation is not, of course, achieved once and for all, and different strategies may be required for a large family size. The process is continuous and is conducted

in response to changing demands and perceptions of the success of the mechanisms which have been tried out (Bailyn, 1978:168).

The postponement of childbirth and limitation of family size, like part time or flexible working arrangements and changes of occupation can all be considered as strategies adopted by women in order to manage, if not resolve, their dual roles. Some strategies have already been examined in previous chapters in relation to employment and patterns of family building. Discussion of the impact of marriage and of children on employment raised the question of priorities and the choice of employment, a topic which is relevant to this section. Time management has been a recurring theme in the analysis of women's professional and family lives and is central to an understanding of how women can combine the two areas. A number of issues are examined here with reference to the adjustments made in time structuring, which may involve extending the length of the working day, adapting worktime schedules, compressing and manipulating the time spent carrying out household tasks or redistributing them amongst family members. The distribution of labour within households is a vital component in the strategic management of the family-work relationship, as are the support structures provided by society to assist women seeking to combine childraising with employment.

Choosing compatible employment

When the problems faced by couples looking for two jobs were studied in the mid-1970s in the United States, a number of strategies were identified amongst dual career couples: in the 'traditional' model the wife followed the husband and subordinated her career choice to his; in the 'non-traditional' couple the husband followed the wife; and in the 'egalitarian' marriage both careers were attributed equal importance (Berger et al, 1978). In the case of the egalitarian model, each spouse might search separately and then accept the best joint option, or they might both apply to the same employer or confine their search to the same area. Another possibility was to alternate in deciding which career should take precedence. The researchers found that the majority of initial decisions were egalitarian, but subsequently most couples reverted to the traditional strategy, generally because the husband had been offered a job first.

In our own study of well qualified women in two EC countries more than a decade later, the traditional strategy was also dominant. The non-traditional approach was found only amongst a small number of the French respondents. In some cases the egalitarian model was adopted as part of a broader strategy to improve the social status of the couple. Having established a high standard of living, it then became difficult to forego one income, unless the partner had good prospects for rapid promotion. In order to maintain the egalitarian strategy, some couples resorted to a commuter marriage, generally as a temporary expedient, reverting to a more traditional model with the arrival of children. An alternative outcome of the egalitarian approach was divorce if the conflicts, which

almost inevitably arose, could not be resolved. In very few couples could the egalitarian principle be sustained, and priority was generally given to the husband's career because he commanded higher status or earnings. Since the career break tends to be interpreted as a sign of a more limited commitment to employment, while husbands are advancing their careers, women who temporarily leave the labour market find they come under increasing pressure to adopt the traditional strategy and follow their spouse.

In France the strategy to be exploited may be determined at an early stage in a relationship and can be interpreted as a conscious decision to invest in the husband's career because he has a greater chance of success (Lollivier, 1988:26). Women who plan to follow this strategy will marry at a younger age and, as already demonstrated, will leave the labour force well before they reach the desired family size in order to devote their energies to their children. Several studies have shown that the chances of academic success for children increase in relation to the standard of education achieved by their mother (for example, Menahem, 1988:46). Well qualified women who opt for a family career may therefore be able to justify their decision as an investment in their children's futures. For women who pursue an employment rather than a family career, the type of occupation they choose may be a critical factor in determining a successful outcome.

TEACHING

In couples following the traditional strategy women may look for employment which is likely to be compatible with family life. The profession most frequently cited as being 'suitable' for women wanting to raise children is teaching. The argument that teaching has become feminized as a result of being compatible with family life is not, however, well founded, for until quite recently women teachers tended not to marry and did not have children. In 1938 63 per cent of women teachers in secondary schools in France were unmarried, and the proportion was still above the average for the population as a whole in the mid-1970s (Cacouault, 1985:102). Rather, in both countries, teaching may have become feminized initially because it was one of the few careers available for women who underwent higher education and were determined to make use of their professional qualifications.

In France teaching has the considerable advantage over most other occupations of requiring a relatively low number of hours of attendance, and they are strictly controlled by the Ministère de l'Éducation Nationale. In primary schools teachers are scheduled for a maximum of 27 hours a week; in secondary schools, if they hold the CAPES, the maximum is 18 hours, and those with the *agrégation* are not required to teach more than 15 hours. The better qualified teachers have considerable flexibility in the way they organize their timetables. They do not have to perform administrative duties, as in the British system, and when they are not teaching they can leave the premises. French women teachers also have the advantage over their British counterparts of being able to adapt their hours to suit

individual needs. The widespread provision of nursery schooling from an early age and the relatively low number of hours of childminding needed for pre-school children mean that continuity of employment is feasible and does not involve such complex scheduling as for women in other occupations. In order to simplify the organization of her life further, a teacher in France can take parental leave until her children reach the age of two and then find a place for them in a nursery school without difficulty. Teachers with young children are the category most likely to take advantage of the free Wednesday (Villeneuve-Gokalp, 1985:277), and they can make the necessary arrangements without having to change to part time hours.

In Britain the problem of childminding for pre-school age children is not resolved so easily, and secondary school hours do not correspond to nursery and primary school timetables. In the absence of provision such as is available in France, the cost of childminding for two young children is at a level which may mean that it is not financially viable to work part time. While the teaching profession can more easily accommodate the time schedules of older children, it is not necessarily a panacea for women with very young children.

The convenience of daily worktime schedules and holidays were mentioned by teachers in our study as important reasons why they were able to combine childraising with full time work. Because teaching is more compatible with family life than most other professional occupations, women with teaching qualifications tend to show greater 'occupational commitment' by accumulating more work experience than the average working woman (Dex, 1987:45). The ready availability of part time arrangements may to some extent explain why teachers are likely to maintain greater continuity than women in other occupations. Although teaching appears to offer conditions which make it feasible to combine what can be satisfying employment with childraising, as in other areas of employment, women who decide to opt for part time in Britain must expect to lose their place on the promotional ladder.

As the teaching profession (or semi-profession) has become increasingly feminized, in both countries it has lost status, and pay levels are commensurably poor, particularly for infant and primary school teaching, which is almost exclusively female. Many women who go into teaching today may do so from a sense of vocation or because it is an occupation which is compatible with raising children. Whereas all the French women in our sample who were teachers had not been employed in other fields, several of the British women had originally held jobs in industry and attempted to follow an egalitarian strategy. Subsequently, they had retrained to become teachers when they had children. The main reasons they gave for changing occupations was not, however, the convenience of working hours. Rather they expressed dissatisfaction with the conditions of employment in industry and were attracted by what they saw as the more personal human values associated with the teaching profession.

PUBLIC SECTOR EMPLOYMENT

Reference was also made by our French respondents to the advantages offered in the public sector to employees other than teachers. Several women in the medical profession, for example, had moved into the public sector specifically because of the conditions of service and working hours which it afforded and which they considered more compatible with childraising. In previous chapters the civil service in both countries has been quoted as providing more favourable working conditions than private industry. The public sector has acted as a trail blazer by introducing schemes for maternity leave and reinstatement, flexible working hours and job sharing, which make it attractive for working women despite the relatively lower levels of pay. Career grade civil servants (*fonctionnaires titularisés*) in France (teachers are included in the classification) have the guarantee of a job for life. Women who achieve this status by passing the relevant competitive examinations are therefore confident that, if they take maternity and parental leave or request reduced working hours, they will not step off the career ladder and return to the lower rungs. National surveys show that women civil servants do have more children than average, and this has been attributed to the fact that they are not likely to lose their employment because of motherhood (Lery, 1984:30). In Britain, by contrast, women in the service who opt for the 'keeping in touch' schemes, rather than maternity or special leave, must resign from their posts.

A disadvantage of public sector employment, particularly in France, is that workers are expected to be mobile and have only limited control over their postings. Young couples are therefore likely to be separated geographically, at least in the early stages of their career. The civil service is, however, very much aware of the problems created and is legally bound (under the *Loi Roustan*) to take family factors into account when making appointments. By the early 1980s, in recognition of the growing importance of cohabitation, provision for unmarried couples to be posted in the same geographical areas was being debated (Davisse, 1983:111).

It has been argued that public sector administration is being required to adjust to the need for more individualized management of human resources and to respond to the specificity of women workers as a result of their family commitments (Timsit and Letowski, 1986:251). With women making up such a large proportion of public sector employees, the situation has already been reached where conditions of employment are being adapted to take account of the fact that women do have different work profiles from men. Women in the public sector in France have had an advantage over those in the private sector since the beginning of the century (Davisse, 1983:27). In Britain too the civil service is presented as being a good employer for women, although this image may not have had the same impact as in France. In the early 1980s the Joint Review Group on Employment Opportunities for Women in the Civil Service stressed that staff needed to be made aware of the provisions for maternity and childcare and other urgent domestic matters and stated that management should

learn to deal with their cases sympathetically (Management and Personnel Office, 1982:106).

In presenting the public sector as the model for worktime restructuring and the reduction of working hours, without a corresponding reduction in pay, at the beginning of the 1980s the French government was seeking to demonstrate that all workers, and not only women, should benefit from greater flexibility of worktime schedules. The immediate objective of creating jobs by sharing working hours over a wider section of the population was not, however, achieved, although productivity levels did improve (Barou and Rigaudiat, 1983:115). The main beneficiaries of these policies may well have been women in the public sector who found they could exploit a range of new opportunities to their own advantage.

SELF-EMPLOYMENT AND HOMEWORKING

Another area offering working conditions compatible with motherhood is self-employment. Studies of the arrangements made by working women to accommodate the demands of their children demonstrate how many self-employed women or women in family businesses or on family smallholdings resolve scheduling problems by working from home. The category in which women are most likely to work from home in France is agriculture, followed by small scale retailing and the professions. Women in these occupations have relatively few problems in coping with times when their children are not at school (Villeneuve-Gokalp, 1985:270).

In the professional occupations for some women, as for example in translating, the decision to have children may be accompanied by a shift to freelancing in order to be able to work from home. For British women work as a freelance translator means they can be available to look after children by fitting assignments around domestic responsibilities. Women who work from home — and the same would apply for telecommuting — may solve some problems but, in trying to adapt their work to suit the needs of their children, they can create other difficulties which affect their career advancement. They may not, for example, be available to answer a call from a client because they are feeding the baby, or they may find they have difficulty contacting clients who work standard hours. Children may demand constant attention at what might be their best times for working. One British freelance translator we interviewed complained of the social isolation of working from home and of problems in trying to remain professional while a baby is yelling and a husband is waiting for his lunch. In these circumstances outside assignments provided a 'blissful contrast'.

When the way one British freelance translator organized her life was compared with that of her French opposite number, the differences recorded in their expectations and management strategies seemed to reinforce the overall impression created by women in other professional occupations in each of the two societies, namely that British women are more restrained in their ambitions. The British translator was satisfied if she managed to devote herself to a continuous two to three hour working

period in a day and find a few uninterrupted hours at the weekend while her husband took the baby out for walks, therefore only accepting commissions which were not urgent. Her French counterpart employed a full time nanny to look after her two year old while she shut herself in her study, observed strict deadlines and maintained a heavy and regular flow of work.

ACADEMIA

Other respondents mentioned the academic setting as being conducive to combining employment and family life, in particular because of its greater flexibility in comparison with the business environment. Studies in the United States suggest that the advantages of flexible scheduling may, however, be outweighed by the permeable boundary between work and family which means that many aspects of an academic's work cannot easily be segmented from family life (Bailyn, 1978:165). The academic is faced with the same conflicts as the freelance translator or secondary school teacher, and indeed any categories of workers who take work home: how to be present but not necessarily available. They also need to resolve the problem of how to be taken seriously if prevented by family reasons from attending conferences, making research trips or from seeking committee membership.

MALE VERSUS FEMALE CAREER CHOICES

Although the traditional strategy of giving precedence to the husband's career still seems to be that most commonly adopted by well educated couples in Britain and France in the 1980s, the growing importance attributed to a woman's career may also be having an impact on the choice of employment amongst men, on their geographical and promotional mobility and their availability. Most employers do not yet have any procedures for handling the job seeking process as a couple (a problem noted in the late 1970s in the United States by Berger et al, 1978:26). Provision for dual career couples is far from being commonplace, but there is some evidence that employers are beginning to recognize that they have to take account of the interests of spouses if they are to recruit and retain well qualified workers. In 1989 the British Foreign Office was, for example, attributing its loss of high calibre employees to the fact that it was virtually impossible for both spouses to follow full time careers (FCO/ODA, 1989:vii). Its Personnel Operations Department was having to take account of the financial and social implications of mobility of spouses when arranging postings. The willingness of women to be 'married to the job' (Finch, 1983) or to accept that they should lose their identity and independence by becoming somebody's wife or mother rather than an individual in their own right can no longer be taken for granted. More women are demonstrating that they want to be as committed to their careers as their husbands. Whereas in the past organizations expected their recruits to have 'unhampered availability' (Rosin, 1988:10), the assumption can no longer be

made that men, as well as women, can sustain excessively long hours and be free to relocate at the whim of their company without regard for family circumstances.

Marriage to a well educated woman may enhance a man's career progression, as was argued in the previous chapter, but it can also impair his promotional development and result in a 'stalled career' by reducing availability, mobility and ambition because it confronts him with alternative values and interests (Allen, 1988:35; Nicole, 1987:72-3; Rosin, 1988:10-1). While removing much of the financial and psychological dependency of women on men, marriage to a career woman can also appear as a threat to masculinity and a source of disruption to marital harmony. A career woman is not an attractive proposition as a marriage partner (de Singly, 1987:173). A man married to a woman who pursues her commitment to full time continuous employment is likely to be less successful than if he has a wife who stops working (de Singly, 1987:83). On the other side of the balance sheet is the argument that the career success of women who marry and have children may be determined in no small measure by the support received from their spouses, which presupposes that they are able to reach agreement over priorities and the strategies to be followed.

Adjusting schedules

Flexibility is sometimes presented as a possible key to solving the problem of conflicts between work and family (Hansard Society, 1990:82; Haut Conseil de la Population et de la Famille, 1987:11). Policy makers in France take for granted that governments should intervene in order to find ways of making work and family schedules more flexible. Few studies have been made of the impact of new worktime structures on the lives of employees in order to determine whether flexible scheduling provides an answer for couples trying to manage the work-family dimension of their lives. The evidence from authors who have looked at the issues involved (for example, Cook et al, 1983, for shift workers in Britain; Bouillarguet-Bernard et al, 1986, for the restructuring of working hours in France) suggests that the flexibility sought by employers is not necessarily to the advantage of workers and may create as many problems of scheduling as it resolves. In a number of studies of the effects of changing worktime structures on non-work time, the object has been primarily to investigate how workers, understood to be male, use their leisure time in a situation where they are out of phase with friends and relatives. For women, and especially for women with children, worktime flexibility has another meaning: it implies the ability to coordinate a number of different schedules, both over the long and short term, many of which are determined by external agents, as well as by family events and related constraints.

In its Action Programme for 1982-85, the European Commission also raised the issue of compatibility of schedules. It recommended that an attempt should be made by EC member states to ensure that public services

and facilities are organized to take account of working hours, school timetables and the needs of workers and dual earner couples with family responsibilities, with a view to promoting equal opportunities for women (Commission of the European Communities, 1982, Annex I:17). This aim was further reiterated in the Second Action Programme with particular reference to transport, the timing of public and private services and their impact on women's employment (Commission of the European Communities, 1986:16).

While attention in France has recently been directed towards so-called 'new forms' of employment, including short term contracts, reductions in standard working hours and the organization of non-standard worktime (Ministère du Travail, de l'Emploi et de la Formation Professionnelle, 1989), part time is the type of flexibility which figures most prominently in the British literature. Women resort to part time work not only to match working hours with daily school times but also to be free during school holidays. The analysis of part time working in Chapter 3 suggested that it was also prevalent, in the form of shorter weekly working hours in France amongst well qualified women who opted for a reduction in worktime in order to accommodate family needs. Shorter hours did not, however, imply loss of status and promotional opportunities as they did for women in lower grade positions or for most women, including the better qualified, in Britain. Women in higher grade occupations in France have been found to be more likely than women in most other categories (with the exception of small scale retailing) to be in a position to adapt their working hours to suit themselves (Villeneuve-Gokalp, 1985:278). A major strategy for combining professional and family life is therefore to find a balance between convenient working hours and an acceptable level of income so that it is feasible economically and psychologically to continue working.

National legislation and public policy regarding worktime and working conditions and institutional structures directly and indirectly influence the possibilities open to women. Whereas British women tend to resume work as their children reach school age because it is then feasible for them to find working hours which correspond to school hours, French women are likely to request a reduction in their working hours once their children enter nursery or primary school in order to be free on Wednesdays. As mentioned previously, few women working full time in France would prefer a shorter working day, even if they start very early or finish late, but women in the higher grade occupations would like a half day off during the week, and this is clearly their main preference as far as any change in working hours is concerned (Villeneuve-Gokalp, 1985:291).

Studies of the development of part time work in France in the 1980s have revealed the extent to which the phenomenon of the *mercredétistes* (women who do not work on Wednesdays) has developed in recent years (Belloc, 1987:116). Already by the beginning of the 1980s, almost 90 per cent of practising teachers with children managed to be free on Wednesdays; some by working reduced hours, others by organizing their timetables accordingly. A relatively small proportion of women in the higher

occupational grades took Wednesdays off (16 per cent), but a number of them were 'available' because they worked from home (Villeneuve-Gokalp, 1985:277).

For many French women a part time job rather than reduced working hours is a hypothetical or purely practical answer, and they express the reservation that worthwhile jobs are not part time. Although flexible worktime schedules might seem to present the best solution, the quantity of working hours rather than their arrangement is the greatest source of constraint for working women Nor are long breaks, in the form of parental leave, considered ideal, particularly if only women avail themselves of the opportunity. At the beginning of the 1980s parental leave was an option pursued by only a small proportion of women who were eligible (22 per cent), and those who did take it were not absent for the whole of the time allowed (74 per cent took a year or less) (Villeneuve-Gokalp, 1985:286). When women with three or more children do continue to work full time, they have clearly decided to do so on the basis that they can make the necessary arrangements. They therefore expect to be fully committed to their employment and are likely to express a high degree of satisfaction with their working hours (Villeneuve-Gokalp, 1985:293).

Women are juggling with a multitude of time frames, which are rigid and specific: their own working hours, those of their spouse, their children's school hours and the opening times of services. Other schedules are more diffuse but nonetheless constraining and relentless: mealtimes, washing and cleaning. Even fixed time structures are not regular. Daily patterns change at different points in the week. School holidays are a major source of disruption. As children grow older and develop outside activities, they make new demands, requiring constant adaptation and different forms of availability. The presence of children inevitably implies a much tighter coordination of schedules and a lack of spontaneity.

The management of time by households requires the development of a combination of complex strategies. Some may be directed towards reducing or restructuring worktime where employers make provision for flexibility. Others involve cutting down time spent travelling to work. Women are more likely than men to try to live near their place of work in order to avoid wasting time travelling. More than 50 per cent of teachers in the Greater Paris area, for example, spend less than 15 minutes travelling to work (Fagnani, 1986:49). As the number of children increases average time spent getting to work decreases. This strategy is, however, less common amongst women in the higher professional grades, particularly in and around Paris, for whom the financial and intrinsic rewards gained from work offset the additional fatigue: only 38 per cent of the women working in administrative and management positions were found to spend less than 15 minutes travelling to work.

The ability to organize personal time is a major concern for well qualified women. Often they perceive and measure their success in combining work and family in terms of their skill at coordinating complex schedules and applying their time management skills to family as well as

professional life. For many women the main temporal strategy is to extend the total amount of time spent on household and paid work at the expense of personal time and sleep. Several of the British women in our study commented on the need to complete their own work late in the evening, as for teachers, or to work in short bursts, as for example in the case of freelance translators based at home. A number of the French women mentioned that they had had to adopt a more regular lifestyle, reduce the number of personal outings and the amount of travel, plan more carefully, avoid staying at work late and accept a much heavier work load. Women who work full time in a demanding job and raise children claim that in order to cope they need to be excellent time managers, displaying the same management skills at home as at the workplace: the ability to plan, organize, delegate, direct and control.

Distribution of household labour

Within the household women's time is generally presented as being at the disposal of other family members (Langevin, 1984:79). Women can and do, however, influence and control the time organization of family life by taking a number of key decisions. The woman usually determines the timing of childbirth. In theory, the woman chooses (although the degree of freedom of choice may be very limited) whether or not to work outside the home. Economically active women most often petition for divorce. A relationship with a husband or long term companion may be seen as a temporal obstacle to pursuing a career. An increasing number of women in France have been deciding to raise children without being encumbered by a stable relationship with a man (a trend reported at the beginning of the 1980s, for example by Savigneau, 1980).

The increase since the 1960s in the proportion of women who are economically active at the stage in their lives when they are also involved in raising children would seem to have had relatively little impact on the way in which responsibility is assigned between spouses in the home. Even though the women we questioned stressed how important it was for them to have their husbands' support and cooperation if they were to be successful in combining family and professional life, within households the organization of family schedules generally remains the woman's responsibility. She has to ensure that the childminding arrangements are satisfactory, that appointments with doctors and dentists are kept, that shopping is done and that her husband's life is made as easy as possible, by arranging her own work schedules around the needs of her children. She has to cope with emergencies and is also frequently expected to care for elderly relatives. Well educated French women who decide to combine professional and family life seem to accept this responsibility as part of the power relationship within the household, managing the family as they would a company (Castelain-Meunier and Fagnani, 1988:52).

If men are perceived as compartmentalizing and managing work and family roles as discrete spheres, working mothers are very much aware that

they will have to lead several lives simultaneously and that they do not have enough hours in the day for all their tasks (Fitoussi, 1987). Where adjustments are called for to reduce the paid workload in response to the need to increase domestic involvement, the woman generally expects to change her work pattern. Flexible or reduced working hours are therefore a means of assuming the extra load rather than redistributing the burden.

Women feel it is their responsibility to take time off to look after a child who is ill and may use their own sick leave for this purpose. Provision is made in the public sector and in some companies in the private sector for paid family leave, as described in Chapter 3. Others allow unpaid leave or the opportunity to make up for time lost, as reported in Chapter 4. Women in higher grade positions are more likely to be eligible for family leave, although the provision is not always used (Villeneuve-Gokalp, 1985:281). In both Britain and France, when absenteeism for maternity is excluded, women are not, for example, found to be absent consistently more often than their male colleagues (Fournier, 1989:49; OPCS, 1986: Tables 6.31-6.38). In Britain women professionals and managers working full time are less often absent than their male counterparts for reasons of personal illness or injury (OPCS, 1986: Table 6.38). Higher grade workers in France are absent five times less often than manual workers (Fournier, 1989:48), and women are no exception (Pelosse, 1987:17). Many working women live in fear of their children falling sick and of seeing the system which they have laboriously constructed break down, but from the available data they would not seem to be abusing their position (Villeneuve-Gokalp, 1985:281). Having responsibility for making arrangements means that they have to find alternatives. This usually involves reserve support systems rather than their own time, and even more rarely that of their spouse.

In its First Action Programme the European Commission argued that the sharing of family responsibilities is a precondition for achieving equal treatment for men and women. The hope was expressed that, by extending family and parental leave and reorganizing worktime, traditional family roles would not be reinforced and would not serve as a pretext for reducing public provision of facilities and services (Commission of the European Communities, 1982, Annex I:8). Member states were exhorted to take action to monitor whether measures such as the extension of part time work were reinforcing labour market segmentation and to identify obstacles to full time work. A further aim of the Commission was to enable men and women to find fulfilment in all aspects of their lives (professional, family and social) and to be able to combine them satisfactorily. One of the key factors identified was the more equitable sharing of family responsibilities and a more equal share for women of the benefits of work and social life, a principle which was further reiterated in the Second Action Programme for 1986-1990.

French policy statements closely reflect the Commission's recommendations: since women are assuming an increasingly important share of paid employment, men and also society at large should accept responsibility for a greater share of domestic labour (Haut Conseil de la

Population et de la Famille, 1987:10). The penalty for not doing so is a fall in the birthrate, which the nation can ill afford. If public policy is able to influence the distribution of domestic labour, the pressures exerted by French governments and the publicity given to them might be expected to have produced a more equal sharing of household tasks than in Britain. Few direct comparisons have been made of the division of labour in British and French households, but the available data would seem to suggest that this may not be the case and that women in dual career families in Britain may be relying more heavily on their husbands than women in similar occupational situations in France.

Analysis of the distribution of household tasks demonstrates that a strict division of labour has been maintained in Britain. Since the early 1960s men's participation in household tasks has increased from about 50 minutes a day to almost 1 hour 15 minutes, which is less than the amount by which time spent by women on domestic labour has decreased: from 4 hours 40 minutes to 3 hours 40 minutes (Gershuny, 1987:12). This does not, however, mean that marriage has become a much more egalitarian relationship than in the past. Almost three-quarters of the women interviewed at the end of the 1970s in the Women and Employment Survey claimed that they did all or most of the housework (Martin and Roberts, 1984:100-3). More than half the women working full time were in this situation and three-quarters of those working part time. By the end of the 1980s the pattern had changed very little (Witherspoon, 1989:183). Husbands were more likely to be involved in childcare tasks than with housework, but even here women continued to do most of the routine physical tasks while men were more likely to play with children or take them out. Only household shopping involved anything approaching a more equal distribution: 43 per cent of households reported equal sharing in 1987 but in 50 per cent of couples it was still mainly the woman who performed this task (Witherspoon, 1989:182). As the amount of time spent by men on shopping has increased, that spent by women has gone up at the same rate (Gershuny, 1987:12). Less than a quarter of couples are found to share household cleaning, and 17 per cent the preparation of the evening meal. Very few couples share washing, ironing and household repair jobs, the only task for which men are mainly responsible. Women not only assume the major burden for housework and childcare but also for the care of elderly or sick dependants. In the mid-1980s 15 per cent of all women were found to be providing this service (Henwood, 1990:24).

Social attitudes surveys suggest that younger unmarried men and women are more likely to believe in the equal sharing of household tasks. The egalitarian principle is also more often espoused by men with a higher level of education, although in practice their participation is confined to tasks associated with their children's education. Although marriage and the arrival of children increase the number of household chores to be performed, the amount of sharing tends to be reduced. If women take a career break or change to part time working when they have children, the assumption is made that they are accepting that they should take on the

major share of the task of childraising, and men's participation falls accordingly.

Recent time budget studies in France confirm that the sharing of household labour has not become more egalitarian (Grimler and Roy, 1987). When the findings from the 1985 national time budget survey are compared with those for 1975, economically active men are shown to have slightly increased the time they spend on household tasks (by an average of 21 minutes a day), while the time spent by women has decreased by four minutes for women employed outside the home and by 54 minutes for women who are not economically active. However, in the age group 25-54, working men spend 2 hours 48 minutes a day performing household tasks and working women 4 hours 50 minutes. Women not employed outside the home spend 8 hours 12 minutes a day compared with 5 hours 9 minutes for men who are not in paid work. The combined total for the number of hours spent on household labour by economically active men and women is therefore close to that for women who are full time housewives. On average women spend an hour less a day in paid employment than men, but their combined total for paid and domestic work is greater. Domestic labour continues to represent an important constraint on women's time, although comparisons with one of the very early surveys of women's use of time, conducted in 1947, indicate that average time spent on household tasks by economically active women has decreased by about 15 hours a week over a period of more than 40 years, the reduction being greater for women who are not gainfully employed outside the home (Stoetzel, 1948:61).

As in Britain, the tasks of cleaning, washing and ironing are almost exclusively confined to women and household repairs and maintenance to men. Women are twice as likely as men to look after the physical needs of their children, but more young fathers are devoting some care and attention to at least their first child. One economically active man in two cooks a daily meal, but he spends less time doing so than a woman (Roy, 1989:9-10). Men in the higher occupational grades spend less time than men in any other social category on housework, although they do not have the longest average daily working hours; they spend slightly longer on childcare than manual workers but less than other categories and, with manual workers, they devote the least time to their children's education. Women in higher grade occupations spend substantially less time than women in other categories on household tasks, more time than all but the intermediate category on childcare, and considerably more time than all other categories on their children's education (Gadbois, 1987:10).

Franco-British comparisons show that French women in full time employment spend more hours on household tasks than full time workers in Britain, and whatever their worktime patterns they have less free time (Roy, 1990:224). When the participation of men in childrearing and household tasks is compared in the two countries, British men have been found to spend more time on household chores than their French counterparts and to play a greater part in decisions about whether and

when to have children (Ferguson, 1987:56). French men tend to display more interest than British men in tasks concerned with the educational and emotional development of their children. In both countries men with a higher level of education are those most interested in childrearing, but in France a larger gap is found to exist between theory and practice.

The French women in our survey who were employed in teaching and research mentioned that more men are beginning to take responsibility for children and are adapting their working patterns accordingly. They claimed, however, that husbands are more likely to help when they are younger and less settled in their own careers. Women in both countries who felt they were successful in combining childraising with a professional career frequently referred to the role played by their husband in sharing tasks and providing moral support, but even with a cooperative and understanding husband, the woman retained responsibility for ensuring and paying for childcare and, if the arrangements broke down or the child was sick, she felt obliged to take time off work or make alternative arrangements.

In both countries, although childbirth may be postponed in dual career couples to enable women to establish themselves in employment, it will nonetheless coincide with a period when paid work is likely to be making heavy demands, involving long hours. If career progression is not to be sacrificed, alternative strategies are needed to prevent women from reverting to the traditional role of housewife and mother. Since the number of hours in the day is not infinite and very few husbands are prepared to contribute an equal share of their non-work time to household tasks, women in paid employment outside the home generally look for ways of cutting down the time devoted to domestic labour.

The increasing use of domestic appliances is one means of reducing time spent on household tasks and may have an effect on the way they are organized. As shown in Table 5.1, more British than French households are equipped with deep freezers, washing machines and especially dishwashers. In France the proportion of households with dishwashers rises to the British level amongst the higher occupational grades.

TABLE 5.1 DOMESTIC APPLIANCES OWNED BY HOUSEHOLDS IN THE UK AND FRANCE (AS A PERCENTAGE OF ALL HOUSEHOLDS), mid-1980s

	UK	France
Deep freezer	37.2	33.8
Washing machine	90.2	83.6
Dishwasher	57.1	22.1

Sources: Central Statistical Office, 1987:Table 6.15; Verger, 1987:397.

Many chores can be compressed, their frequency reduced, and those which are mobile, such as cleaning and washing, may be relegated to the weekend. In theory, shopping can be done less often, meals can be prepared at the weekend for a whole week, pre-prepared foods can be purchased and washing could be confined to once or twice a week. As already shown, time spent shopping has continued to increase, and marriage still provokes a doubling or trebling of the time women spend on cooking, cleaning and washing, which is only partially offset by the ready availability of ever more sophisticated household appliances.

Another solution is to subcontract tasks either to different family members or outside the home, rather than expecting them to be taken on by men. If working women spend much less time than women who are not economically active on cooking and particularly on cleaning, it seems reasonable to suppose that this is the result not only of compression but also of delegation or subcontracting.

Support networks

In the absence of equal sharing of tasks the ability to manage time is determined to a great extent by the availability of other forms of support, not least those provided by public authorities. A common strategy adopted by women in both countries for coping with the additional demand on their time is to subcontract as many household and childcare tasks as they consider reasonable or necessary. Since women do not have wives and only very few husbands are prepared to accept role reversal or the delegation of the majority of household and childcare tasks, most women working full time need to find a substitute who can deputize for them when they are away from the home.

The type of childminding to which women most frequently have recourse varies according to social status and household income. In Britain, where state provision of services presupposes a division of labour in the home which ensures the availability of mothers to service other family members, the external support network for women who do not fit into this mould is limited. More than half the arrangements made by working mothers in Britain involve the child's father and a quarter a grandmother. Most full time workers have recourse to a grandmother. The solution commonly adopted by mothers of young children in low paid jobs is to work part time in order to ensure that they can arrange childminding by themselves or their husbands, preferably by undertaking evening jobs which fit in with the availability of the father until children reach school age, and then by working during school hours (Moss, 1988:22-3).

For women in the higher occupational grades childcare arrangements depend largely on the level of income, working hours and the availability of suitable childminders. When asked about their preferences for childcare very few parents in Britain express interest in nurseries or childminders. They would much prefer their children to be in a nursery school/class or in a playgroup (reported by Cohen, 1988: Table 9.3). For all but women in some

of the most highly paid jobs, childcare costs continue to be prohibitive. One of the teachers amongst our British respondents claimed that, with one child, it was just feasible to work part time but, with two children, it was no longer financially viable to continue working, even part time. A British graduate who had lived in France and returned to England soon after having a baby described how she had been planning to continue working after maternity leave in France and had negotiated part time hours with her employing organization, which would have given her entitlement to the same benefits as full time employees. She anticipated having no problem in finding a suitable registered childminder. In Britain satisfactory childcare facilities were more difficult to arrange, and the financial incentives to return to work were cancelled out by the higher cost of childcare: in Paris she would have paid 20 per cent of her net salary and in London nearer 40 per cent

Parents in France prefer their children to be minded either by the mother herself or a *crèche* rather than by an outside childminder or another relative. With a greater range of provision available at a lower cost, it is relatively easy for women to find a type of childcare with which they are satisfied. Women in the higher grade occupations are more likely than women in other socioeconomic categories to pay a childminder to look after children in their own home (18 per cent of women with young children in the higher administrative grades) and to use *crèche* facilities (16 per cent) rather than having recourse to a relative (Leprince, 1987:513). Women in lower paid jobs rely heavily on help from relatives (Daune-Richard, 1984:129-35). Most women in the higher occupational grades use a combination of different arrangements, with the childminder and *crèche* covering most situations. They are less likely than women in the medium grade occupations to place children in a *crèche* at the age of two, but their children are more often attending nursery school by the age of three, and this is the most common form of care for children at this age. For a woman working full time the hours, although generally longer than in Britain, are inadequate to cover the average length of time during which women are likely to be away from home because of the longer working day. Nursery schooling is therefore normally combined with other types of minding, including recourse to public provision which has been made by local authorities for the supervision of children on school premises before and after school hours.

In our study of well qualified women with children, more of the British than the French respondents employed a nanny or *au pair*, the same proportion paid for the services of a childminder in her home and a similar number used a combination of arrangements. None of the British women left her children in a *crèche*, whereas this was the single form of care most frequently used by the French mothers. Very few children in either country were looked after by a relative. These findings would seem to reflect not only the availability of different care arrangements in the two countries (three-quarters of the French respondents spoke of having access to *crèche*

facilities compared with just over a third of the British women), but also perceptions of their functions, cost and convenience.

The issue of childminding after school hours and during holidays is difficult to resolve for most working mothers. For women on low incomes it may be a critical factor in their ability to continue working, in the absence of extensive publicly provided facilities. In a British study, it was found that the majority of the women interviewed solved the problem by working less than 30 hours a week or by making arrangements for paid or unpaid leave in order to be on holiday at the same time as their children (Petrie and Logan, 1986:13). Others worked weekends only or mainly from home. Only a small proportion of the women in the sample (14 per cent) worked more than 30 hours a week and during holidays. The main strategies were either not to work or to look for work which fitted in with childcare. A very small number of women had recourse to a paid childminder after school, and a few made informal arrangements with neighbours or relatives. In most cases holidays required a combination of different forms of care, particularly for mothers in better paid and more satisfying jobs. About a third of the mothers interviewed made use of daycare play schemes, but very few children attended them regularly and frequently (Petrie and Logan, 1986:24). High usage was associated with single parent households, working class and low income families, corresponding to the original intention that provision should be confined to children at risk. A survey of local authorities in the same study showed that provision of play schemes was very sparse and uneven. Some authorities provided their own schemes and also supported voluntary initiatives; others set up schemes only for children in need.

In France the period which is most problematic for working mothers is when their children are aged between three and six. Up to the age of three children who cannot be looked after by their mother or a relative are generally cared for by a paid childminder or a *crèche* for the whole day (59 per cent of the children of working mothers in the 1980-81 survey, according to David and Gokalp, 1984:62). From the age of three, the situation becomes more complicated because school hours do not correspond to working hours. Although after-school care is generally available, mothers are reluctant to leave very young children at school premises for the whole day (Villeneuve-Gokalp, 1985:271). A relatively small proportion of the children of women in higher grade occupations have lunch at school and stay on at school at the end of the day (David and Gokalp, 1984:67). From the age of seven the situation becomes less problematic since children can occasionally be left alone.

Women in higher grade professions more frequently than other categories mention problems experienced over childminding after school hours, on Wednesdays, during the childminder's holidays and during school holidays (Villeneuve-Gokalp, 1985:270). A large proportion of women in professional and managerial occupations (21 per cent of women in the category) worked from home and did not therefore have problems at these times. The majority of women in this category would not, however,

want to work from home if they had the opportunity (Villeneuve-Gokalp, 1985:272). They therefore need to find alternative coping strategies.

For women who are not able or do not want to be free on a Wednesday to look after young children when there is no schooling, local authorities provide leisure services (crafts, sports and other cultural activities) at local leisure centres. The same services operate on Saturday afternoons and during holidays as a support for working mothers. In addition, many firms, particularly the nationalized industries, make provision for the children of their employees by organizing holiday centres. In the early 1980s a number of companies in France were providing their own holiday centres (available for 23 per cent of employees), childminding centres on Wednesdays (six per cent), workplace *crèches* (four per cent), and 10 per cent of employees were able to take their children to work with them occasionally (Villeneuve-Gokalp, 1985:286). The options available to parents therefore include sending children to the various forms of holiday camps, leaving them with relatives and friends or ferrying them backwards and forwards to day centres. Most parents use a combination of arrangements.

Relatively few of the women we questioned were dissatisfied with the way they were able to organize their lives. A larger proportion of the French women in the sample (nearly 50 per cent compared with just over 25 per cent of the British women) maintained that the strategies they had adopted were what they had planned. The French respondents were also more likely to express satisfaction with the way the situation had worked out (57 per cent compared with 35 per cent for the British women). The ideal for women in both countries was a household where tasks were shared equitably and where reliable back-up networks and flexible employers would relieve them of the anxiety created not only by unforeseen circumstances (an unscheduled meeting, a difficult client at the end of the day, a business trip abroad at short notice), but also by the need to be present to support their children at a school fête or for a doctor's appointment during working hours.

From the evidence presented in previous chapters, French women should be in a better position to achieve the ideal since they receive greater public support from the state in their dual roles, and because more pressure is exerted on employers to provide convenient working arrangements. In a national context, such as the British one, where it is assumed that the family consists of a male breadwinner and a woman who is responsible for the welfare of her husband, children and other dependants, no direct pressure is exerted through positive social policies to encourage a redistribution of labour in the home. Rather, where the wife's income remains secondary since women have interrupted employment patterns and are less often working full time, traditional gender roles tend to be confirmed and reinforced. In this context the domestic division of labour and the segregation of male and female paid work can be said to be 'mutually reinforcing' (Lewis, 1983:8). Women who add paid employment on the same basis as the male model to their family responsibilities shoulder a double burden and are left to work out their own means of

coping, on the grounds that it is their own choice and the state does not have a duty to interfere. The ability of British women with children who are working full time to manage family commitments so that they do not impinge on professional life depends to a much greater extent than in France on the material and psychological support structures available outside the public sector. Due to the limited provision mediated directly through employment and family policies and in the absence of publicly funded external support, husbands in Britain would appear to have little option but to accept a larger share of the responsibility for family life than their counterparts in France if their wives are not to forego their own careers completely.

Towards greater compatibility of family and professional life

Much has been said and written about the need for change in gender roles, and the European Commission's Action Programmes are giving a lead to governments in this area. In its second programme the Commission recommended that childcare facilities should be improved with a view to providing greater equality of opportunity between children and more choice for parents within the context of concern about demographic issues (Commission of the European Communities, 1986:16). The fundamental issue of how to manage the relationship between work and family life is less often addressed and is only rarely on the policy agenda. In France, where governments are intent on persuading their electorate that society needs children but also expects women to be economically active, the question has been made explicit in policy documents.

The attitude of French governments, as presented in policy statements, closely reflects the Commission's recommendation: policy is directed towards giving couples the chance to choose how they organize their family and professional lives. The government does not see its role as relieving them of their responsibilities but rather as giving them support for whatever choice they make (Haut Conseil de la Population et de la Famille, 1987:11). In Britain women have relieved the state of the need to provide more generous family allowances or childcare facilities by simultaneously making a contribution to household income and looking after their own children. Political pressures have been exerted to ensure that women do, as far as possible, care for their own children, at least up to the age of two, and preferably five, when the state assumes the task of their formal education but does not take responsibility for them outside school hours. This liberal welfare attitude has been interpreted as a form of interference, in that it reduces freedom of choice (Ruggie, 1984:210).

In a study of mothers at work, many of the women interviewed were found to accept stoically that they had to find solutions to any problems which arose by themselves (Brannen and Moss, 1988:10). If problems did not arise or if their individual strategies were successful, then the women concerned considered themselves to be lucky. The responses received from well educated women in Britain confirmed this attitude. The French

women, by contrast, expected to be able to make satisfactory arrangements with support from outside publicly funded agencies.

Governments, such as that in France, intent on making it possible for women to combine paid employment and family are demonstrating increasingly that they are aware it is not enough to offer financial incentives in the form of child allowances or paid maternity leave if women are to be encouraged to have more children without adverse effects on their economic activity. Abundant state provision for mothers and young children would seem to have a practical and psychological impact on the ability of women to combine motherhood with continuous paid employment. Although the lack of adequate facilities and the prohibitive cost of those which are available in Britain are quoted as disincentives and as factors preventing women from being successful in combining a career with childraising, in France, where public childcare provision and other family services are taken for granted, additional strategies have been developed to enable women to manage their dual roles. Most of these centre around time structuring. Governments have, for example, intervened to help overcome the problems of childcare at times of the week and year when most working parents are not available to look after their children themselves. The reduction in the length of the working week has created greater flexibility. The extended opening times of public and commercial services ensure easier access. The ready availability of domestic helpers, registered childminders and other forms of subcontracting help to reduce the pressure of trying to cope with different and varying schedules.

While women may remain responsible for organizing family life, it does not necessarily follow that they have to carry out all the tasks themselves. Management of work and family life simultaneously would seem to require a multifaceted approach, encompassing public provision for childcare, adaptations to employment and individual flexibility (Kamerman, 1980:108). The French may have come closer to formulating policies which create the working conditions needed by this approach although, for the majority of working women, flexibility has meant poor job security (Maruani and Nicole, 1989). Well qualified women may be in a better position to take advantage of new forms of work organization, as illustrated by their use of reduced working hours, but the fact that it is generally women who avail themselves of opportunities to break away from standard worktime patterns only serves to confirm what is believed to be their lesser attachment to employment. Policies intended to encourage greater interchangeability of domestic roles imply that employment roles should also be interchangeable. Although policy statements in France stress that the opportunity to take parental or family leave, to work part time or job share is available to both men and women, social pressures mean that it is still extremely rare for a man to become a househusband or for him to request time off to care for sick children or take them to dental appointments. Women who reach the higher occupational grades feel that they must conform to the male model and not allow family problems to

interfere with their work commitments, despite the psychological conflicts which inevitably ensue (humorously portrayed by Fitoussi, 1987).

Analysis of the strategies adopted by French women who are combining professional and family life suggests that an important ingredient for success is their frame of mind in pursuing their objectives, and this too may be influenced by the prevailing political environment. As demonstrated in a study of couples working for insurance companies in France, for women who are intent on pursuing a career, the sharing of tasks and recourse to support systems must be conceived as the consequence of a career and not as a precondition (Nicole, 1987:103). Ultimately, success is more likely to be dependent on individual motivation rather than on the impetus given by the family unit, but individuals may be more easily motivated to succeed when they feel their action is legitimized and supported by policy.

Conclusion

An important aim in using comparisons, particularly between two nations, is to seek to gain a better understanding of how different societies function and to highlight features which might not otherwise be apparent. In attempting to explain the similarities and differences observed in terms of their wider sociocultural context, it may also be possible to draw out implications for future policy directions.

The starting point for the study reported in this book was the observation that many well qualified women in Britain did not appear to be exploiting their investment in higher education by pursuing a full time continuous career producing for them the same level of returns from professional life as for their male contemporaries. An obvious explanation for the shortfall was that well educated women tend to follow the same pattern of employment as other British women who have not experienced higher education, in that they take a career break of several years or switch to part time work or job sharing, thereby destroying, or at least undermining, prospects for promotion. From the standpoint of employers, this discontinuous pattern of employment is believed to be associated with a low level of attachment to work and does not satisfy the criteria needed to qualify for career posts. Although well educated women are found to have more continuous work histories and are less likely to work part time than women who have not pursued their studies after leaving school, disruptions to employment in the form of the career break are, nonetheless, considered inevitable both by employers and, frequently, by the women themselves as and when they decide to have children.

Women who have undergone higher education might be expected to display the motivation needed to capitalize on their personal investment of time and effort, in accordance with human capital theory (Bruegel, 1983:155-7; Crompton and Sanderson, 1986:26; Dex, 1984:102), and therefore seek to adopt behaviour which will enable them to progress further in a career than their less well educated contemporaries. The educational system and its paymaster also expect returns on their financial investment. Evidence of the greater continuity of employment amongst better qualified women would suggest the theory has some foundation. Women who undergo higher education do not, however, seem able to avoid the impact of the social pressures shaping professional opportunities and face many of

the same constraints as women who have not reached such a high level of educational attainment. The obstacles to promotion may also be greater in that women in this situation are often encroaching onto traditionally male territory and therefore need to be equipped to compete on the same terms as men. Higher education may lead many women to question the force of traditional assumptions about professional and domestic roles but, as yet, relatively few women in Britain seem able to impose or adopt alternative models. The data examined in this study confirm that British women generally expect lower returns from their education than their male counterparts. They follow courses and enter areas of employment where job prospects are more limited and, subsequently, further undermine their chances of advancement by stepping out of the fast stream.

Comparing British and French women

In the 1950s, it was being argued that women were no longer prevented from working outside the home by external obstacles and lack of opportunities (Myrdal and Klein, 1956:136). Rather conflicts were said to be internalized and the pull between career and family went on almost throughout a woman's life. The authors of these observations may have been optimistic in thinking that all external constraints on women pursuing a career while raising a family had been removed. Women are not formally banned from entering the occupation of their choice but, as has been shown repeatedly in the course of the present study, their chances of reaching the same status or of commanding the same earnings as male graduates who embarked on a career at the same time are much lower. Despite changes in legislation on women's rights and equal opportunities, in more than 30 years attitudes and behaviour have not altered to the extent that occupational segregation has been removed; as intimated in Chapter 3, it may even be increasing.

Comparisons suggest that developments are not occurring uniformly across Europe and that they may be influenced by societal factors. At the macrosocial level, Britain and France appear to be following very similar trends. Almost the same proportions of women of working age are in employment in the two countries, average family and household size are virtually identical. Well qualified women are more likely than women in other categories to have continuous patterns of employment, to remain unmarried and to postpone childbirth. In both countries women's long term promotional prospects are reduced by marriage and the arrival of children, and spouses in dual career families are unlikely to take on an equitable share of domestic tasks. Close analysis of microsocial data reveals, however, that these overall similarities are achieved by different processes and involve what could be described as national differences in the attitudes and perceptions relating to the social environment in each country.

The numerical similarity in women's economic activity rates conceals differences in patterns of employment from one age group to another: a peak is reached in France at the age at which a trough occurs for women in

Britain. Whereas British women return to work as their children reach school age and seek part time hours to fit in with school schedules, French women are more likely to work full time until their children begin attending school and then to seek reduced working hours, for example, in order to be available on Wednesdays when most young children have no schooling. While British women continue in their part time status at least until their children are old enough to manage by themselves, French women will have recourse to a wide range of support services and maintain a fuller commitment to continuous employment. Whereas British women are likely to take a career break when their children are young because it is difficult to do otherwise and widely accepted that they should stop work, French women may leave the labour market if they are planning to have a large family and choose to devote themselves to a 'family career'. They are not being 'forced to stop' because they cannot manage to combine work and a family. French women are probably better equipped both in material and psychological terms to combine a family and professional life without sacrificing one to the other. They will also be in a much stronger position to plan their lives without having to rely too heavily on their husbands' contribution to childcare. They would seem to set their ambitions accordingly and to consider the management of their dual career as a challenge, which they are ready to meet.

By comparing the work histories of British women who have undergone higher education with those of women with a similar educational background from a neighbouring West European country, one of the intentions was to demonstrate that the inevitability attributed to the activity patterns of British women was socially rather than biologically constructed and that the levelling process expected from EC membership was far from having eliminated national peculiarities. France, like Sweden or the United States outside the EC, offers an example of a society which meets some of the preconditions needed to enable women to break out of the vicious circle created by the traditional division of domestic labour and strongly entrenched occupational segregation. Employment legislation in France is responsive to women's needs as mothers, positive action programmes are in operation, and the state subsidizes childcare provision and other forms of family support on a large scale.

Comparisons of the place of women in the educational systems in the two countries show that French women have established a stronger position in higher education. Subsequently, they demonstrate a greater degree of attachment to a career by more often pursuing an uninterrupted work history. A larger proportion of economically active women in France are present in the higher occupational grades. They are more likely to be aware of and to exercise employment rights in order to ensure that they do not forego opportunities for promotion or lose eligibility for benefits and other guarantees if they decide, for example, to reduce working hours temporarily in order to make employment more compatible with family life. Expressed in terms of human capital theory, French women would

seem to be exploiting their educational resources more fully than their British counterparts.

From the data assembled in the course of this study profiles can be drawn of the early years of the work histories of well educated women in the two countries. The typical British woman graduate will have left school at the age of 18 with three 'A' level grades, leading on to three or four years in higher education. She will initially have greater difficulty than her male contemporaries in finding a job because of her subject choice. Her promotional prospects may not be so good, but this will not be the main criterion on which she bases her choice between the available options. She will probably spend two to three more years undergoing a traineeship in a company. At this stage she will be performing well in comparison with many of her male contemporaries. Her maturity, interpersonal skills and capacity for hard work will make her a valued employee. While in higher education she is likely to have met the man she will marry. The location of her first job was probably chosen with this plan in mind: the big cities offered the best chance of finding a suitable combination of positions for a dual career couple. A temporary separation during a training period was not out of the question. At the first career move, she will be holding her own, but an opportunity for promotion for her husband could mean a geographical move and the difficult decision whether to commute or follow him. The higher salary he is likely to be attracting by this time will probably mean that she moves with him rather than incurring the expense of running two separate homes, particularly if they are beginning to think about starting a family. The decision to have children will be postponed for as long as possible because the couple is reluctant to forego the standard of living which two salaries allow. When they do decide to raise a family, the arrival of children will mean a career break for the woman, since a cost benefit analysis demonstrates that even their combined incomes will not make it feasible for her to pay for a full time nanny and to hire cleaning help, and relatives live too far away. Moreover, she wants to be with her children while they are young and feels she should ensure that they have a mother figure permanently on call. Part time work is not readily available in her field of employment and would not, in any case, solve the childminding question. She plans to return to work when her child reaches school age, although she is contemplating a change of direction which would make it easier to deal with the problem of school hours and holidays. A second child, which both parents would like, will delay the return to work further and mean that she will have difficulty in making up for the years spent out of the labour market, even though she may be fortunate to have worked for a company which operates a career break scheme. Meanwhile, living on a single income involves a major change of lifestyle. The pressures on her husband have increased as he is now the only breadwinner. He works late and is frequently away on business and therefore sees little of the children except at weekends. His contribution to household tasks has been reduced to a minimum. By the time they are in their early thirties the couple has reverted to the traditional division of

labour, and the wife's professional aspirations have been modified, if not curtailed. Her reactions to her situation are mixed: she feels gratified as a mother but her satisfaction is tinged with frustration and guilt at having interrupted her career. She misses the intellectual stimulus of the work environment but has lost her ambition and wonders whether she will be able to re-establish herself after an absence of several years.

The typical French woman qualifier will follow a somewhat different pattern. She will leave school at the age of 19 with the *baccalauréat* and embark on a university course. The first two years will be spent deciding what she is most interested in, and two further years will take her to the *licence* and probably a *maîtrise*. However, neither of these qualifications is a passport for a job, so she will try to collect another more vocational qualification while also beginning her job search. Her choice of subjects may mean that she takes longer to find employment initially compared with some of her male contemporaries, particularly those who pursued the *grande école* option. However, the competitive civil service examinations or a teacher's diploma will guarantee a secure employment future when she enters the labour market at the age of 24 or 25. By this stage she will probably be living with a male companion, and the couple will plan their career development together. Her first posting may mean a temporary separation, or her male companion could seek employment in the area where she is appointed. Motherhood will be a reasonable proposition by her late twenties, and she will return to work after statutory maternity leave, having arranged for the child to be minded at a local authority *crèche*. With the arrival of the second baby, the childminder is a better solution since the first child will be attending nursery school and can be collected by the minder. When they are both at nursery school she will request and obtain a 20 per cent reduction of working hours so that she can be with the children on Wednesdays. With the third child two years' parental leave might be worth considering and would give her the opportunity to study in order to enhance her promotional prospects. Meanwhile her husband has been advancing his career. They have moved from their flat near the city centre to the suburbs so that the children have more space. The husband does not see much of the children, nor does he contribute to household tasks, but a cleaner does most of the more time consuming and arduous chores, and tax relief and allowances can be claimed for childcare. At the age of 32 she has an interesting and satisfying job, which gives her enough flexibility to accommodate family life. She does suffer from the stress of having to organize and coordinate different schedules and lacks personal time to pursue her own interests, but the situation is manageable. She may not attain the heights of her profession, but she has not lost her position in the hierarchy or her ambition. She is satisfied that her children are being well cared for and she feels justified in combining professional and family life.

The experience of women graduates who have lived and worked in both Britain and France confirms that these two national portraits may not simply be parodies of the situation of a small number of women or of

extreme cases. In both countries examples can be found of women who decide not to marry and have children in order to pursue an upwardly mobile career, or of women who remain single because their commitment to their career makes them unattractive as marriage partners. Amongst well qualified women in Britain the domestic model depicted above is still dominant, and dual labour market theory provides a fairly accurate description of the position of the many women graduates who have an interrupted career and for whom work and family are consecutive. In France the domestic model would seem to have been eroded to a greater extent in favour of a modified career model, although the more 'traditional' pattern has not completely disappeared amongst better educated women. This does not mean that women have reached parity with men in terms of career prospects or that they have abandoned motherhood. Rather the balance has shifted towards the simultaneous management of work and family. While role conflicts have not been eliminated, French women in the social category which was the focus of this book appear to exercise greater control over their career paths. For a growing number of women in this situation the career objective has been taken much further: their personal strategy is planned around a career, and family life is not allowed to interfere with it. In none of these models are men taking on an equal share of household labour, and French women working full time have not been relieved of domestic overload, but they are able to delegate an increasing number of tasks to external agents, particularly if they command a reasonable level of income, such as might be expected from a full time higher grade position. Their continued responsibility for the management of the household is not seen as an imposition but rather as recognition of their competence.

State intervention and national differences

One of the main reasons suggested in this study to explain why French women are better able to pursue a continuous and more upwardly mobile employment career than their British counterparts was that they have been supported morally and financially in their dual roles by the state. The falling birthrate has been an issue of on-going political concern since the early part of the twentieth century, and the preoccupation with demographic trends has led successive governments to devote considerable attention to women in their capacity as mothers. At the same time, unlike their British neighbours, French policy makers have accepted that the increased and long term participation of women in the labour force is irreversible. While work, defined as the conditions under which a professional occupation is carried out, has been stagnating, it has been argued that employment, defined as access to the labour market in its different forms, has become a necessity for women (Maruani, 1987:39). Although a large proportion of women are subjected to poor conditions of employment (unemployment levels are higher for women than for men; they experience longer periods of unemployment than men; and they are

more often engaged on temporary, short term and part time contracts), they nonetheless continue to demand the right to full time continuous employment, regardless of the prevailing economic climate. French government policy, particularly since the late 1960s, has therefore focused on encouraging childrearing by making it possible for women to raise a family while maintaining their employment status and upholding their employment rights. Parental choice is supported by policies designed to reduce the financial impact for those who do decide to leave work and by generous provision of childcare support facilities for those who continue in employment. In addition, as in Sweden, parental and family leave are made available to either parent in an attempt to encourage a more equal sharing of roles.

The result of differences in policy stance in the two countries is that an environment has been created in which women in France expect to be able to pursue a career while also raising children, whereas in Britain women are more often faced by the choice between continued career development and motherhood. Successive British governments have been reluctant to interfere in areas concerned with personal and family welfare unless individuals are considered to be at risk. In France, by contrast, women have come to expect the state (and employers) to support them in their dual role, and the state, for its part, sees itself as having a duty to promote the well-being of women and the family.

The French approach is set out unequivocally in official documents which state that it is the responsibility of society and of individuals to ensure that everyday life is organized so that women can fulfil their legitimate ambition of pursuing family and professional life in such a way that the two are mutually beneficial. Children are assigned a central, though not exclusive, place within such a society (Haut Conseil de la Population et de la Famille, 1987:39). There is no question of expecting women to choose between family and work, and they are not left solely to their own devices in managing the situation. The subject is, moreover, openly debated in France. A much publicized conference, held in 1987 under the auspices of Michèle Barzac (the glamorous junior minister in charge of health and the family in Jacques Chirac's centre right government from 1986-88, herself a qualified doctor and mother of two young girls), brought together researchers, government and union representatives, family organizations, practitioners and international observers to discuss issues concerning the organization of family and professional life, ostensibly with a view to making improvements in policy and practice. The conference was the second on the topic to take place during the Mitterrand presidency. The first, in 1983, had centred on the theme of research and families, illustrating the importance attributed to the symbiosis of policy makers and researchers. A third international conference in 1989 focused on the family within the European context and underlined the role which the French government feels it can play in orientating family policy within the EC. Whether or not any concrete results emerge from such gatherings, the fact that governments are directly involved in sponsoring research and

organizing public debate raises the level of general awareness, and consequently also the expectations of women who are encouraged to believe that their concerns are legitimate.

Many of the policies implemented by French governments in the 1980s to improve working conditions and reduce unemployment have involved restructuring working hours and creating more flexible worktime practices. The available evidence would seem to suggest that flexibility in the form of part time work and the break in employment, which are particularly characteristic of women's working patterns, are used for different reasons and to different effect from one society to another and from one occupational category to another. Part time work and parental leave (the practical if not conceptual equivalent of the career break) are governed by stricter controls in France giving part-timers and women on maternity or parental leave entitlement to employment rights similar to those of full-timers and also to reinstatement without loss of status. In Britain, by contrast, many part time workers have not been eligible for protection under employment law because they work less than 16 hours a week or receive earnings below the National Insurance threshold. Reinstatement after pregnancy is also subject to more restrictive terms than in France.

State intervention in France has not been confined to employment law but has extended to other areas of social policy, with special emphasis on the family since the 1940s and on women's rights in the 1970s and early 1980s. Although the women's rights movement may have been less coordinated in France than in Britain, it does seem to have had more of an impact on attitudes at an official level, as testified by the number of ministerial appointments in the area of women's rights and welfare and family policy. A momentum has developed since the 1970s amongst French women which any government would have difficulty in reversing.

Alternatives to public policy

Policies which were implemented in the immediate post-war period in Britain have continued to shape attitudes towards women's employment in more recent years. Women who have managed to combine employment and family life have done so despite, rather than because of, any assistance from the state. When employers have needed women's labour, they have been prepared to adapt working conditions, but they have generally reverted to the *status quo ante* as economic and political circumstances have changed. The career break and part time working hours have therefore been the only options for the majority of women who do not want to forego motherhood, almost always at the expense of their career prospects.

Whereas the initiative to make working conditions more compatible with family life is coming from governments in France, there is a growing body of evidence that, for reasons other than political inducement, employers in Britain are being forced to take account of family factors in their human resource management strategies. Until the late 1980s the

prevailing social climate in Britain did not provide women graduates with an incentive to pursue an employment career in the face of the opposition many of them encountered from employers, relatives and society at large. The response to the anxiety expressed over the downturn in demographic trends has been for employers to begin to adopt various expedients in order to encourage women to return to work after a career break of several years. Schemes for women returners, like some aspects of women's rights legislation in France, recognize that women enter the workforce on different terms from men and therefore require different treatment, a point not taken fully into account in the British equal opportunities legislation.

In the absence of any change in direction of government policy, more progress will probably be made towards creating better opportunities for women in Britain if employers intervene actively, rather than if women have to rely on their own efforts to manage a career break. The current fall in the population of 18 year olds and the compensatory mechanism of an increase in the number of women applicants for jobs would seem to have provided an incentive to improve the chances of women being able to exploit their qualifications more effectively in the labour market. While examples can still be found in Britain of employers who actively seek to remove women from their workforce when they become mothers, the financial loss on investment is proving a powerful inducement for employers to look for ways of encouraging well qualified women to return after a period of leave. In both countries employers are able to make arrangements which are more favourable than those required by law, and they are more likely to exercise this option when they want to attract and retain a well qualified workforce. The concept of women as the 'reserve army' of labour may not be without relevance at this point in time. When employers need women they are prepared to be adaptive to their special needs. Sir Francis Tombs, Chairman of the Engineering Council, reflected the views of many employers when he stated publicly that the industry would have to make it possible for women to have a family and a career by introducing career breaks, adjusting working hours and making other arrangements (The Engineering Council, 1987).

Whereas the ideology of women's rights and welfare has not served as a sufficient justification in Britain for government intervention, the action taken by industry has been echoed in public sector employment. The drop in the number of applicants for teacher training in traditionally female subject areas such as languages (by 16 per cent between 1987-88) at a time when schools were in the process of implementing a national curriculum did, for example, prompt government action to search for ways of persuading women to enter and remain in teaching for political and economic reasons.

In a situation, such as that which is developing in Britain, where highly qualified and trained workers are in short supply, women who have relevant skills, knowledge and experience may be able to benefit professionally from both public and private sector initiatives. While attempts by French employers, prompted by state policies, to create a more

flexible workforce may have resulted in less stable working patterns for a large proportion of women who are economically active, some categories of women workers, particularly those in the higher grade occupations and the public sector, have been able to take advantage of the many opportunities to adopt more flexible worktime arrangements, which they use in order to meet the challenge of reconciling work with a family. In Britain women in higher grade occupations have not yet reached a situation where they are prepared to exploit fully the many forms of flexibility which would make family and professional life more compatible. For example, they experience more difficulty than women in other occupational groups in securing part time working arrangements, but they are more likely to be reinstated after pregnancy and the career break. While their skills are in short supply, women in this category may have opportunities to seek more advantageous working conditions by following the example of their French counterparts.

Women's expectations for the future

The comparisons conducted in this book between two West European societies, which are geographically close neighbours but represent extreme cases in terms of public policy towards working women, suggest that policy orientations can have an impact on women's lives and on their expectations and ambitions. The non-interventionist liberal welfare approach adopted by British governments may be an important factor determining the relatively poor economic status of women and their generally low aspirations. The strong mediating role played by the state in France, while not a panacea, has helped to create conditions favouring women's labour market participation and relieving them of some of the strain of their two roles. Dual career families are by no means a new phenomenon. What is new, at least in France, is the acceptance that they are a permanent feature of society and that their needs must be accommodated with assistance from the state.

The policies adopted in France and the efforts to make them highly visible are evidence that French governments have recognized the importance of encouraging women to have children, while they are also aware that women are demanding their place in the workforce 'as of right'. Women are not asking to be relieved of their dual role but they do expect to be supported in their fulfilment of it.

The presence of an increasing number of women in employment in both countries, policies on women's rights and changes in employment law and family policy have not substantially altered the conditions under which most women work. Women cannot be said to have achieved equality of opportunity or of income. They are still segregated in a small number of occupations and do not have an equal share of the most prestigious high status jobs. Salary differentials have been reduced over the past four decades but have not disappeared. Nor is household labour shared equally between men and women, which would seem to confirm that

individual motivation, ambition, attitudes and legislation are not enough to remove deep seated structural inequalities either in the home or in the labour market.

In France it has been argued that well educated women have been best able to take advantage of the changes brought about during the 1980s in the position of women in society and that they have been able to renegotiate household roles most effectively (Battagliola and Jaspard, 1987:54). Well qualified women might be expected to serve as a model for other social categories, and there is evidence to suggest that the boundary between women in the higher and medium grade occupations is becoming less clearly defined

National models are rarely directly applicable to different societal contexts, but they can offer examples of alternative ways of approaching similar problems and they may help in shaping objectives. Accounts by women who have been geographically mobile confirm that the opportunities for women may be greater in France than in Britain. If well qualified women are to move freely around Europe, the conditions under which they can expect to combine work with raising their children may be an important consideration in choosing one country in preference to another. Employers seeking to attract graduates from abroad will also need to be aware of the personal expectations and aspirations of both male and female recruits from different national backgrounds in a situation where the ability to manage professional and family life is no longer a concern only for employees.

Bibliography

AGCAS Polytechnic Statistics Working Group (1987) *First Destinations of Polytechnic Students Qualifying in 1987*, London, Committee of Directors of Polytechnics.

Allan, G. (1985) *Family Life: Domestic Roles and Social Organization*, Oxford, Blackwell.

Allen, I. (1988) *Any Room at the Top? A Study of Doctors and their Careers*, London, Policy Studies Institute.

Arregger, C.E. (ed.) (1966) *Graduate Women at Work: A Study by a Working Party of the British Federation of University Women*, London, Oriel Press.

Audirac, P-A. (1987) Le développement de l'union libre chez les jeunes, *Données sociales*, Paris, INSEE, 502-9.

Bailyn, L. (1978) Accommodation of Work to Family, in R. Rapoport and R.N. Rapoport (eds.), *Working Couples*, London, Routledge and Kegan Paul, 159-74.

Baker, K. (1989) Higher Education 25 Years On, Speech given at Lancaster University, 5 January.

Barou, Y. and Rigaudiat, J. (1983) *Les 35 heures et l'emploi*, Paris, La Documentation Française.

Barrère-Maurisson, M-A., Daune-Richard, A-M. and Letablier, M-T. (1989) Le travail à temps partiel plus développé au Royaume-Uni qu'en France, *Économie et statistique*, No. 220, April, 47-56.

Battagliola, F. and Jaspard, M. (eds.) (1987) Séquences de la vie familiale, évolution des rapports familiaux, in *IVe Colloque de l'IDEF. Temps et durée dans la vie professionnelle et familiale*, Paris, Ministère des Affaires Sociales et de l'Emploi.

Baudelot, C. and Glaude, M. (1989) Les diplômes se dévaluent-ils en se multipliant?, *Économie et statistique*, No. 225, October, 3-15.

Beechey, V. and Perkins, T. (1987) *A Matter of Hours: Women, Part-Time Work and the Labour Market*, Cambridge, Polity Press.

Belloc, B. (1986) De plus en plus de salariés à temps partiel, *Economie et statistique*, Nos. 193-4, November-December, 43-50.

Belloc, B. (1987) Le travail à temps partiel, *Données sociales*, Paris, INSEE, 112-9.

Benveniste, C. and Hernu, P. (1987) Progression de pouvoir d'achat pour toutes les catégories de salariés, *Économie et statistique*, Nos. 199-200, May-June, 13-8.

Berger, M., Foster, M. and Wallston, B.S. (1978) Finding Two Jobs, in R. Rapoport and R.N. Rapoport, *Working Couples*, London, Routledge and Kegan Paul, 23-35.

Biraben, J-N. (1978) L'Europe: données statistiques, *Population*, 33 (4-5), 989-98.

Bommel, S., Borcier, M., Fauconnier, D., Meilhaud, J. and Perucca, B. (1985) Vers une flexibilité accrue du travail: le point de la situation dans les principaux pays européens, *L'usine nouvelle-hebdo*, 3 October, reproduced in *Problèmes économiques*, No. 1,946, 30 October, 11-6.

Bouillaguet-Bernard, P., Boisard, P. and Letablier, M-T, (1986) Le partage du travail: une politique asexuée?, *Nouvelles questions féministes*, Nos. 14-5, 31-51.

Bouillaguet-Bernard, P., Gauvin-Ayel, A. and Outin, J-L. (1981) *Femmes au travail: prospérité et crise*, Paris, Economica.

Boyer, R. (ed.) (1986) *La flexibillité du travail en Europe: une étude comparative des transformations du rapport salarial dans sept pays de 1973 à 1985*, Paris, Editions La Découverte.

Boys, C.J. and Kirkland, J. (1987) *Degrees of Success: Career Aspirations and Destinations of a Cohort of College, University and Polytechnic Graduates 1982-1985*, Unpublished report, Brunel University, Department of Government.

Boys, C.J. and Kirkland, J. (1988) Lies, Damned Lies and Destination Statistics, *Times Higher Education Supplement*, 12 August, 15.

Brannen, J. and Moss, P. (1988) *New Mothers at Work: Employment and Childcare*, London, Unwin Hyman.

Braybon, G. and Summerfield, P. (1987) *Out of the Cage: Women's Experience in Two World Wars*, London, Pandora.

Brennan, J. and McGeevor, P. (1988) *Graduates at Work: Degree Courses and the Labour Market*, London, Jessica Kingsley Publishers.

Bruegel, I. (1983) Women's Employment, Legislation and the Labour-Market, in J. Lewis (ed.), *Women's Welfare Women's Rights*, London, Croom Helm, 130-69.

Buckley, M. and Anderson, M. (eds.) (1988) *Women, Equality and Europe*, London, Macmillan.

Bue, J. (1987) Horaires et aménagements du temps de travail, *Cahiers français*, No. 231, May-June, Notice 3.

Bue, J. and Cristofari, M-F. (1986) Contraintes et rythme de travail des salariés à temps pariel, *Travail et emploi*, No. 27, March, 31-41.

Cacouault, M. (1985) De la célibataire diplômée à l'«épouse intellectuelle du cadre»: utilisation des richesses culturelles chez les professeurs femmes de l'enseignement secondaire, in Temps sociaux: trajectoires selon le sexe, *Cahiers de l'APRE*, No. 2, May, 101-18.

Caisse Nationale des Allocations Familiales (1986) Création de l'Aged, *Dossier CAF*, No. 4, 52-4.

Castelain-Meunier, C. and Fagnani, J. (1988) Deux ou trois enfants: les nouveaux arbitrages des femmes, *Revue française des affaires sociales*, 42 (1), January-March, 45-65.

Census of England and Wales 1911 (1913) *Occupations and Industries*, 10 (2), London, HMSO.

Census of England and Wales 1911 (1915) *Summary Tables*, London, HMSO.

Central Services Unit (1987) *The Output of UK Universities by Institution and Discipline 1986*, Manchester, Central Services Unit.

Central Statistical Office (1985) *Social Trends 15*, London, HMSO.

Central Statistical Office (1987) *Social Trends 17*, London, HMSO.

CEREQ (1989) *L'insertion professionnelle des diplômés de l'enseignement supérieur en quelques chiffres*, January, Paris, CEREQ.

Cernigoj-Sadar, N. (1989) Psycho-Social Dimensions of Paid Work and Family Life, in K. Boh, M. Bak, C. Clason, M. Pankratova, J. Qvortrup, G.B. Sgritta and K. Waerness (eds.), *Changing Patterns of European Family Life: A Comparative Analysis of 14 European Countries*, London, New York, Routledge, 141-71.

Chapman, T. (1986) Men and Women Graduates in the Labour Market: Orientations to Work and Experience of Employment One Year after Graduation, *CNAA Development Services Unit Paper*, London, CNAA.

Chapman, T. (1989) Just the Ticket? Graduate Men and Women in the Labour Market Three Years after Leaving College, *HELM Working Paper*, No. 8, London, CNAA.

Charlot, A. (1988a) Quelles études après le bac?, *Bulletin de recherche sur l'emploi et la formation*, No. 31, March-April, 1-6.

Charlot, A. (1988b) Rendement des premiers cycles universitaires et réussite des jeunes bacheliers, *Formation emploi*, No. 24, October-December, 11-25.

Charlot, A. and Pottier, F. (1988) L'insertion professionnelle des diplômés de l'enseignement supérieur, *Bulletin de recherche sur l'emploi et la formation*, No. 36, October, 1-4.

Choffel, P. (1987) Les évolutions individuelles de salaires (1976-1980), *Données sociales*, Paris, INSEE, 153-8.

Civil Service Department (1977) *Civil Service Statistics 1976*, London, HMSO.

Clarke, J., Rees, A. and Meadows, P. (1988) 1980 Graduates — Where are they now? First Results from the Survey of 1980 Graduates and Diplomates, *Employment Gazette*, September, 495-506.

CNAA (1966) *Annual Report 1965-66*, London, CNAA.

CNAA (1988) *Annual Report 1986-87*, London, CNAA.

CNIDF-INSEE (1986) *Femmes en chiffres*, Paris, CNIDF-INSEE.

Le CNRS a 50 ans (1989) *Lettre de Matignon*, No. 277, 30 October, 3.

Cohen, B. (1988) *Caring for Children: Services and Policies for Childcare and Equal Opportunities in the United Kingdom*, London, Commission of the European Communities.

Commission of the European Communities (1982) Equal Opportunities: Action Programme 1982-1985, *Women in Europe*, 41/X/82, Supplement No. 9, Brussels, Commission of the European Communities.

Commission of the European Communities (1986) Equal Opportunities: 2nd Action Programme 1986-1990, *Women in Europe*, X/77/86, Supplement No. 23, Brussels, Commission of the European Communities.

Committee of Vice-Chancellors and Principals and University Funding Council (1989) *University Management Statistics and Performance Indicators in the United Kingdom*, London, Committee of Vice-Chancellors and Principals and of the Universities of the United Kingdom.

Cook, F., Clark, S., Chambers, D. and Carr, P.G. (1983) *Changing Patterns of Work and Leisure in the North-West Textile Industry*, University of Liverpool, Department of Sociology.

Crompton, R. (1987) Gender, Status and Professionalism, *Sociology*, 21 (3), 413-28.

Crompton, R. and Sanderson, K. (1986) Credentials and Careers: Some Implications of the Increase in Professional Qualifications amongst Women, *Sociology*, 20 (1), 25-42.

Crompton, R. and Sanderson, K. (1987) Where Did All the Bright Girls Go?, *The Quarterly Journal of Social Affairs*, 3 (2), 135-47.

Crompton, R. and Sanderson, K. (1990) *Gendered Jobs and Social Change*, London, Unwin Hyman.

Dale, A. and Glover, J. (1987) Women's Work Patterns in the UK, France and the USA, *Social Studies Review*, 3 (1), 36-9.

Daniel, W.W. (1980) *Maternity Rights: The Experience of Women*, London, Policy Studies Institute.

Daune-Richard, A-M. (1984) *Travail professionnel et travail domestique: étude exploratoire sur le travail et ses représentations au sein de lignées féminines*, Aix-en-Provence, Paris, Petite Collection CEFUP, Document Travail et Emploi.

David, M-G. and Gokalp, C. (1984) La semaine d'un enfant scolarisé, *Consommation*, No. 1, January-March, 59-88.

Davies, P.L. (1987) European Equality Legislation, U.K. Legislative Policy and Industrial Relations, in C. McCrudden (ed.), *Women, Employment and European Equality Law*, London, Eclipse, 23-51.

Davisse, A. (1983) *Les femmes dans la fonction publique: rapport au ministre de la Fonction publique et des Réformes administratives*, Paris, La Documentation Française.

Department of Education and Science (1970a) *Education Statistics for the United Kingdom 1967*, London, HMSO.

Department of Education and Science (1970b) *Education Statistics for the United Kingdom 1968*, London, HMSO.

Department of Education and Science (1971) *Education Statistics for the United Kingdom 1969*, London, HMSO.

Department of Education and Science (1973) *Statistics of Education 1971*, Vol. 2, *School Leavers, C.S.E. and G.C.E.*, London, HMSO.

Department of Employment and Productivity (1971) *British Labour Statistics: Historical Abstract 1886-1968*, London, HMSO.

Desplanques, G. (1987) Calendrier des familles, *Données sociales*, INSEE, Paris, 477-95.

Desplanques, G. and Saboulin, M. de (1986) Activité féminine: carrières continues et discontinues, *Économie et statistique*, Nos. 193-4, November-December, 51-62.

Dex, S. (1984) Women's Work Histories: An Analysis of the Women and Employment Survey, *Research Paper*, No. 46, London, Department of Employment.

Dex, S. (1987) *Women's Occupational Mobility: A Lifetime Perspective*, London, Macmillan.

Dex, S. and Shaw, L. B. (1986) *British and American Women at Work: Do Equal Opportunities Policies Matter?*, London, Macmillan.

Dex, S. and Walters, P. (1989) Women's Occupational Status in Britain, France and the USA: Explaining the Difference, *Industrial Relations Journal*, 20 (3), 203-12.

Docksey, C. (1987) The European Community and the Promotion of Equality, in C. McCrudden (ed.), *Women, Employment and European Equality Law*, London, Eclipse, 1-22.

The Engineering Council (1987) Britain is Missing Out On 'the Other Half', Press Release, in Equal Opportunities Commission, *Conference Report: Managing the Career Break*, London, 28 April, 41-2.

Equal Opportunities Commission (1985) *Women and Men in Britain: A Research Profile*, London, HMSO.

Equal Opportunities Commission (1986) *Women and Men in Britain: A Research Profile*, London, HMSO.

Equal Opportunities Commission (1987) *Women and Men in Britain: A Research Profile*, London, HMSO.

Equal Opportunities Commission (1988) *Women and Men in Britain: A Research Profile*, London, HMSO.

Establet, R. (1988) Subversion dans la reproduction scolaire, *Revue économique*, 39 (1), 71-91.

Eurostat (1986) *Labour Force Survey: Results 1984*, Luxembourg, Eurostat.

Eurostat (1988) *Labour Force Survey: Results 1986*, Luxembourg, Eurostat.

Eurostat (1989a) *Demographic Statistics*, Luxembourg, Eurostat.

Eurostat (1989b) *Earnings: Industry and Services (1)*, Luxembourg, Eurostat.

Eurostat (1989c) *Employment and Unemployment*, Luxembourg, Eurostat.

Eurostat (1989d) *Labour Force Survey: Results 1987*, Luxembourg, Eurostat.

Euvrard, F., David, M-G. and Starzek, K. (1985) Mères de famille: coûts et revenus de l'activité professionnelle, *Documents du Centre d'Etude des Revenus et des Coûts*, No. 75, Paris, CERC.

Fagnani, J. (1986) La durée des trajets quotidiens: un enjeu pour les mères actives, *Économie et statistique*, No. 185, February, 47-55.

FCO/ODA (1989) *FCO/ODA Expenditure 1988-90: Third Report*, London, HMSO.

Ferguson, M. (1987) New Perspectives on Male Roles: Some Findings from a Small-Scale Cross-National Study of Men in France and Great Britain, in L. Hantrais and S. Mangen (eds.), Language and Culture in Cross-National Research, *Cross-National Research Papers*, No. 3, 51-62.

Fernandez de Espinosa, B. (1981) L'activité féminine depuis le début du siècle, *Bulletin d'information*, Centre d'Études de l'Emploi, No. 49, April, 3-6.

Finch, J. (1983) *Married to the Job: Wives' Incorporation in Men's Work*, London, George Allen and Unwin.

Fitoussi, M. (1987) *Le ras-le-bol des super women*, Paris, Calmann-Lévy.

Fogarty, M.P., Allen, I. and Walters, P. (1981) *Women in Top Jobs, 1968-1979*, London, Heinemann Educational.

Fournier, J-Y. (1989) Les absences au travail: 16 jours par an pour un ouvrier 3,5 jours pour un cadre, *Économie et statistique*, No. 221, May, 47-53.

Gadbois, C. (ed.) (1987) Rythmes de la vie familiale, in *IVe Colloque de l'IDEF. Temps et durée dans la vie professionnelle et familiale*, Paris, Ministère des Affaires Sociales et de l'Emploi.

General Register Office (1956) *Census 1951 England and Wales: Occupation Tables*, London, HMSO.

General Register Office (1966) *Census 1961 England and Wales: Occupation Tables*, London, HMSO.

Gershuny, J. (1987) The Leisure Principle, *New Society*, 13 February, 10-3.

Glaude, M. (1987) La structure des salaires en 1985, *Données sociales*, Paris, INSEE, 159-71.

Glover, J. (1989) The Classification of Occupations in Cross-National Research: Issues Relating to the Secondary Analysis of Large National Data Sets, in L. Hantrais (ed.), Franco-British Comparisons of Family and Employment Careers, *Cross-National Research Papers*, Special Issue, Birmingham, AMLC, 80-2.

Government Statistical Service (1988) *Education Statistics for the United Kingdom: 1988 Edition*, London, HMSO.

Gregory, A. (1987) Le travail à temps partiel en France et en Grande-Bretagne, *Revue française des affaires sociales*, 41 (3), 53-60.

Gregory, A. (1989) Le travail à temps partiel dans les grandes surfaces alimentaires en France et en Grande-Bretagne, in Ministère du Travail, de l'Emploi et de la Formation Professionnelle, *L'évolution des formes d'emploi*, Document Travail-Emploi, Paris, La Documentation Française, 376-82.

Grignon, M. (1987) Travail et vie personnelle: les hommes et les femmes souvent du même avis..., *Consommation et modes de vie*, No. 15, January.

Grimler, G. and Roy, C. (1987) Les emplois du temps en France en 1985-1986, *Collections de l'INSEE: Premiers Résultats*, No. 100, June, Paris, INSEE.

Grosvenor, J. (ed.) (1988) *The Ivanhoe Guide to Chartered Accountants 1989*, Oxford, The Ivanhoe Press.

Le guide des études supérieures (1989) *L'étudiant*, Special issue.

Hagen, E. and Jenson, J. (1988) Paradoxes and Promises: Work and Politics in the Postwar Years, in J. Jenson, E. Hagen and C. Reddy (eds.), *Feminization of the Labour Force: Paradoxes and Promises*, Oxford, Polity Press, 3-16.

Hakim, C. (1979) Occupational Segregation: A Comparative Study of the Degree and Pattern of the Differentiation between Men and Women's Work in Britain, the United States and Other Countries, *Research Paper*, No. 9, London, Department of Employment.

Hansard Society (1990) *The Report of the Hansard Society Commission on Women at the Top*, London, The Hansard Society for Parliamentary Government.

Hantrais, L. (ed.) (1989) Franco-British Comparisons of Family and Employment Careers, *Cross-National Research Papers*, Special Issue, Birmingham, AMLC.

Hantrais, L., Clark, P.A. and Samuel, N. (1984) Time-Space Dimensions of Work, Family and Leisure in France and Great Britain, *Leisure Studies*, 3 (3), 301-17.

Haskey, J. (1983) Social Class Patterns of Marriage, *Population Trends*, No. 34, 12-9.

Haskey, J. and Kiernan, K. (1989) Cohabitation in Great Britain — Characteristics and Estimated Numbers of Cohabiting Partners, *Population Trends*, No. 58, 23-32.

Hatchuel, G. (1989) Accueil des jeunes enfants «La course à la débrouille», *Consommation et modes de vie*, No. 41, July-August.

Haut Conseil de la Population et de la Famille (1987) *Vie professionnelle et vie familiale, de nouveaux équilibres à construire*, Paris, La Documentation Française.

Henwood, M. (1990) *Community Care and Elderly People. Policy, Practice and Research Review*, London, Family Policy Studies Centre.

HM Treasury (1985) *Civil Service Statistics*, London, Government Statistical Service, HMSO.

HM Treasury (1987) *Civil Service Statistics*, London, Government Statistical Service, HMSO.

Huet, M, (1985) Évolution de la situation professionnelle des femmes depuis la crise, Crise et emploi des femmes, *Cahiers de l'APRE*, No. 1, February, 15-34.

Huet, M. and Schmitz, N. (1984) La population active, *Données sociales*, Paris, INSEE, 26-34.

Humphries, J. (1983) *Part-Time Work*, London, Kogan Page.

Huppert-Laufer, J. (1982) *La féminité neutralisée? Les femmes cadres dans l'entreprise*, Paris, Flammarion.

INSEE (1975) Données statistiques sur les familles, *Collections de l'INSEE*, M 48, Paris, INSEE.

INSEE (1979) Enquêtes sur l'emploi de 1968 à 1975: série redressée, *Collections de l'INSEE*, D 68, Paris, INSEE.

INSEE (1982) Enquête sur l'emploi d'octobre 1981: résultats détaillés, *Collections de l'INSEE*, D 89, Paris, INSEE.

INSEE (1985) Enquête sur l'emploi de 1985: résultats détaillés, *Collections de l'INSEE*, D 107, Paris, INSEE.

INSEE (1987a) Enquête sur l'emploi: résultats détaillés de 1987, *Collections de l'INSEE*, D 122, Paris, INSEE.

INSEE (1987b) *Tableaux de l'économie française: édition 1987*, Paris, INSEE.

INSEE (1989) Enquête sur l'emploi de 1989: résultats détaillés, *INSEE résultats*, Nos. 28-9, Paris, INSEE.

Jenson, J., Hagen, E. and Reddy, C. (eds.) (1988) *Feminization of the Labour Force: Paradoxes and Promises*, Oxford, Polity Press.

Joshi, H. (1984) Women's Participation in Paid Work: Further Analysis of the Women and Employment Survey, *Research Paper*, No. 45, London, Department of Employment.

Joshi, H. (1986) The Wages of Motherhood. Paper presented to the Resources in Households Study Group, Institute of Education, London.

Kamerman, S. (1980) Managing Work and Family Life: A Comparative Policy Overview, in P. Moss and N. Fonda (eds.), *Work and the Family*, London, Temple Smith, 87-109.

Kelsall, R. K. (1980) Teaching, in R. Silverstone and A. Ward (eds.), *Careers of Professional Women*, London, Croom Helm, 185-206.

Kergoat, D. (1984) *Les femmes et le travail à temps partiel*, Paris, La Documentation Française.

Kergoat, J. (1985) Les distorsions de la «flexibilité», *Le monde*, 16 July, 14.

Kogan, M. (1988) The Responsiveness of Higher Education, in H. Silver (ed.), *Higher Education and the Labour Market — Flexible Responses to Change*, London, Higher Education International, 13-25.

Labourie-Racapé, A. (1981) L'emploi féminin dans le secteur bancaire, *Bulletin d'information*, Centre d'Études de l'Emploi, No. 49, 7-10.

Labourie-Racapé, A., Grozelier, A-M., Chalude, M., Jong, A. de, Povall, M. and Seear, N. (1982) L'emploi féminin dans le secteur bancaire: l'exemple de quatre banques, Belgique, France, Pays-Bas, Royaume-Uni, *Gestion et techniques bancaires*, No. 416, April, 485-91.

Labourie-Racapé, A., Letablier, M-T. et Vasseur, A-M. (1977) L'Activité féminine: enquête sur la discontinuité de la vie professionnelle, *Cahiers du Centre d'Etudes de l'Emploi*, No. 11, Paris, Presses Universitaires de France.

Lallement, M. (1987) Le travail à domicile, *Cahiers français*, No. 231, May-June, Notice 5.

Land, H. (1983) Who Still Cares for the Family? Recent Developments in Income Maintenance, Taxation and Family Law, in J. Lewis (ed.), *Women's Welfare Women's Rights*, London, Croom Helm, 64-85.

Lane, C. (1989) From 'Welfare Capitalism' to 'Market Capitalism': A Comparative Review of Trends towards Employment Flexibility in the Labour Markets of Three Major European Societies, *Sociology*, 23 (4), 583-610.

Langevin, A. (1984) Le caractère sexué des temps sociaux, *Pour*, No. 95, May-June, 75-82.

Laufer, J. (1984) Égalité professionnelle, principes et pratiques, *Droit social*, No. 12, December.

Laufer, J. (1986) Égalité professionnelle: un atout négligé pour gérer les ressources humaines, *Revue française de gestion*, No. 55, January-February, 41-53.

Laufer, J. (1987) L'égalité professionnelle: une entreprise légitime, in C. Alezra, J. Laufer, M. Maruani and C. Sutter (eds.), La mixité du travail: une stratégie pour l'entreprise, *Les Cahiers du Programme Mobilisateur «Technologie, Emploi, Travail»*, No. 3, June, Paris, La Documentation Française, 7-14.

Leprince, F. (1987) La garde des jeunes enfants, *Données sociales*, Paris, INSEE, 510-5.

Lery, A. (1984) Les actives de 1982 n'ont pas moins d'enfants que celles de 1968, *Économie et statistique*, Nos. 171-2, November-December, 1984, 25-34.

Lewis, J. (ed.) (1983) *Women's Welfare Women's Rights*, London, Croom Helm.

Lewis, S.N.C. and Cooper, C.L. (1988) Stress in Dual-Earner Families, in B. Gutek, A. Stromberg and L. Larwood, (eds.), *Women and Work: An Annual Review*, Vol. 3, London, Sage, 139-68.

Linhart, D. and Tourreau, R. (1981) Mon vendredi...! Qui gagne au change?, *Revue française des affaires sociales*, 18 (1), 139-57.

Lollivier, S. (1988) Activité et arrêt d'activité féminine. Le diplôme et la famille, *Économie et statistique*, No. 212, July-August, 25-9.

Mallier, A.T. and Rosser, M.J. (1987) *Women and the Economy: A Comparative Study of Britain and the USA*, London, Macmillan.

Management and Personnel Office (1982) *Equal Opportunities for Women in the Civil Service: A Report by the Joint Review Group on Employment Opportunities for Women in the Civil Service*, London, Management and Personnel Office.

Marpsat, M. (1989) Types de ménage et mode de cohabitation des individus. Paper presented at the Centre for Economic Policy Research Conference, Beyond National Statistics: Household and Family Patterns in Comparative Perspective, April, London.

Marry, C. (1989) Femmes ingénieurs: une (ir)résistible ascension?, *Information sur les sciences sociales*, 28 (2), 291-344.

Martin, J. and Roberts, C. (1984) *Women and Employment: A Lifetime Perspective*, London, HMSO.

Maruani, M. (1987) La soudaine prospérité de l'emploi féminin, in C. Alezra, J. Laufer, M. Maruani and C. Sutter (eds.), La mixité du travail: une stratégie pour l'entreprise, *Les Cahiers du Programme Mobilisateur «Technologie, Emploi, Travail»*, No. 3, June, Paris, La Documentation Française, 39-42.

Maruani, M. and Decoufle, A-C. (1987) Pour une sociologie de l'emploi, *Revue française des affaires sociales*, 41 (3), 7-29.

Maruani, M. and Nicole, C. (1989) La flexibilité dans le commerce: temps de travail ou mode d'emploi?, in Ministère du Travail, de l'Emploi et de la Formation Professionnelle, *L'évolution des formes d'emploi*, Document Travail-Emploi, Paris, La Documentation Française, 368-75.

Maumusson, V. (1988) Études: pourquoi les filles sont meilleures que les garçons, *Le point*, No. 823, 27 June, 59-64.

Maurice, M. (1979) For a Study of 'the Societal Effect': Universality and Specificity in Organization Research, in C.J. Lammers and D.J. Hickson (eds.), *Organizations Alike and Unlike: International and Inter-Institutional Studies in the Sociology of Organizations*, London, Routledge and Kegan Paul, 42-60.

McRae, S. (1989) *Flexible Working Time and Famile Life: A Review of Changes*, London Policy Studies Institute.

Meehan, E. (1983) Equal Opportunity Policies: Some Implications for Women of Contrasts between Enforcement Bodies in Britain and the USA, in J. Lewis (ed.), *Women's Welfare Women's Rights*, London, Croom Helm, 170-92.

Meehan, E.M. (1985) *Women's Rights at Work: Campaigns and Policy in Britain and the United States*, London, Macmillan.

Menahem, G. (1988) L'activité professionnelle des mères a augmenté les chances de réussite de leurs enfants, *Économie et statistique*, No. 211, June, 45-8.

Mendès-France, B. (1987a) Les dépenses publiques d'éducation: les effets redistributifs n'éliminent pas toutes les inégalités, *Économie et statistiques*, No. 203, October, 37-48.

Mendès-France, B. (1987b) Les effets redistributifs des dépenses d'éducation, *Données sociales*, Paris, INSEE, 238-41.

Meron, M. (1987) Les salaires dans la fonction publique, *Données sociales*, INSEE, Paris, 172-5.

Meynaud, H-Y. and Auzias, C. (1987) Une recherche sur l'égalité professionnelle à l'Électricité et Gaz de France, in C. Alezra, J. Laufer, M. Maruani and C. Sutter (eds.), La mixité du travail: une stratégie pour l'entreprise, *Les Cahiers du Programme Mobilisateur «Technologie, Emploi, Travail»*, No. 3, June, Paris, La Documentation Française, 19-24.

Michal, M-G. (1973) L'emploi féminin en 1968: rappel des résultats de 1962, *Collection de l'INSEE*, D 25, Paris, INSEE.

Ministère de l'Éducation Nationale, de la Jeunesse et des Sports (1988) *Repères et références statistiques sur les enseignements et la formation*, Paris, Ministère de l'Éducation Nationale, de la Jeunesse et des Sports, Direction de l'Évaluation et de la Prospective.

Ministère des Affaires Sociales et de l'Emploi, Délégation à la Condition Féminine (1988) *Guide des droits des mères de famille*, Paris, CNIDF-Édition.

Ministère des Droits de la Femme (1982) *Guide des droits des femmes*, Paris, La Documentation Française.

Ministère des Droits de la Femme and Ministère des Affaires Sociales et de la Solidarité Nationale (1983) *L'égalité professionnelle entre les femmes et les hommes*, Paris, Ministère des Droits de la Femme and Ministère des Affaires Sociales et de la Solidarité Nationale.

Ministère du Travail, de l'Emploi et de la Formation Professionnelle (1989) *L'évolution des formes d'emploi*, Document Travail-Emploi, Paris, La Documentation Française.

Mission pour l'Égalité Professionnelle (1985) *L'égalité professionnelle*, Paris, Ministère des Droits de la Femme and Ministère du Travail, de l'Emploi et de la Formation Professionnelle.

Monnier, A. (1986) La conjoncture démographique: l'Europe et les pays développés d'outre-mer, *Population*, 41 (4-5), 823-46.

Montagner, H. (1983) *Les rythmes de l'enfant et de l'adolescent: ces jeunes en mal de temps et d'espace*, Paris, Stock, Pernoud.

Moss, P. (1987) Employment and Income in Households with Young Children: Some Issues from a European Perspective. Paper presented to the Resources in Households Study Group, Institute of Education, London.

Moss, P. (1988) *Childcare and Equality of Opportunity: Consolidated Report to the European Commission*, Brussels, Commission of the European Communities.

Moss, P. and Fonda, N. (eds.) (1980) *Work and the Family*, London, Temple Smith.

Myrdal, A. and Klein, V. (1956) *Women's Two Roles: Home and Work*, London, Routledge and Kegan Paul.

Nicole, C. (1984) Les femmes et le travail à temps partiel: tentations et perversions, *Revue française des affaires, sociales*, 38 (4), 95-109.

Nicole, C. (1987) *Une carrière en famille: masculin pluriel, féminin singulier*, Paris, CNAM, MAIL.

Niessen, M. and Peschar, J. (eds.) (1982) *Comparative Research on Education: Overview, Strategy and Applications in Eastern and Western Europe*, Oxford, Pergamon Press.

Note d'information (1987) Coût moyen d'un élève et coût d'une scolarité dans les établissements publics en 1983, No. 87-31, Paris, Ministère de l'Éducation Nationale, Direction de l'Évaluation et de la Prospective.

Note d'information (1987) Effectifs de l'enseignement supérieur: évolution de 1960-1961 à 1984-1985, No. 87-24, Paris, Ministère de l'Éducation Nationale, Direction de l'Évaluation et de la Prospective.

Note d'information (1987) Effectifs de la population universitaire en France à la rentrée 1986-1987 — situation au 12 décembre 1986, No. 87-40, Paris, Ministère de l'Éducation Nationale, Direction de l'Évaluation et de la Prospective.

Note d'information (1987) Les diplômes délivrés en 1985 par les établissements publics d'enseignement supérieur universitaire, No. 87-23, Paris, Ministère de l'Éducation Nationale, Direction de l'Évaluation et de la Prospective.

Note d'information (1987) Les effectifs d'élèves dans les classes préparatoires aux grandes écoles en 1986-1987, No. 87-44, Paris, Ministère de l'Éducation Nationale, Direction de l'Évaluation et de la Prospective.

Note d'information (1987) Les personnels de l'enseignement supérieur 1986-1987, No. 87-35, Paris, Ministère de l'Éducation Nationale, Direction de l'Évaluation et de la Prospective.

Note d'information (1988) Effectifs de la population universitaire en France à la rentrée 1987-1988 — situation au 14 décembre 1987, No. 88-53, Paris, Ministère de l'Éducation Nationale, Direction de l'Évaluation et de la Prospective.

Note d'information (1988) Le baccalauréat — session 1987: statistiques définitives, No. 88-17, Paris, Ministère de l'Éducation Nationale, Direction de l'Évaluation et de la Prospective.

Note d'information (1988) Les diplômes délivrés en 1986 par les établissements publics d'enseignement supérieur universitaire, No. 88-45, Paris, Ministère de l'Éducation Nationale, Direction de l'Évaluation et de la Prospective.

Note d'information (1988) Les effectifs d'élèves dans les classes préparatoires aux grandes écoles en 1987-1988, No. 88-42, Paris, Ministère de l'Éducation Nationale, Direction de l'Évaluation et de la Prospective.

Note d'information (1988) Les effectifs d'étudiants dans les instituts universitaires de technologie en 1987-1988: diplômes universitaires de technologie délivrés en 1987, No. 88-25, Paris, Ministère de l'Éducation Nationale, Direction de l'Évaluation et de la Prospective.

Note d'information (1989) La scolarisation des jeunes de 16 à 25 ans. Apprentissage inclus 1987-1988, No. 89-05, Paris, Ministère de l'Éducation Nationale, Direction de l'Évaluation et de la Prospective.

Note d'information (1989) Le coût de l'éducation: évaluation provisoire du Compte de l'Education 1988, No. 89-35, Paris, Ministère de l'Éducation Nationale, Direction de l'Évaluation et de la Prospective.

OECD (1965) *Manpower Statistics 1954-1964*, Paris, OECD.

OECD (1980) *Women and Employment*, Paris, OECD.

OECD (1985) *The Integration of Women into the Economy*, Paris, OECD.

OECD (1986) *Girls and Women in Education: A Cross-National Study of Sex Inequalities in Upbringing and in Schools and Colleges*, Paris, OECD.

OECD (1988) *Labour Force Statistics, 1966-86*, Paris, OECD.

OECD (1989) *Labour Force Statistics, 1967-87*, Paris, OECD.

Oeuvrard, F. (1984) Le système éducatif, *Données sociales*, Paris, INSEE, 470-82.

OPCS (1986) *General Household Survey 1984*, No. 14, London, HMSO.

OPCS (1989a) *General Household Survey 1987*, No. 17, London, HMSO.

OPCS (1989b) *Labour Force Survey*, No. 3, London, HMSO.

Paukert, L. (1984) *The Employment and Unemployment of Women in OECD Countries*, Paris, OECD.

Peemans-Poullet, H. (ed.) (1984) *Partage des responsabilités professionnelles, familiales et sociales*, Luxembourg, Commission des Communautés Européennes.

Pelosse, J. (1987) La mixité du travail: des enjeux convergents pour les AGF et les femmes de l'entreprise, in C. Alezra, J. Laufer, M. Maruani and C. Sutter (eds.), La mixité du travail: une stratégie pour l'entreprise, *Les Cahiers du Programme Mobilisateur «Technologie, Emploi, Travail»*, No. 3, June, Paris, La Documentation Française, 15-8.

Petrie, P. and Logan, P. (1986) *After School and in the Holidays: The Responsibility for Looking after School Children*, London, University of London Institute of Education.

Pigelet, J-L. (1989a) Devenir des bacheliers dans l'enseignement supérieur et origine scolaire, Working paper, Paris, Centre d'Études et de Recherches sur les Qualifications, February.

Pigelet, J-L. (1989b) Perspectives récentes sur l'insertion professionnelle des diplômés de l'enseignement supérieur court (IUT-STS), Working paper, Paris, Centre d'Études et de Recherches sur les Qualifications, March.

Podmore, D. and Spencer, A. (1986) Gender in the Labour Process — the Case of Women and Men Lawyers, in D. Knights and H. Willmott (eds.), *Gender and the Labour Process*, London, Gower, 37-53.

Population et sociétés (1986) L'évolution démographique comparée de la France, No. 200, March.

Population et sociétés (1989) Douze pyramides des âges, plus une, No. 238, September.

Poulet, P. (1987) L'enseignement supérieur, *Données sociales*, Paris, INSEE, 555-8.

Povall, M., Jong, A. de, Chalude, M., Racapé, A. and Grozelier, A-M. (1982) Banking on Women Managers, *Management Today*, February, 50-3, 108.

Raban, T. (1988) Employment Opportunities for Graduates within Europe, in L. Hantrais (ed.), *Higher Education for International Careers*, Birmingham, London, AMLC, CILT, 43-8.

Radcliffe, P. and Warner, M. (1986) *Philosophy Graduates and Jobs: A Report for the Royal Institute of Philosophy*, London and Coventry, Royal Institute of Philosophy and University of Warwick.

Ray, M. (1981) Travail: le changement au féminin, *Le monde dimanche*, No. 11,421, 18 October, I, VI-VII.

Rebérioux, M. (1982) *Les femmes en France dans une société d'inégalités*, Paris, La Documentation Française.

Reinberg, A., Fraisse, P., Leroy, C., Montagner, H., Péguignot, H., Poulizac, H. and Vermeil, G. (1979), *L'homme malade du temps*, Paris, Pernoud, Stock.

Rendel, M. (1984) Women Academics in the Seventies, in S. Acker and D.W. Piper (eds.), *Is Higher Education Fair to Women?*, Guildford, SRHE and NFER-Nelson, 163-79

Rose, M. (1985) Universalism, Culturalism and the Aix Group: Promise and Problems of a Societal Approach to Economic Institutions, *European Sociological Review*, 1 (1), 65-83.

Rosin, H.M. (1988) Men in Two Career Families: Consequences for Careers, Marriage, and Family Life, *Canadian Journal of Administrative Sciences*, 5 (4), 9-13.

Routh, G. (1980) *Occupation and Pay in Great Britain 1906-79*, 2nd edition, London Macmillan.

Roy, C. (1989) La gestion du temps des hommes et des femmes, des actifs et des inactifs, *Économie et statistique*, No. 223, July-August, 5-14.

Roy, C. (1990) Les emplois du temps dans quelques pays occidentaux, *Données sociales*, Paris, INSEE, 223-5.

Ruggie, M. (1984) *The State and Working Women: A Comparative Study of Britain and Sweden*, Princeton, New Jersey, Princeton University Press.

Saboulin, M. de (1989) Définitions et classifications des ménages et des familles. Paper presented at the Centre for Economic Policy Research Conference, Beyond National Statistics: Household and Family Patterns in Comparative Perspective, April, London.

Savigneau, J. (1980) Un enfant pour elles toutes seules, *Le monde dimanche*, 9 March, iv-v.

Scherrer, V. (1987) *La France parasseuse*, Paris, Seuil.

Secrétariat d'État à la Condition Féminine (1976) *Cent mesures pour les femmes*, Paris, La Documentation Française.

Secrétariat d'État Chargé des Droits des Femmes (1989) *Ressources humaines et égalité professionnelle entre les femmes et les hommes: stratégie et moyens d'actions*, Paris, Secrétariat d'État Chargé des Droits des Femmes.

Secretary of State for Education and Science (1987) *Higher Education: Meeting the Challenge*, CM 114, London, HMSO.

Seys, B. (1987) Les groupes socioprofessionnels de 1962 à 1985, *Données sociales*, Paris, INSEE, 37-72.

Silverstone, R. (1980) Accountancy, in R. Silverstone and A. Ward (eds.), *Careers of Professional Women*, London, Croom Helm, 19-50.

Silverstone, R. and A. Ward (eds.) (1980) *Careers of Professional Women*, London, Croom Helm.

Singly, F. de (1987) *Fortune et infortune de la femme mariée: sociologie de la vie conjugale*, Paris, Presses Universitaires de France.

Soulez Larivière, D. (1987) *Les juges dans la balance*, Paris, Éditions Ramsay.

Statistical Bulletin (1987) International Statistical Comparisons in Higher Education, 4/87, London, Department of Education and Science.

Statistical Bulletin (1989) Student Numbers in Higher Education — Great Britain 1975 to 1987, 4/89, London, Department of Education and Science.

Statistiques des enseignements: tableaux et informations (1968-69a) Les étudiants: effectifs des élèves de l'enseignement public dans les classes préparatoires aux Grandes écoles, les sections de Techniciens Supérieurs et les Instituts Universitaires de Technologie. Année scolaire 1968-69, No. 5.1, Paris, Ministère de l'Éducation Nationale, Service Central des Statistiques et Sondages.

Statistiques des enseignements: tableaux et informations (1968-69b) Les étudiants dans les universités. Année scolaire 1968-69, No. 5.2, Paris, Ministère de l'Éducation Nationale, Service Central des Statistiques et Sondages.

Statistiques des enseignements: tableaux et informations (1968-69c) Les étudiants: effectifs des élèves dans les grandes écoles publiques et privées. Annéee scolaire 1968-69, No. 5.3, Paris, Ministère de l'Éducation Nationale, Service Central des Statistiques et Sondages.

Statistiques des enseignements: tableaux et informations (1969-70) Les examens et les diplômes dans les universités en 1969, No. 6.3, Paris, Ministère de l'Éducation Nationale, Service Central des Statistiques et Sondages.

Statistiques des enseignements: tableaux et informations (1973) Les examens et les diplômes: le baccalauréat, No. 6.2, Paris, Ministère de l'Éducation Nationale, Service Central des Statistiques et Sondages.

Stoetzel, J. (1948) Une étude du budget-temps de la femme dans les agglomérations urbaines, *Population*, Vol. 1, 47-62.

Sullerot, E. (1984) Le statut matrimonial: ses conséquences juridiques, fiscales et sociales. Rapport présenté au nom du Conseil Économique et Social, *Journal officiel*, 25 January, 19-86.

Syndicat National Unifié des Impôts (1990) *Guide pratique du contribuable. Revenus 1989*, Paris, Syndicat National Unifié des Impôts.

Tabah, L. and Maugué, C. (eds.) (1989) *Démographie et politique familiale en Europe*, Paris, La Documention Française.

Tableaux statistiques (1987a) Les écoles de sciences juridiques et administratives: effectifs des élèves en cours d'études, diplômes délivrés en 1986, No. 5641, Paris, Ministère de l'Éducation Nationale, Direction de l'Évaluation et de la Prospective.

Tableaux statistiques (1987b) Écoles d'enseignement supérieur non universitaires (écoles d'architecture, écoles vétérinaires, autres écoles dépendant du ministère de l'agriculture, spécialisations diverses), No. 5645, Paris, Ministère de l'Éducation Nationale, Direction de l'Évaluation et de la Prospective.

Tableaux statistiques (1988) Statistiques des étudiants inscrits dans les établissements universitaires: enquête détaillée par fiches individuelles,

No. 5690, Paris, Ministère de l'Éducation Nationale, Direction de l'Évaluation et de la Prospective.

Tarsh, J. (1985) Trends in the Graduate Labour Market, *Employment Gazette*, July, 269-73.

Tarsh, J. (1987) Subject to Demand..., *Times Higher Education Supplement*, 26 June, 13.

Tarsh, J. (1988) The Graduate Labour Market in the United Kingdom, in H. Silver (ed.), *Higher Education and the Labour Market — Flexible Responses to Change*, London, Higher Education International, 91-108.

Taylor, J. (1984) The Unemployment of University Graduates, *Research in Education*, No. 31, 11-24.

Thurman, J.C. and Wildon, D.C. (1985) *Careers Survey of Undergraduates who Completed Courses in BIO between 1975 and 1979*, Norwich, University of East Anglia Careers Service.

Tilly, L.A. and Scott, J.W. (1978) *Women, Work and Family*, New York, London, Holt, Rinehart and Winston.

Timsit, G. and Letowski, J. (1986) *Les fonctions publiques en Europe de l'Est et de l'Ouest*, Paris, CNRS.

Le travail des femmes en France (1966) *Notes et études documentaires*, No. 3,336, 12 November, Paris, La Documentation Française.

UCCA (1989) *UCCA: Twenty-Sixth Report 1987-8*, Cheltenham, Universities Central Council on Admissions.

Universities' Statistical Record (1982) *University Statistics 1980*, Vol 2, *First Destinations of University Graduates 1980-81*, Cheltenham, Universities' Statistical Record.

Universities' Statistical Record (1987) *University Statistics 1986-1987*, Vol. 1, *Students and Staff*, Cheltenham, Universities' Statistical Record.

Universities' Statistical Record (1988) *University Statistics 1986-87*, Vol 2, *First Destinations of University Graduates*, Cheltenham, Universities' Statistical Record.

Universities' Statistical Record (1989) *University Statistics 1987-88*, Vol 2, *First Destinations of University Graduates*, Cheltenham, Universities' Statistical Record.

Universities' Statistical Record (1990) *University Statistics 1988-89*, Vol. 1, *Students and Staff*, Cheltenham, Universities' Statistical Record.

University Grants Committee (1984) *A Strategy for Higher Education into the 1990s: The University Grants Committee's Advice*, HMSO, London.

Verger, D. (1987) Biens durables: disparités d'équipement, *Données sociales*, Paris, INSEE, 397-405.

Villeneuve-Gokalp, C. (1985) Incidences des charges familiales sur l'organisation du travail professionnel des femmes, *Population*, 40 (2), 267-98.

Vincens, J. (1986a) Enseignement supérieur et marché du travail, *Note*, No. 37 (86-02), Toulouse, Centre d'Études Juridiques et Économiques de l'Emploi.

Vincens, J. (1986b) Les formations élitistes et l'évolution de l'enseignement supérieur, *Note*, No. 39 (86-04), Toulouse, Centre d'Études Juridiques et Économiques de l'Emploi.

Ward, A. and Silverstone, R. (1980) The Bimodal Career, in R. Silverstone and A. Ward (eds.), *Careers of Professional Women*, London, Croom Helm, 10-8.

Wheeler-Bennett, J. (1977) *Women at the Top: Achievement and Family Life*, London, Peter Owen.

Wicks, M. (1983) *Families in the Future*, London, Study Commission on the Family.

Witherspoon, S. (1989) Interim Report: A Woman's Work, in R. Jowell, S. Witherspoon and L. Brook (eds.), *British Social Attitudes: The 5th Report*, London, SCPR, Gower, 175-200.

Yeandle, S. (1984) *Women's Working Lives: Patterns and Strategies*, London, Tavistock.

Zabalza, A. and Tzannatos, Z. (1985) *Women and Equal Pay: The Effects of Legislation on Female Employment and Wages in Britain*, Cambridge, Cambridge University Press.

Zucker-Rouvillois, E. (1987) Natalité et modèles familiaux dans les pays du Conseil de l'Europe et en France, *Revue française des affaires sociales*, 41 (1), 113-30.

Index